PUBLIC ART NEW YORK

PUBLIC ART NEW YORK

Jean Parker Phifer

Photography by Francis Dzikowski

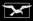

W. W. Norton & Company

New York • London

Every effort has been made to contact the copyright holder of each of the works of art. Any rights holder not credited should contact W. W. Norton & Company, Inc., 500 Fifth Avenue, New York, NY 10110 and correction will be made in the next printing of the book.

For information about permission to reproduce selections from this book, write to Permissions, W. W. Norton & Company, Inc., 500 Fifth Avenue, New York, NY 10110

For information about special discounts for bulk purchases, please contact W. W. Norton Special Sales at specialsales@wwnorton.com or 800-233-4830.

Manufacturing by Colorprint Offset
Book design by Vivian Ghazarian
Production manager: Leeann Graham

Library of Congress Cataloging-in-Publication Data

Phifer, Jean.
 Public art New York / Jean Phifer ;
 photography by Francis Dzikowski ;
 foreword by Kent L. Barwick.
 p. cm.
 Includes bibliographical references and index.
 ISBN 978-0-393-73266-5 (pbk.)
 1. Public art—New York (State)—New York—Guidebooks.
 2. New York
(N.Y.)—Tours. I. Dzikowski, Francis. II. Title.
 N8845.N7P45 2009
 707.4'7471—dc22

 2008029094

ISBN 978-0-393-73124-8

W. W. Norton & Company, Inc.,
500 Fifth Avenue, New York, N.Y. 10110
www.wwnorton.com

W. W. Norton & Company Ltd.,
Castle House, 75/76 Wells Street, London W1T 3QT

0 9 8 7 6 5 4 3 2 1

The author acknowledges the generous support of Furthermore, a program of the J. M. Kaplan Fund, toward the design and printing of the book.

Acknowledgment is made to the Artists Rights Society (ARS), New York for permission to reproduce works on the following pages:
© 2009 ARS, New York / ADAGP, Paris: 5, 35 (Dubuffet); 55 (Schein); 95 (Chagall); 101 (Janniot); 128 (Chagall); © 2009 ARS, New York / VEGAP, Madrid: 105 (Sert); © 2009 ARS, New York / VG Bild-Kunst, Bonn: 59 (Arp); © 2009 ARS, New York /VISCOPY, Australia: 74 (Jones), 87 (Davidson); © 2009 Calder Foundation, New York / ARS, New York: front cover, 132, 175 (Calder); © 2009 Estate of Louise Nevelson / ARS, New York: 36, 182 (Nevelson); © 2009 Estate of Pablo Picasso / ARS, New York: 58 (Picasso); ©2009 Estate of Richard Lippold / ARS, New York: 129 (Lippold); © 2009 Estate of Tony Smith / ARS, New York: 174 (Smith); © 2009 Jenny Holzer, member ARS, New York: 38 (Holzer); © 2009 Jime Dine / ARS, New York: 115 (Dine); © 2009 Morgan Art Foundation Ltd. / ARS, New York: 115 (Indiana); © 2009 The Isamu Noguchi Foundation and Garden Museum, New York / ARS, New York: 34, 106, 112, 181, 236-37 (Noguchi)

Acknowledgment also is made to VAGA for permission to reproduce works on the following pages:
25: art © Marisol Escobar/Licensed by VAGA, New York, NY
45, 63: art © Tony Rosenthal/Licensed by VAGA, New York, NY

Groupe de Quatres Arbres, see page 35.

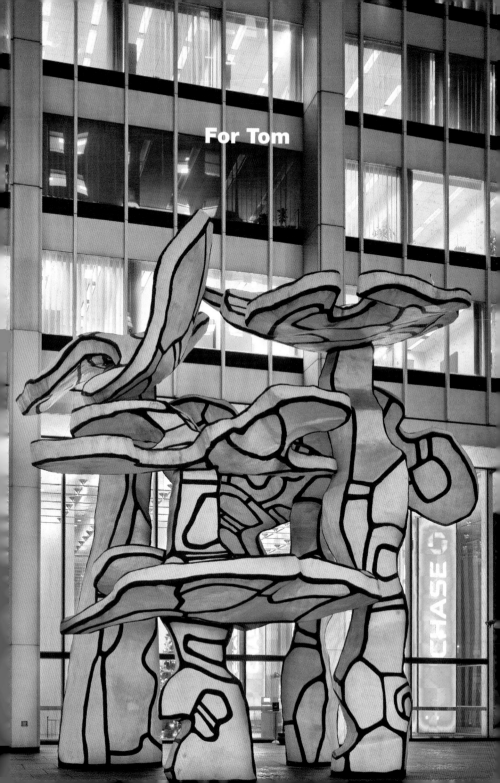

CONTENTS

Foreword

BY KENT L. BARWICK

One of the great joys of New York is the enduring freedom of its streets. In an era infatuated with gated communities, concerned with better securing our borders, and unembarrassed by hiding our highest leaders in undisclosed locations, it is reassuring that the public environment of America's leading city is indeed public. The city's ambition to maintain the civility and dignity of urban space is a source of pride to New Yorkers and a credit to the leadership of the Bloomberg administration during one of the most trying times in New York's history.

Like Winston Churchill keeping up funding for the arts in the darkest days of the London Blitz ("so that people will see what we are fighting for"), New York's leaders in the awful wake of 9/11 have proceeded to restore and expand upon an incomparable collection of parks, cultural institutions, and public art.

Older and often neglected works of public art have also been given new life. The Municipal Art Society, originally organized in 1893 to privately sponsor civic art, has been proud to work collaboratively with New York City's Public Design Commission, formerly known as the Art Commission, and Parks Department in recent years to restore and maintain some fifty monuments and murals through the Adopt-a-Monument and Adopt-a-Mural programs.

It is a good time for a look at what's been going on. And who better to guide us than architect Jean Phifer, who served so effectively as President of the Art Commission of the City of New York from 1998 to 2003.

This extremely attractive sampling of New York's public treasures documents the work of a wide array of living and often young artists, and an increasingly rich and sensuous use of new materials. It also pays affectionate respect to earlier works whose power to engage shifts subtly over time.

It is, above all, an invitation to hit the streets. Phifer has not pretended to be encyclopedic (that would take volumes), but these striking photographs of both the new and what we thought familiar remind us of the ever-changing and compelling landscape we are so lucky to inhabit and so rarely take the time to see.

Dichroic Light Field, see page 133.

Introduction

Why another book on public art in New York?

There are several answers. This book is the first inclusive survey, in color, of a varied selection of public art in all five boroughs of New York City. While limitations of space and budget mean that it is hardly comprehensive, it does present a well-considered overview of the subject in a portable format. It examines public art in the broadest sense, including not only outdoor sculpture but also murals and other wall art, works of art in lobbies accessible to the public, outstanding public plazas and landscapes, and even a few examples of artistic sidewalks and creative lighting. The choice of projects is intended to be wide in scope but selective in quality. I have tried to balance traditional and contemporary works of art and to include only works of art that can be viewed at no charge, at least some of the time. Not included are projects in public schools, which are generally not accessible for reasons of security; art in the subways; and more than a few of the many temporary works of sculpture installed under the auspices of the Public Art Fund, Creative Time, and other contemporary arts organizations.

How could I possibly pick the best or most interesting among the thousands of works of art in the city? There is, of course, the matter of personal taste, but there is also the recognition that, likeable or not, the best public art should engage a broad range of people, enhance its setting, and serve as an anchor or a lightning rod in the public domain. Public art can serve as a record of history, as a reflection of the transitory, and as a magnifier of a moment in time. Some of the works in the book have weathered controversy to become beloved fixtures in their neighborhood; others are the focus of continuing debate. In serving more than five years on the Art Commission of the City of New York, now the Public Design Commission, I learned to weigh not only the prominence of the location, the enthusiasm of the community, or the renown of the artist but also the complex interplay between a work of public art and its immediate physical surroundings. Thus, as an architect and planner, I have focused particularly on how these works of art enrich and amplify the architecture and public space encompassing them, contributing to urban sustainability in the larger sense.

Books of note about public art include the definitive *Guide to Manhattan's Outdoor Sculpture* by Margot Gayle and Michele Cohen (1988). This excellent and

comprehensive survey includes, however, only outdoor sculpture in one borough of New York City, photographed in black and white. A number of well-designed books issued more recently focused on tightly circumscribed categories of public art: *PLOP* (about temporary works sponsored by the Public Art Fund); *City Art* (documenting public projects installed under New York City's Percent for Art Program); and *Along the Way: MTA Arts for Transit* (featuring projects in the subways). Yet because of their limited scope, these do not convey an understanding of the rich variety of media, subject matter, sites, and installations for permanent public art throughout New York City.

Moreover, several important new projects have been built since the 1988 *Guide* was published, and, sadly, several works of art have been lost. Some of the numerous new works featured in these pages include James Carpenter's Icefall at the Hearst Building; Brian Tolle's Irish Hunger Memorial at the north end of Battery Park City; Elizabeth Catlett's Ralph Ellison Memorial on Riverside Drive; and Eric Fishl's Memorial to Arthur Ashe at the National Tennis Center. The striking Postcards Memorial to the World Trade Center on Staten Island is only one of several memorials to 9/11 that have been and will be constructed around the New York metropolitan area. The principal 9/11 memorial at Ground Zero on the site of the World Trade Center in Lower Manhattan remains several years from completion as of this writing.

It has been tremendously rewarding to revisit each work in the book in the company of the talented photographer Francis Dzikowski. Since we only photograph in fair weather, the days spent outside have been optimal for seeing public art in, literally, its best light. A photographer interprets objects in a different way than an architect does, and Francis has illuminated aspects of these works in fresh ways for me and for readers of this book.

The chapters are organized by neighborhood, and the beautiful maps at the beginning of each chapter allow the book to be used as a walking guide.

It was an enormous effort to make the final selection of works of art. We are well aware that many excellent or popular works are not included here. We hope to have the opportunity to update the book in the future, so that newly completed works of art and significant works that we may have overlooked can be added.

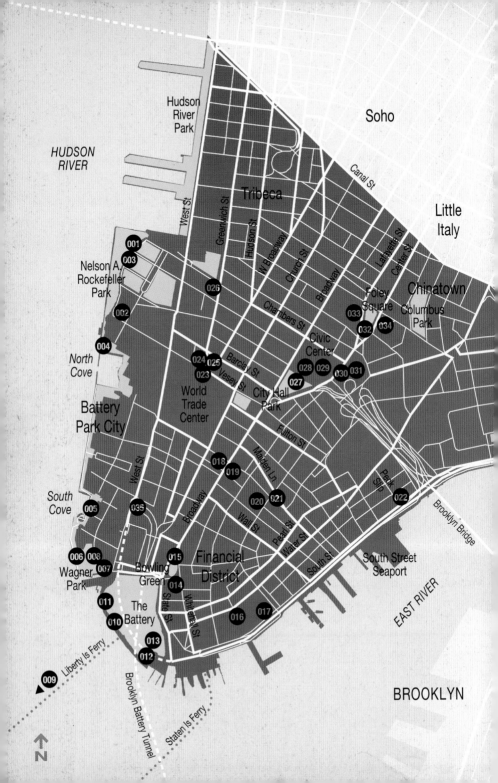

1

Lower Manhattan

Battery Park City

A planned development built on landfill mined primarily from the excavation of the World Trade Center in the 1960s, Battery Park City has from the start incorporated public art into the fabric of its community spaces. Based on a 1979 master plan by Cooper Eckstut, more than 30 percent of the site has been reserved for parkland, public plazas, and the stunning waterfront esplanade. These communal green spaces offer innumerable sites for public art, and a striking number of permanent works have been installed here over the last twenty-five years. The Battery Park City Authority's overall plan for open space and public art received a special recognition award from the Art Commission of the City of New York in 1984. A selection of these works is described below.

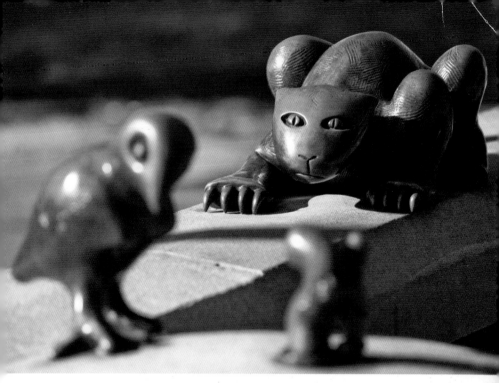

001 **The Real World**

TOM OTTERNESS, 1992
COLLECTION OF THE BATTERY PARK CITY AUTHORITY

Nelson A. Rockefeller Park, North River Terrace between Chambers and Warren Streets

Set on the inland side of a ravishing lawn that terminates the north end of Battery Park City's esplanade, this delightful playground appeals to both children and adults. Otterness has sprinkled the whimsical figures of his sculptural ensemble throughout the playground, not only on the ground but also on the chess tables, wall, and lampposts. It's a game to search for all of the figures, but it doesn't take long to grasp the humorous themes of humanity's quest for money and the playful war for domination between different creatures and social classes. A leaning house peopled by odd anthropomorphic creatures and topped by Humpty Dumpty occupies a fountain piled with pennies near the middle of the site, suggesting the fragility of wealth and happiness. A sinuous line of pennies set into the pavement offers children a path through the playground, leading at the south end to a cat stalking a bird perched on a wall. Look again, and you'll see a dog at the base of the wall, patiently tailing the cat.

The Irish Hunger Memorial

BRIAN TOLLE, ARTIST; GAIL WITTWER, LANDSCAPE ARCHITECT;
1100 ARCHITECT, 2002
COLLECTION OF THE BATTERY PARK CITY AUTHORITY

North End Avenue at Vesey Street

Sited between the buildings at the north end of Battery Park City and the Hudson River esplanade, and surrounded by recently minted commercial buildings and ongoing construction, the Irish Hunger Memorial at first glance appears to be out of both place and time. Its very incongruity grabs the attention of passersby and establishes the strength of the scheme. If you approach from the east, it looks like a floating plane of native grasses sloping up to the west. This quarter acre of landscape is served up as an abstract yet realistic representation of the Irish landscape, canted like a display in a museum case. It includes not only boulders, grasses, and wildflowers but also the ruins of an actual Irish stone hut, a combination that suggests both historical immediacy and the romantic sublime.

Artist Brian Tolle says, "For this memorial it was very important that the Irish landscape, which played such a critical role in the tragedy of the famine, function as an element contained within the sculpture, rather than the artwork sitting on the ground in the middle of the park landscape." He recalls the added poignancy of working to build this memorial in the difficult months immediately following the destruction of the World Trade Center just steps away. Because of its proximity to Ground Zero, resuming construction of the Irish Hunger Memorial within a month of the tragedy became an important expression of community healing.

Walking around the side of the memorial, you see the clearly articulated rough concrete edge of the landscaped plane and then the more elegant, finely detailed masonry base below. This base is built of the same handsome, dark gray oolitic limestone as the sidewalk, set in thin horizontal strips interspersed with bands of glass block. The bands, featuring quotes that document and literally illuminate aspects of hunger all around the world, run

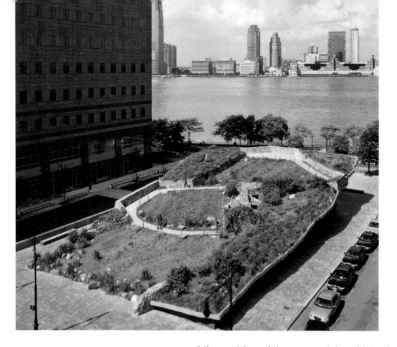

around three sides of the memorial and into the entry passage on the west side.

The elegant but somber passage, inspired by prehistoric Irish tombs and enlivened by sound tracks of additional quotes, slopes gently upward from the exterior sidewalk into the interior of the memorial, not an indoor room but a bright outdoor space defined by the stone ruins set into the landscaped plane. Visitors move through this walled space upward onto the landscape, the primary image of the memorial.

The undulating furrows of turf recall both potato fields and anonymous mass graves. Native Irish plants are scattered among boulders gleaned from each county in Ireland. The landscape's slightly arid and unkempt appearance is a deliberate evocation of famine and suffering; scattered wildflowers and poppies heighten the expression of memory and loss. Visitors reaching the top of the slope are rewarded by an expansive view over the Battery Park City esplanade and the Hudson River to the Statue of Liberty and Ellis Island, where many Irish escaping the famine first arrived in the United States.

In an effort to include diverse voices and to continue active dialogue on the persistent issue of world hunger, the artist arranged for both the written and recorded quotes in the memorial passage to be updated and replaced over time in collaboration with the World Food Organization.

003 **The Pavilion**

DEMETRI PORPHYRIOS, 1992
COLLECTION OF THE BATTERY PARK CITY AUTHORITY
North River Terrace at Warren Street

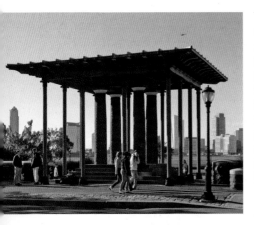

This stately pavilion is a work of urban art at many levels. Seen from the grid of nearby streets, it serves as an effective transition from the street into the park, providing ample space for seating in the shade or the sun. Constructed in an archaic style, it combines traditional materials in fresh ways—for example, applying wrought-iron capitals to cedar columns. It straddles the line between architecture and artifice, recalling historic forms with understatement and irony.

004 **The Pylons**

MARTIN PURYEAR, 1995
COLLECTION OF THE BATTERY PARK CITY AUTHORITY
North side of North Cove, west of the Winter Garden

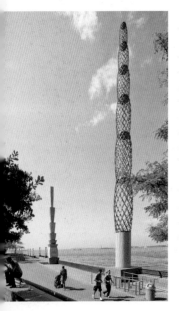

Located at the water's edge directly on the centerline of the Winter Garden, these pylons create a powerful axis between the heart of the World Financial Center and the Hudson River. One wishes the ferry boats that tie up further north could disgorge their passengers at this axial gateway; but in reality this would not do, because the need for functional structures related to ferry operations would overpower the pylons. The pylons sit on monumental granite bases and present two contrasting expressions of stainless steel: one, stacked boxes of solid, tapering forms; the other, an open latticework tower evoking double helixes. They are elegant examples of the urban-scaled work of Martin Puryear, whose intriguing art in wood, stone, and wire mesh was featured in a popular retrospective show at the Museum of Modern Art in 2007. The pylons are especially arresting when illuminated at night.

South Cove

MARY MISS, ARTIST; STANTON ECKSTUT, ARCHITECT;
SUSAN CHILD, LANDSCAPE ARCHITECT, 1988
THE BATTERY PARK CITY AUTHORITY

**West of Battery Place between West Thames Street
and 1st Place**

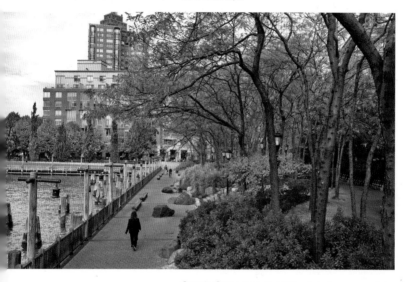

South Cove is one of the most successful public art instal-
lations at Battery Park City. A truly integrated collaboration
of an environmental artist, a landscape architect, and
an architect, South Cove is successful in part because
both the natural and man-made materials are simple and
consistent with the waterfront setting. The wooden dock
parallel to the water's edge is animated with blue lights
that evoke the historic waterfront. As with the parks of
Frederick Law Olmsted, however, what appears to be
natural is entirely man-made; the mounded boulders and
grasses that have been carefully laid out on the inland
side of the dock are interspersed with steps leading
to raised, shaded seating areas, creating a two-tiered
promenade for fast and slow circulation.

At the south end of the cove, an open, steel viewing
tower that vaguely recalls the form of the Statue of
Liberty's crown offers a higher vantage point from which to
view the cove. The straight wooden pier reaches out over
a bridge into the river and is topped by a curved wooden
arcade at the water's edge. Although these structures add
some whimsy to the scheme, it is the basic combination
of dock, boulders, grasses, and shaded seating that
makes this a compelling waterfront destination.

006 Robert F. Wagner Jr. Park

MACHADO & SILVETTI, ARCHITECTS; THE OLIN PARTNERSHIP,
LANDSCAPE ARCHITECTS; LYNDEN B. MILLER, PUBLIC GARDEN
DESIGN, 1996
THE BATTERY PARK CITY AUTHORITY

West of Battery Place, between 1st Place and West Street

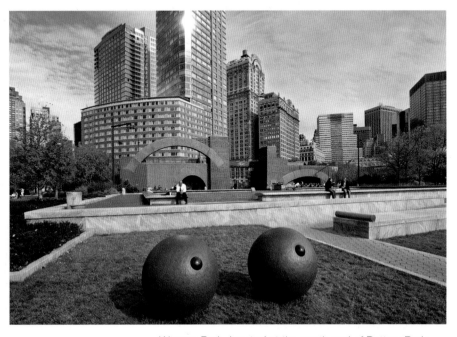

Wagner Park, located at the south end of Battery Park City, presents an outstanding integration of architecture, landscape, and horticulture. Although the public art pieces are by well-known artists, it is the view of the harbor and the Statue of Liberty that steal the show. Machado & Silvetti designed a gateway to the spectacular view that pumps up a modest program to create a dynamic, highly idiosyncratic piece of architecture surrounded by lush gardens, a formal lawn, and an allée or walk between rows of trees. Louise Bourgeois's granite *Eyes* (1995) faces the riverfront esplanade.

The entrance side of the building facing West Street appears to consist entirely of two sets of monumental steps flanking a central, bridge-like structure between two towers that frame the view beyond. The steps lead up to twin viewing platforms that feature high-backed teak benches and are linked by the bridge.

007 **Public Gardens**

LYNDEN B. MILLER, PUBLIC GARDEN DESIGN, 1996
COLLECTION OF THE BATTERY PARK CITY AUTHORITY

The south side of the building houses a good Italian restaurant that makes full use of its riverside terrace to overlook the small, formal public lawn facing the esplanade. From inside you cannot see the richly colored public gardens that frame the building on its narrow north and south ends. These gardens, beautifully maintained

by the Battery Park City Parks Conservancy, feature a theme of "cool" colors to the south and "hot" colors to the north, with striking mixtures of leaf shapes and sizes, sophisticated color combinations, and juxtapositions of mounded and spiking forms; their enclosure by high yew hedges adds to the sense of "secret" gardens hardly visible from the street.

008 **Resonating Bodies**

TONY CRAGG, 1996
COLLECTION OF THE BATTERY PARK CITY AUTHORITY

Two enigmatic pieces recalling musical instruments flank the entrance on the street side of the building; the wavy lines animating the surfaces represent invisible energy forces.

On the river side of the building, the small structure gains substantially in heft from its densely laid, dark red brick masonry and the repeated use of monumental arch motifs at both the first and second floor levels. The monumentality of the arches is undercut, however, by the curved stainless steel mega-lintel visible under the longest arch.

Statue of Liberty

FRÉDÉRIC-AUGUSTE BARTHOLDI, SCULPTOR; RICHARD MORRIS
HUNT, ARCHITECT; GUSTAVE EIFFEL, ENGINEER, 1875–84
COLLECTION OF THE NATIONAL PARK SERVICE; STATUE A GIFT OF THE CITIZENS
OF FRANCE; PEDESTAL BASE A GIFT OF THE CITIZENS OF THE UNITED STATES

New York harbor southwest of The Battery

Visitors entering New York Harbor by boat often say that
the most moving moment of arrival is the first glimpse of
the Statue of Liberty, the preeminent symbol of America as
the land of opportunity. Because the colossal statue faces
out to sea from its island base, its visual impact is most
dramatic from the harbor approach, consistent with its role
as a beacon to immigrants; a trip on the Staten Island Ferry
is an excellent substitute for arrival by ocean liner.

When seen from the land in New York City or New
Jersey, the great statue anchors the bustling seascape
of the harbor. Its profile is unique and unmistakable, as
intended by Bartholdi, who realized it would be seen from
many angles and from great distances. It is also a triumph
of engineering by the innovator Gustave Eiffel, who had
to design the steel armature to resist the gale-force winds
and corrosive atmosphere of the harbor. Architect Richard
Morris Hunt placed the copper-clad statue on a hefty
and well-proportioned masonry pedestal, the base of
which is reminiscent of military architecture.

Formally named Liberty Enlightening the World, the
gargantuan statue sports many symbols of freedom,
including the iconic crown of light, the torch, and the
broken chains of bondage at Liberty's feet. The date of
the Declaration of Independence, July 4, 1776, is engraved
on the book she holds in her left hand. Paid for by
subscriptions raised from French citizens, the statue was
intended to honor French-American friendship and to
herald the success of American constitutional democracy.

Liberty's compelling nature stems in part from the
fact that this stupendous statue depicts not a manly form
like the Colossus of Rhodes but a classically draped female
figure. The folds of the toga and the soft green of the
weathered copper skin reinforce the figure's humanistic
and cultured tone. She is at once reassuring and inspiring.

One of the most striking views of the Statue of Liberty
is from the highest point of Brooklyn, in historic Green-Wood
Cemetery; here the statue *Minerva* (227), erected in 1920
on the anniversary of the Revolutionary War's Battle of
Brooklyn (also known as the Battle of Long Island), salutes
the Statue of Liberty clearly visible in the distance.

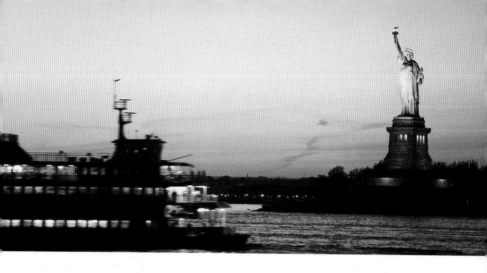

The Battery

Key to the revival of The Battery as a vibrant public park at the tip of Manhattan have been the regreening of the park's open spaces and the refocusing of the park on its waterfront heritage by The Battery Conservancy, a public/private partnership. New, sinuous granite benches offer a comfortable perch from which to enjoy the sumptuously planted Gardens of Remembrance and the Battery Bosque against the lively backdrop of the expansive New York Harbor. The numerous commemorative sculptures that dot The Battery include several traditional war memorials, a memorial to immigrants, one to the explorer Verrazano, and sculptures of two nineteenth-century inventors.

The River That Flows Two Ways

WOPO HOLUP, 2002

COLLECTION OF THE CITY OF NEW YORK, COMMISSIONED BY THE BATTERY
CONSERVANCY

Perimeter seawall of The Battery

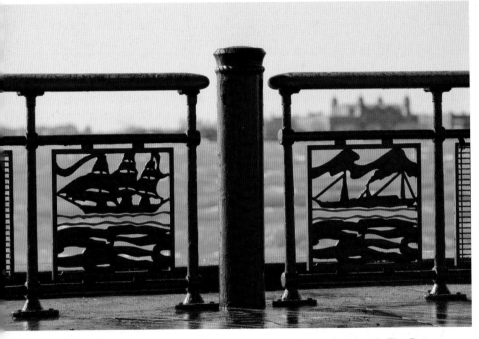

One of the most inventive works of art in The Battery is the 1,500-foot-long decorative cast-iron fence that runs along the water's edge. It fancifully represents the mythic allure as well as the commercial significance of the Hudson River in the history of New York City with panels in decorative relief spaced intermittently along the fence. Depictions of various aquatic creatures fill the lower half of each panel, while events of local human history are woven along the top half. Historical events include, for instance, the arrival of Henry Hudson, the launching of Fulton's steamboat, and the use of Castle Clinton, the fort at the south tip of the Battery, as an immigrant depot before the construction of Ellis Island. The fence combines artful design with practical purpose: the graceful form draws visitors to the water's edge while giving them a safe vantage point from which to enjoy the water view.

011 # American Merchant Mariners' Memorial

MARISOL, 1991
COLLECTION OF THE CITY OF NEW YORK
In the water just west of The Battery

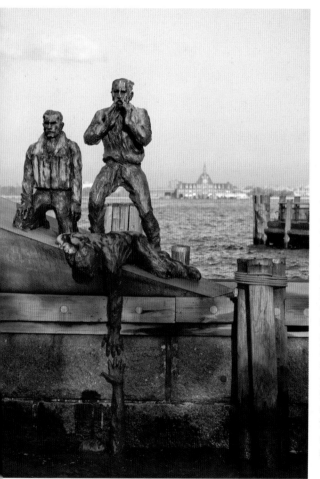

As you approach Pier A at the northwest edge of The Battery, the striking silhouette of several bronze figures poised on what appears to be the prow of a sinking ship attracts your eye. One figure is shouting for help, one scans the horizon, and a third reaches down into the water to pull his comrade from the sea. This intriguing fourth figure alternately appears and disappears with every wave, depending upon the tide and the wind. The monument was based, as cited on the plaque, on "a photograph of the victims of a submarine attack on an American merchant ship during World War II. Left to the perils of the sea, the survivors later perished." With a graphic realism unusual for the end of the twentieth century, this monument brings the dangers of wartime marine service vividly to life.

012 East Coast Memorial

GEHRON AND SELTZER, 1963

COLLECTION OF THE UNITED STATES GOVERNMENT

Southeast section of The Battery

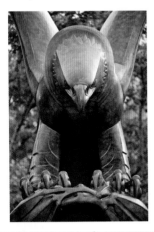

Despite its heavy-handed use of huge, symmetrically placed granite panels that bear the names of the 4,601 servicemen who perished in the Atlantic Ocean during World War II, the East Coast Memorial creates a powerful spatial statement at the tip of The Battery. Oriented toward the Statue of Liberty to the southwest and the high-rise buildings of State Street to the north, the monument centers on a large bronze eagle placing a wreath on a symbolic wave. Only a few months before he was assassinated, President John F. Kennedy, himself a survivor of naval warfare in World War II, dedicated the monument.

013 **Battery Bosque and Fountain**

SARATOGA ASSOCIATES LANDSCAPE ARCHITECTS; PIET OUDOLF, HORTICULTURIST; WEICZ & YOES ARCHITECTS; LINNEA TILLETT, LIGHTING DESIGN, 2005
COLLECTION OF THE CITY OF NEW YORK, COMMISSIONED BY THE BATTERY CONSERVANCY

South end of The Battery

A striking addition to The Battery is the spiral fountain built of granite at the center of the Battery Bosque landscape. (A bosque is a grove of trees.) The fountain is beautifully lit at night, its glow enlivening this whole area of the park. The plantings of perennials and bulbs underneath the trees have transformed what used to be a shoddy paved area into a delightful garden with seasonal horticultural interest and benches for seating.

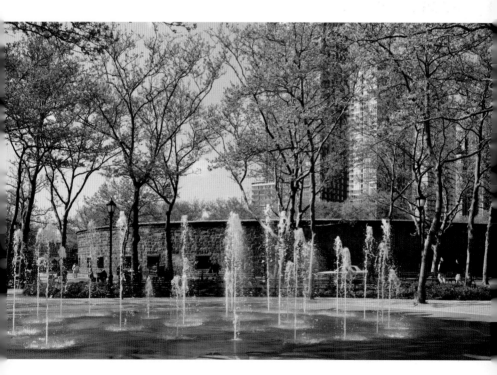

Bowling Green

Located at the foot of Broadway in the heart of the original Dutch village of New Amsterdam, Bowling Green is the oldest remaining vestige of original open space in the city. Surrounded by a restored eighteenth-century fence and punctuated by reconstructed but inoperable gas lamps, this small park is centered on a large twentieth-century fountain ringed by flowers. The simple gravel walkways, benches, and lawns shaded by sycamore trees offer a peaceful respite from the Broadway traffic. Although no permanent artwork is located in the park, several significant works are immediately adjacent.

The Four Continents

DANIEL CHESTER FRENCH, 1903–7

COLLECTION OF THE UNITED STATES GENERAL SERVICES ADMINISTRATION

Museum of the American Indian,

Alexander Hamilton U.S. Customs House

CASS GILBERT, ARCHITECT, 1907

Battery Place at Broadway

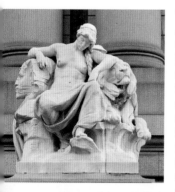

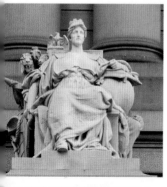

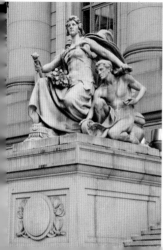

To the south, the park fronts on the magnificent Beaux-Arts façade of the original Custom House designed by Cass Gilbert, now the Museum of the American Indian. Daniel Chester French's majestic figures *The Four Continents* animate and flank the principal entrances of the building. These anthropomorphic representations of the cultural characteristics of each continent, supplemented by animal mascots and symbolic details, illustrate common American attitudes at the turn of the twentieth century. Africa, surrounded by a sleeping lion and a decayed Sphinx, is dozing (top). Europe (center) is depicted as learned and regal, with books and a globe serving as props. Predictably, the statue of America (bottom) is shown as vital and dynamic, surrounded with plentiful crops and vigorous citizens of both European and Native American descent. Mystical Asia (below) is meditating, flanked by a tiger and what appear to be slaves.

On the cornice above are twelve limestone statues of various maritime powers in trade, sculpted by eight different artists. If the façade were not usually in shadow due to its northerly orientation, it would be even more appreciated. Taken all together, these sculptures bring life and light to the otherwise barren plaza between the building and Bowling Green. Inside the building's ornate oval rotunda are decorative maritime murals painted in 1936–37 by Reginald Marsh.

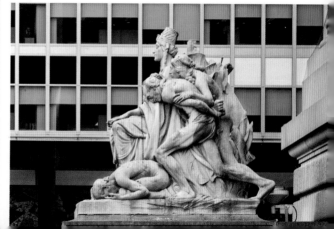

015 **Charging Bull**

ARTURO DI MODICA, 1989

COLLECTION OF THE ARTIST, INSTALLED ON PROPERTY OF THE CITY OF NEW YORK

© ARTURO DI MODICA, 1998

North of Bowling Green

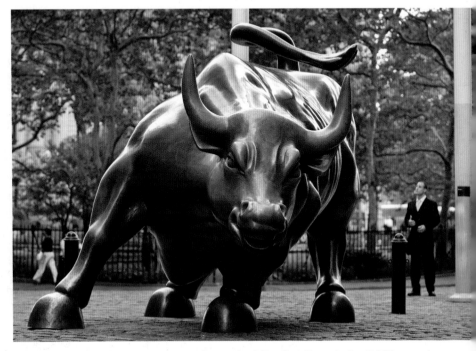

Just to the north of Bowling Green is the 7,000-pound bronze statue of a charging bull, embodiment of the "up" or "bull" side of the "bull" and "bear" sobriquets for surging and receding markets. Representing the fierce and volatile spirit of Wall Street, the muscular bull paws the ground and seems to snort, exuding raw strength and brute energy.

The statue was first installed surreptitiously by the artist in front of the Stock Exchange on Wall Street in 1989. The city's Department of Parks & Recreation then moved it to this site on a temporary basis. Although neither location was ever formally approved by the city's Art Commission, the statue has become a popular tourist destination. Given its placement on a triangle at the foot of Broadway, it has received a degree of exposure unprecedented for a rogue work of art.

016 **Vietnam Veterans Memorial**

WORMSER & FELLOWS, ARCHITECTS; JOSEPH FERRADINO, WRITER, 1985; PLAZA RENOVATED BY ETM ASSOCIATES AND JEFFREY S. POOR, 2001

COLLECTION OF THE CITY OF NEW YORK, GIFT OF THE NEW YORK VIETNAM VETERANS MEMORIAL COMMISSION

East of Water Street at Broad Street

Growing out of a 1982 design competition, New York's memorial to the veterans of the Vietnam War is simple but eloquent testimony to personal sacrifice and public service in a time of great social upheaval. The green glass block walls of the compact structure are engraved with fragments of letters and anecdotes of soldiers who served in the conflict. The smoothness of the frosted glass and luminousness of the backlit blocks perfectly offset the crispness of the incised letters and the poignancy of the messages they convey. The monument draws the visitor back in time to contemplate the enormous personal and social cost of the conflict.

Because the original memorial is set back a long distance from and perpendicular to Water Street, and therefore failed to engage passersby, the 2001 redesign of the park focused on increasing the commemorative and informational features and on drawing more visitors into the site. This was accomplished by adding an informative map of the area of conflict, creating a Walk of Honor with parallel piers leading directly to the memorial, and adding more greenery and benches. The slightly inclined piers list the New Yorkers who were killed as a result of their service in the war. A large amphitheater and fountain just to the south of the original memorial now provide a generous space for passersby to linger at the site.

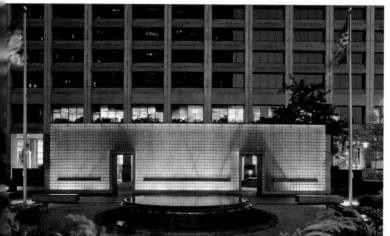

55 Water Street Park

ROGERS MARVEL ARCHITECTS; KEN SMITH LANDSCAPE
ARCHITECTS; ROBERT A. HEINTGES, GLASS CONSULTANT;
JIM CONTI, LIGHTING DESIGN, 2005
OWNED BY THE NEW WATER STREET CORPORATION

55 Water Street

The privately owned park at 55 Water Street was designed to recapture for the public the windswept and underutilized "public" space on the third story of a large commercial office building overlooking the East River. Approached by long escalators reaching up from Water Street, the small park was isolated from the street and had scant amenities to lure pedestrians. As redesigned, the plaza steps up from west to east on terraces landscaped with grasses and native plants, culminating in the riverfront promenade. There are plenty of places to sit in sun or shade and enjoy panoramic views of the East River. The architects placed a tall, glass-paneled "beacon" on the northeast corner to mark the secondary elevator access to the site and to provide nighttime lighting. The beacon provides a lively visual anchor for this refreshing piece of landscape design that reconnects this busy office area to the waterfront.

018 **Joie de Vivre**

MARK DI SUVERO, 1998
COLLECTION OF THE BROOKFIELD CHARITABLE FOUNDATION

Zucotti Park

COOPER ROBERTSON AND PARTNERS, ARCHITECTS
Broadway at Liberty Street

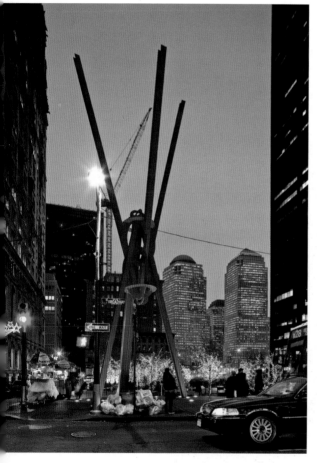

One of the first public plazas in the vicinity of Ground Zero to be entirely redesigned and rebuilt, Zucotti Park, formerly known as Liberty Park Plaza, provides a revitalized link between Ground Zero and lower Broadway. As the site slopes up from west to east, the placement of Mark di Suvero's exuberant sculpture *Joie de Vivre* at the southeast corner of the park creates a brilliant punctuation mark in the urban fabric. The 70-foot-tall, red-painted interlaced steel beams create a focal point from every direction, and they lead the eye through the grid of honey locusts in the park along the primary path of travel to the southeast. But perhaps the most exciting aspect of the sculpture is the phenomenal conversation it sustains with Noguchi's *Red Cube* (019) to the east across Broadway. The extroverted ranginess of the di Suvero, which was relocated here from the entrance to the Holland Tunnel, is the perfect riposte to the tightly controlled geometry of the Noguchi classic.

At the northwest corner of the park, J. Seward Johnson's *Double Check* has been restored to its location prior to 9/11. The piece, covered in dust when the Twin Towers fell, has been recast to incorporate replicas of the many mementos left there after the tragedy.

019 **The Red Cube**

ISAMU NOGUCHI, 1967

COMMISSIONED BY THE 140 BROADWAY COMPANY

HSBC Building, formerly Marine Midland Building

GORDON BUNSHAFT/SKIDMORE OWINGS AND MERRILL,
ARCHITECT, 1967

140 Broadway

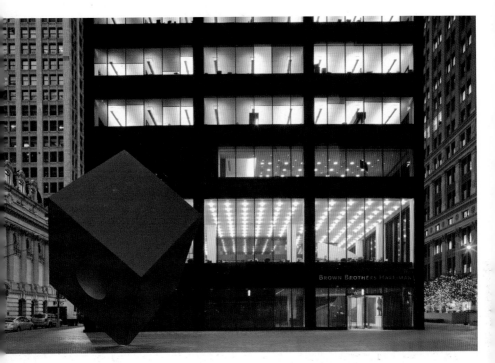

One of the iconic public art pieces of twentieth-century New York, *The Red Cube* dominates the open plaza between the Marine Midland Building and lower Broadway. Because it is red and balanced on the tip of one corner, *The Red Cube* acts as a jaunty counterpoint to the staid, modernist architecture of the bank and surrounding historic neighborhood. The almost imperceptibly elongated proportions and the dark hole in the middle of the cube capture and hold the eye beyond the first impression. Because the image of the cube on its point recalls the rolling of dice that typifies risky investment strategies, Noguchi's masterfully executed sculpture, developed in collaboration with the architect Gordon Bunshaft, is an inspired choice for the front of this bastion of corporate culture.

020 **Groupe de Quatres Arbres**

JEAN DUBUFFET, 1972
COLLECTION OF THE MUSEUM OF MODERN ART, GIFT OF DAVID ROCKEFELLER

Chase Manhattan Plaza

GORDON BUNSHAFT/SKIDMORE, OWINGS & MERRILL,
ARCHITECT, 1961

Off Pine Street between Nassau and William Streets

The selection of Jean Dubuffet to design a work of art for this large corporate plaza resulted in one of the most felicitous installations of public art in urban America. The Chase bank's advisory art committee settled on the Dubuffet more than ten years after construction of the building. Having considered many proposals by various artists, architect Bunshaft and bank vice-chairman David Rockefeller finally persuaded the committee that the Dubuffet was the appropriate choice.

The curvaceous artificial trees, which appear to be made of papier-mâché but are in fact made of fiberglass resin over an aluminum frame, bring an element of delightful whimsy to this otherwise formal, modernist setting. They look like three-dimensional cartoons of the concept of large-scale public art that decorates so many corporate plazas, and they are equally a riff on the

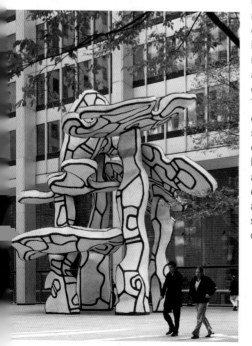

ubiquitous groves of trees that enliven many public spaces, including this one. Despite or perhaps because of its irreverent character, however, this masterpiece holds its own in both scale and aesthetic weight against Bunshaft's cerebral glass and aluminum façade. The plaza itself benefits from its raised elevation relative to the surrounding streets: the stairs and low retaining walls on all sides prevent the need for security bollards (low posts to prevent vehicular access) or large planters. The only visual elements competing with the Dubuffet are the simple allée of trees on the east side and the large sunken fountain designed by Isamu Noguchi.

Shadows and Flags

LOUISE NEVELSON, 1977
COLLECTION OF THE CITY OF NEW YORK, GIFT OF THE MILDRED ANDREWS FUND
Louise Nevelson Plaza, Maiden Lane at William Street

Although the paving, seating, and streetscape amenities
of this small, triangular plaza have aged poorly and are
due for renovation, the works of art in weathering steel are
well suited to the site. The small pieces at the east end
of the plaza are of the same scale as the linden trees and
fit comfortably into the streetscape even though some
of their detail is obscured by the trees. At the broader
west end of the triangle, the largest piece soars into the
open space in front of the Federal Reserve Bank. The
dark brown color of the weathering steel is a handsome
complement to the warm beige masonry of the Federal
Reserve Bank, and the curved shapes of the sculpture
echo the arched windows of the landmark building. This
is a harmonious and eloquent pairing of contemporary art
with historic architecture of an imposing scale.

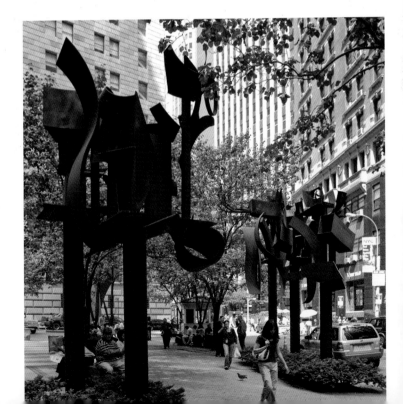

022 **Peck Slip Arcade**

RICHARD HAAS, 1978; REPAINTED, EVERGREEN STUDIOS, 2002
COLLECTION OF CONSOLIDATED EDISON, SPONSORED BY CITYWALLS

Peck Slip at corner of Front Street

A gloriously urban-scaled mural fills the north side of Peck Slip with its evocation of the view of the nearby Brooklyn Bridge that might have existed on this spot were it not for the existing featureless substation building. Haas has succeeded in combining historical memory with artistic license and visual delight. The painting conjures up picturesque historic storefronts from the 1850s, and it delightfully turns the corners at the protruding and receding portions of the building.

The mural is in good condition thanks to a repainting project in 2002, when Haas was delighted to "have the opportunity to make about a hundred small changes and improvements that I had always wanted to make!" The yard between the façade and the curb has been fenced off and finished with gravel paving. Despite this slightly unwelcoming detail at the pedestrian level, the wonderfully executed mural enlivens the whole block by recalling the ghost of Peck Slip past.

7 World Trade Center

SKIDMORE, OWINGS & MERRILL, ARCHITECTS, 2006
250 Greenwich Street at Vesey Street

As the first World Trade Center building to be
redesigned and rebuilt following 9/11, 7 World
Trade Center addresses the conflicting demands
of premier architectural design, heightened
building security, and welcoming public space.
The footprint of the building was altered to restore
the continuation of Greenwich Street through the
site as a pedestrian plaza, correcting one of the
shortcomings of the old site plan. The building is
also one of the first Manhattan high rises to achieve
a LEED (Leadership in Energy and Environmental
Design) rating, a measure of sustainable design.

023 **Podium and Curtain Wall**

IN COLLABORATION WITH JAMES CARPENTER DESIGN ASSOCIATES

COMMISSIONED BY SILVERSTEIN PROPERTIES

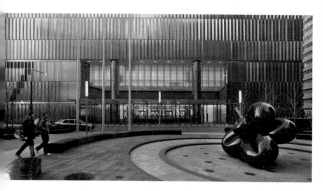

The first eight stories of the building, treated as a podium, are sheathed with a sophisticated and luminous perforated stainless steel skin. By dynamically reflecting light and allowing the passage of air into the building, this skin artfully masks the fact that the lower stories of the building house a windowless electrical substation. At night the podium is lit from within with a soft blue glow. Artist Carpenter says, "Tower Seven is an example of how both the curtain wall and podium respond to the unique characteristics of light in downtown Manhattan and how that interaction transforms one's experience of site."

024 **For 7 World Trade**

A COLLABORATION OF JENNY HOLZER, ARTIST WITH JAMES CARPENTER DESIGN ASSOCIATES, 2006

COMMISSIONED BY SILVERSTEIN PROPERTIES

7 World Trade Center Lobby

This lively and site-specific work of public art benignly dominates the lobby of 7 World Trade Center and is clearly legible through the clear glass wall from the plaza outside. In a wonderful takeoff on the relentless crawlers that have migrated from Times Square to the bottom of the screen on TV news programs, Holzer has illuminated the words of poets and writers on life in New York. Moving beyond her characteristic political commentary, this work presents joyful and inspiring thoughts about the city by writers as diverse as Walt Whitman, Elizabeth Bishop, and Langston Hughes. The white words glide through a 14-foot-high translucent glass wall outfitted with light-emitting diodes, allowing precise programming of the spacing and pace of the phrases. The kinetic activity on this wall behind the reception desk masks its other function, as a resilient blast screen in case of explosion, a post-9/11 precaution.

Balloon Flower (Red)

© JEFF KOONS, 1995–2000

COLLECTION OF THE ARTIST, ON LONG-TERM LOAN TO 7 WORLD TRADE CENTER

7 WTC Park

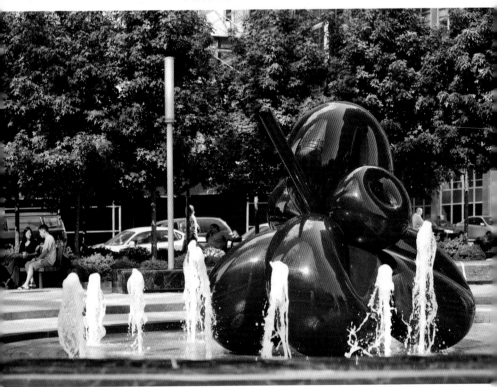

The new plaza, designed by landscape architect Ken Smith with sweet gum trees, evergreen shrubs, and attractive stone paving, is centered on the luminescent *Balloon Flower (Red)* in the middle of a low, 30-foot-wide fountain. The artist intended the eye-popping and reflective ruby red of the wry sculpture to be a strong antidote to the pervasive gray of the surrounding neighborhood and the extensive street paving on this site. The balloon form is part of Koons's Celebration series inspired by children's toys, and it has been fabricated in high chromium stainless steel in different colors for several other installations. This cheerful and evocative object, surrounded by the jets of the fountain in warm weather, establishes a message of hope and joy at an emotionally loaded site that will be undergoing reconstruction for years to come.

Dreaming of Faraway Places: The Ships Come Into Washington Harbor

DONNA DENNIS, ARTIST; RICHARD DATTNER AND PARTNERS, ARCHITECTS,1998

COLLECTION OF THE CITY OF NEW YORK, SPONSORED BY THE PERCENT FOR ART PROGRAM OF THE DEPARTMENT OF CULTURAL AFFAIRS

P.S. 234, Chambers Street at Greenwich Street

Any fence that encloses a schoolyard protects the students within, keeps errant dodge balls from spilling out, and defines the special jurisdiction of a school. Donna Dennis's innovative painted steel fence rises above these mundane tasks to spark the imagination of students by evoking the lively maritime history of New York City. Based upon the forms of historic vessels that plied the nearby harbor, the forms silhouetted on the fence read graphically from afar but also provide fascinating details upon closer inspection. The vessels include clipper ships, tugboats, and others of many scales and periods. The bottom portion of the fence is a tightly spaced abstraction of waves that read like the basso profundo of the composition. Using simple painted steel sheet, Dennis has created a vibrant piece of urban art that has become a neighborhood favorite and an inspiration for the many other decorative fences that have proliferated around the city.

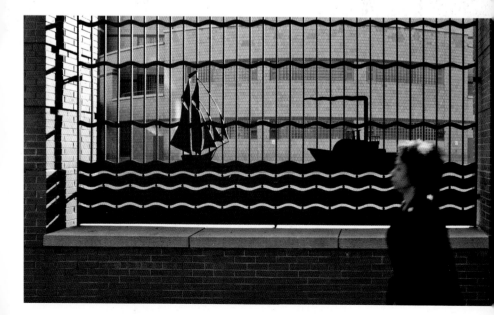

City Hall Park

When City Hall Park was renovated in the 1990s under Mayor Rudolph Giuliani, the ornate sandstone and granite fountain originally designed by Calvert Vaux was reconstructed in the center of the triangle, complete with reproduction faux gas lamps, and the granite paving south of the fountain was incised with images from the history of the park. The surrounding landscape was renewed as a venue for temporary art exhibitions amid flowering shrubs and perennials. A wrought-iron fence reinforced below grade for impact resistance was installed around the entire perimeter, and control booths were installed at the entrance plaza in front of City Hall.

027 Justice

ANONYMOUS, 1887; RESTORED 1998, LES METALLIERS
CHAMPENOIS, CONSERVATOR
COLLECTION OF THE CITY OF NEW YORK
On the dome of City Hall

The dome of the elegant marble City Hall, built in 1812, is topped by a late-nineteenth-century mass-produced statue of Justice in sheet copper painted off-white to match the stone below. This is the third statue of Justice to be placed on the building; the previous two were wood.

028 Nathan Hale

FREDERICK MACMONNIES, 1890, GRANITE BASE BY STANFORD
WHITE, MCKIM, MEAD & WHITE; RESTORED BY WILSON
CONSERVATION, 1999.
COLLECTION OF THE CITY OF NEW YORK, GIFT OF THE SONS OF THE REVOLUTION
OF NEW YORK
City Hall Park, just south of City Hall

The statue of Nathan Hale faces City Hall, directly south across a paved plaza from the entrance. Because of security controls, this plaza is inaccessible to anyone who does not have business in City Hall, so members of the public are hard pressed to see more than the back of the statue from the accessible portion of the park. Nonetheless, the iconic Nathan Hale statue has remained one of the most popular sculptures in New York. MacMonnies depicts a handsome hero who stands proudly erect even though his arms have been bound behind him. His famous last words are fixed in bronze letters around the granite base: I only regret that I have but one life to lose for my country.

029 **Horace Greeley**

JOHN QUINCY ADAMS WARD; BASE BY RICHARD MORRIS
HUNT, 1890; RESTORED BY WILSON CONSERVATION, 1999

COLLECTION OF THE CITY OF NEW YORK, GIFT OF THE TRIBUNE ASSOCIATION

City Hall Park, east of Tweed Courthouse near Park Row

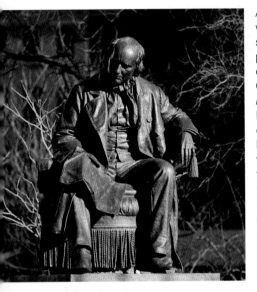

Although this magnificent sculpture was inaccessible to the public for several years following 9/11, the nearby pathway through City Hall Park has been opened, restoring public access. Horace Greeley, the distinguished founder of the *New York Tribune*, worked just across Park Row in the Tribune Building, also designed by Richard Morris Hunt but no longer standing. This studied likeness was originally mounted in a niche on the side of the building; the statue was relocated to the park in 1915. Greeley looks thoughtfully down and to the side, a copy of the *Tribune* on his lap. His serious demeanor, carefully modeled body and clothing, and even the realistic irregularity of the fringe on the chair all contribute to the arresting strength of the sculpture.

030 **Civic Fame**

ADOLPH WEINMAN, 1913–14; RESTORED 1991

COLLECTION OF THE CITY OF NEW YORK

Top of the Municipal Building, Center Street at Chambers Street

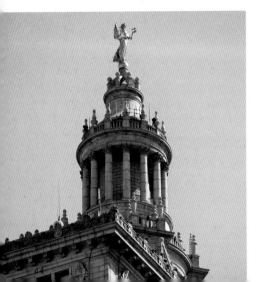

Although *Civic Fame* is reputedly the largest statue in Manhattan, it might not be noticed high on top of the mammoth Municipal Building were it not beautifully gilded. The allegorical figure, draped in classical robes and crowned with laurel, is made of sheet copper supported on a steel armature, similar to the construction of the Statue of Liberty. She lifts a five-tipped crown in her left hand and a laurel branch in her right hand, symbolizing the union of the five boroughs into one city at the end of the nineteenth century. *Civic Fame* was restored at the urging of Margot Gayle, eminent preservationist.

031 **Five in One**

TONY ROSENTHAL, 1974; RESTORED 1989

COLLECTION OF THE CITY OF NEW YORK

Police Plaza, between the Municipal Building and Police Headquarters

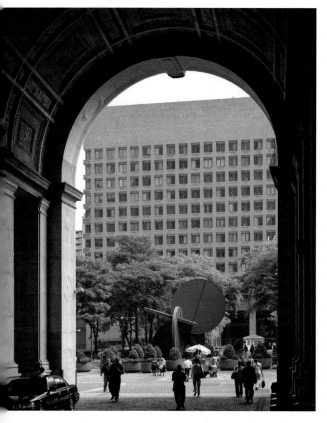

Although abstract in form, the five large discs of Tony Rosenthal's *Five in One*, gracefully linked and powerfully balanced, provide another indirect reference to the city's five boroughs. The sculpture was designed as part of a competition to enliven the plaza and to visually link the Municipal Building with police headquarters. Interestingly, it is not placed on axis with the dominant arch of the Municipal Building. Originally conceived with a painted red finish, the sculpture was actually executed in weathering steel on the advice of the Art Commission to use a more "natural" material and to minimize the need for maintenance. However, since the weathering steel caused its own problems (unsightly flaking and staining) the sculpture was cleaned and painted as originally intended in 1989 with the blessing of the Art Commission.

Now bright red, *Five in One* relates well to the scale and irregular geometry of the surrounding buildings. Despite the unfortunate placement of incongruous planters directly next to the sculpture, the exuberant form invigorates the huge plaza, providing a focus of just the right scale for the expansive open space.

032 Triumph of the Human Spirit

LORENZO PACE, ARTIST; COE LEE ROBINSON ROESCH,
LANDSCAPE ARCHITECTS, 2000
COLLECTION OF THE CITY OF NEW YORK, SPONSORED BY THE PERCENT FOR ART
PROGRAM OF THE DEPARTMENT OF CULTURAL AFFAIRS

Foley Square

Located in the middle of historic Foley Square, *Triumph of the Human Spirit* is the centerpiece of a large fountain

DEDICATED TO ALL THE UNKNOWN AND UNNAMED ENSLAVED
AFRICANS BROUGHT TO THIS COUNTRY INCLUDING THE
427 AFRICANS EXCAVATED NEAR THIS SITE.

The inscription refers to the African burial ground that was discovered when excavation was begun for the federal building on Duane Street. Although efforts to erect a memorial at the nearby burial site were stymied for twelve years by political and artistic challenges, the sculpture and fountain are a striking commemoration in a highly visible public space.

The tall granite shape rising up in the middle of the fountain was inspired by the abstracted female antelope form of Chi Wara headdresses of the Bamana people of West Africa. Its tripartite composition has an uplifting, almost jaunty appearance despite its jet black color. The elongated base is meant to recall the form of both slave ships and Native American canoes and, in a measure of personal import, the artist placed a replica of the slave

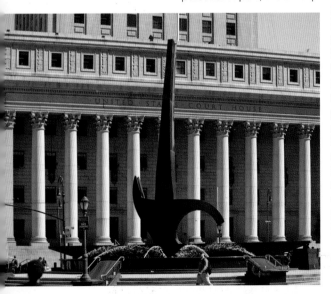

lock passed down to him from his great-great-grandfather in the base of the sculpture. Because of the slope of the square, the north side of the fountain is raised handsomely above granite steps. The nearby African Burial Ground National Monument, administered by the National Park Service, was completed in 2007. Its visitor center with extensive interpretive exhibits is located at 290 Broadway.

033 **Jacob Javits Plaza**

MARTHA SCHWARTZ INC., 1992–96

COMMISSIONED BY THE UNITED STATES GENERAL SERVICES ADMINISTRATION

West side of Foley Square at Jacob K. Javits Federal Building

This colorful collection of serpentine benches, decorative railings, and mounded greenery is a successful antidote to the grim seriousness of the court structures around Foley Square. The light-hearted approach is especially noteworthy given the proliferation of commonplace mail-order planters and bollards in front of most government buildings; it also serves to exorcize the public memory of Richard Serra's severe *Tilted Arc*, which was perceived by some as overbearing and was removed from the site.

Although the pattern of the curvilinear design can best be appreciated from the windows of the buildings above, the lime green color of the benches and the spiraling, curlicue design of the metal railings on the steps rising from the street entice passersby to explore the raised terrace. Here are unlimited places to sit on the swirling benches, and the planters filled with simple, clipped boxwood provide refreshing and elegant visual anchors. In an ironic reference to New York's most famous park, the designer has balanced the popular Central Park luminaires on exceedingly tall lampposts.

034 Law Through the Ages

ATTILIO PUSTERLA, 1936; CONSERVED 1988, PRESERVAR,
GREENLAND STUDIOS
COLLECTION OF THE CITY OF NEW YORK

New York State Supreme Court, 60 Centre Street

A major consolation for having to report for jury duty at the
New York State Supreme Court is the opportunity to see
the spectacularly colorful and stately murals painted inside
the dome above the central hall of the courthouse. Even
members of the public who are not jurors can make their
way through the metal detectors to see these beautifully
restored and well-lit murals, but photography is strictly
forbidden. The artist articulated the dome in six sections,
each of which is centered upon two seated figures
representing the legal innovations of their culture. Starting

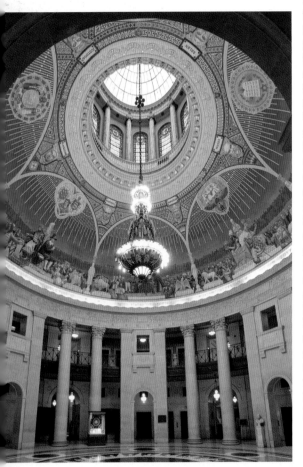

with ancient civilizations, moving
through Egypt, Israel, Greece, and
Rome, and then jumping to English
history, the figures culminate in
the giants of the American legal
system: a pilgrim is seated back to
back with William the Conqueror,
and Abraham Lincoln with George
Washington. But the visual appeal
of these murals arises from
the intricacy of the decoration,
drawing from the rich patterns and
saturated colors of late-nineteenth-
century decorative arts. There are
layers of historical reference in
the additional medallions, heraldic
shields, and animal mascots
depicted, and the frieze of
massed humanity in haunting blue
monochromatic hues that rings the
dome behind the colorful principals
is a particularly successful device.
Despite the clearly circumscribed
and anachronistic representation
of history and the stiffly didactic
themes, Pusterla has achieved a
tour de force of decorative art that
lifts the spirits of countless citizens
passing through the courthouse.

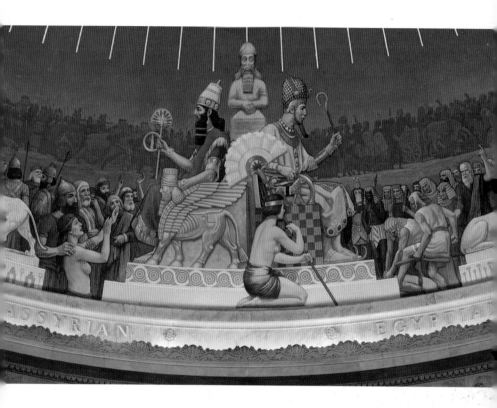

Tribute in Light

CONCEPT: JOHN BENNETT, GUSTAVO BONEVARDI, RICHARD NASH
GOULD, JULIAN LAVERDIERE, AND PAUL MYODA WITH PAUL
MARANTZ. DETAIL DESIGN AND EXECUTION: FISHER MARANTZ
STONE, INC.

SPONSORED BY THE MUNICIPAL ART SOCIETY AND CREATIVE TIME, WITH THE
ASSISTANCE OF THE BATTERY PARK CITY AUTHORITY

Various sites near the former World Trade Center

Originally conceived separately, but roughly simultaneously,
by several artists and designers, *Tribute in Light* was a
strong idea whose elegant simplicity transcended the
multiplicity of competing proposals for a temporary
memorial to the tragedy of 9/11. The idea of twin shafts
of light beamed into the night sky evokes both the
conceptual ghost of the Twin Towers and the restorative,
spiritual, and healing power of light.

Tribute in Light was first installed on a vacant lot close
by the former site of the Twin Towers on March 11, 2002,
six months after the attack on the World Trade Center.
The array consisted of two 50-foot squares of forty-four
lights each, set 130 feet apart. The lights, each using a
high-intensity xenon light bulb magnified by a parabolic
reflector, were assembled from existing stocks around the
country. Con Edison donated several generator trucks
to power them. (Other corporate sponsors included
General Electric and Deutsche Bank.) When the first
display struck a deep chord with the public, efforts were
made to ensure a repeat performance on the anniversary
each year for at least five years. A grant from the Lower
Manhattan Development Corporation (using HUD funds)
enabled the Municipal Art Society to purchase a new set
of the powerful lights. A new site also had to be secured
because the original site at Vesey and West Streets went
under construction; the current site is on the MTA garage
at the entrance to the Brooklyn-Battery Tunnel.

Subsequent displays have lasted about a week each
year, since it takes the production team several nights to
focus the lights prior to September 11; the lights are at
full force from dusk September 11 to dawn on September
12. Depending on weather conditions, the shafts of light
appear to reach far into space or to disappear in low
clouds. When the air is humid and still, masses of moths
appear as radiant sparkles, seemingly bringing the light
to life. Whatever the climate, *Tribute in Light* has given
ethereal form to our collective grief for all that was lost,
and luminous expression to our hope for the future.

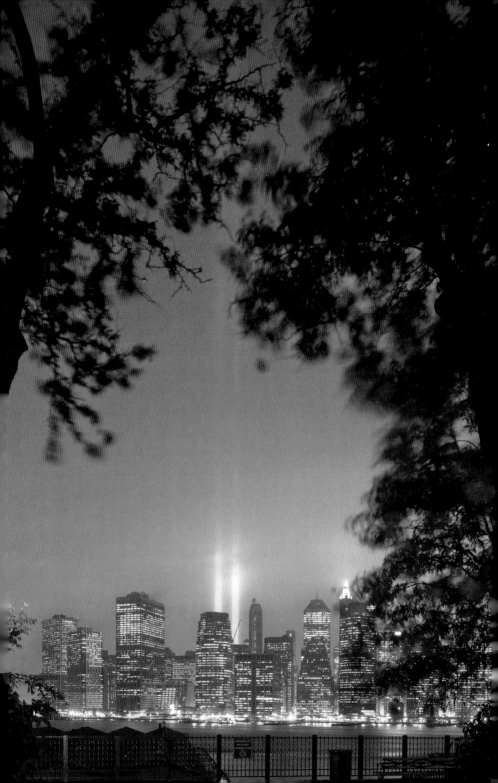

2

Soho to Lower Midtown

Façade mural

RICHARD HAAS, 1975
SPONSORED BY CITYWALLS

112 Prince Street

Located in the heart of the Soho Cast Iron Historic District, 112 Prince Street sports on its east façade the first outdoor Richard Haas mural in New York. According to Haas, this was also the first revival in America of traditional trompe l'oeil painting techniques on a building exterior. Because it is located just west of a one-story structure at the intersection of Greene and Prince Streets, the painting of a windowed cast-iron façade commands the corner. The mural extends the pattern of columns, cornices, and windows from the real north façade onto the formerly blank side of the building. Drawing inspiration from the Italian tradition of quadratura illusionistic architectural painting in perspective, Haas endeavored "to make the encounter with the painting as 'plausible' as possible, to make one feel that it belongs where it is, that it was always part of the natural cityscape."

In juxtaposing the real architecture with the artistic interpretation of it, Haas imposed the rhythmic pattern of painted cast-iron columns, painted in tones of ivory and brown, directly over the real steel shutters that flank the only two actual windows in the façade. The presence of the real windows in the grid of painted ones, and the use of playful painted details such as two cats on an open window sill, endow this mural with enchanting irony. However, the shutters have rusted, the paint has aged, and some of the plaster substrate has fallen off, endangering the artistic integrity of the mural; one hopes that timely intervention will preserve this Soho classic.

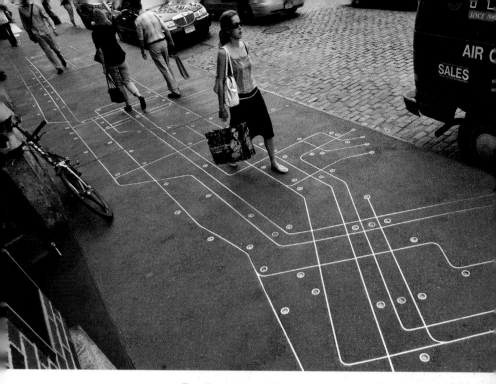

037 Subway Map

FLOATING ON A NEW YORK SIDEWALK, FRANCOISE SCHEIN,1986
COLLECTION OF THE CITY OF NEW YORK, SPONSORED BY THE DEPARTMENT
OF TRANSPORTATION

110 Greene Street

Conceived by a Belgian artist, this distinctive sidewalk
extends the entire length of the building at 110 Greene
Street and features an abstract diagram of the subway
system rendered in stainless steel strips set into dark-
tinted asphaltic concrete. The recessed lights with
which the artist originally intended to indicate each
subway stop were not installed at the time, but the entire
sidewalk installation was torn up in 2006 and the concept
completed with a new integral fiber optic lighting system.
Now that this unusal and creative project has been
restored and enhanced, it has become a lively focal point
on the busy commercial street.

Sidewalk Art

KEN HIRATSUKA, 1983–84
INSTALLED ON PROPERTY OF THE CITY OF NEW YORK
Northwest corner of Broadway and Prince Street

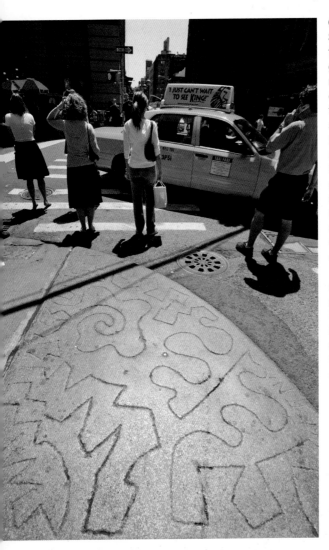

One of the glories of the Soho neighborhood is the massive and historic granite sidewalk paving, remarkable for the extraordinary size and thickness of individual slabs that often serve as both paving and curb. A stroller can find several lively carvings in random granite slabs that are signed by "Ken," Japanese artist Ken Hiratsuka. One of the most noticeable was completed under cover of night in the early 1980s at the northwest corner of Broadway and Prince Street, a busy intersection at the heart of the commercial shopping district; another is found on the north side of Spring Street between Broadway and Lafayette. These carvings, installed surreptitiously on public property, cannot be removed easily like painted graffiti. However, the animistic abstractions, based on one continuous incised line, offer momentary delight to the observant passerby.

039 The Wall

FORREST MYERS, 1973; RESTORED 2007
SPONSORED IN 1973 BY CITYWALLS

599 Broadway, southwest corner of intersection facing Houston Street

One of the saddest losses of public art in New York was the disassembly in 2002 of Forrest Myers's pioneering work of art on the south side of Houston Street. The work consisted of a grid of forty-two aluminum beams painted turquoise green, projecting perpendicular to channel irons on the brick wall of the building painted violet blue. The whole composition came to be perceived as the gateway to Soho. The owner of the property in 1997 claimed that the poor condition of *The Wall* threatened the integrity of the building's exterior, but it was also clear that the wall without the artwork was an extremely valuable location for the gigantic advertising billboards rising all around the city. The New York City Landmarks Preservation Commission reluctantly approved the temporary removal of the artwork with the understanding that it would be reinstalled after completion of waterproofing repairs.

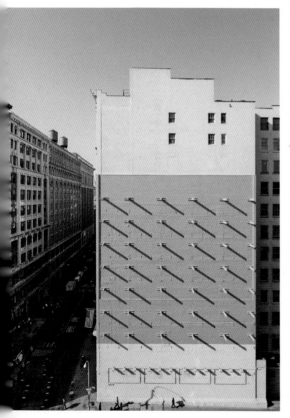

The owners did not reinstall the artwork, and legal proceedings worked their way through the courts until 2005, when a compromise was finally reached with the blessing of the New York City Landmarks Preservation Commission and the Municipal Art Society. The artwork was raised 18 feet to separate it from four small advertising panels at pedestrian level. "This landlord that was initially so opposed to maintaining the piece became, in the end, very supportive and has agreed to maintain its integrity in perpetuity," says Myers. The bright colors and crisp geometry of the restored elements of *The Wall* bring home the power and vibrancy of the original piece, and they far outshine the small advertising panels below.

040 Carmine Street Mural

KEITH HARING, 1987
COLLECTION OF THE CITY OF NEW YORK, © ESTATE OF KEITH HARING
Carmine Recreation Center and James J. Walker Park, Clarkson Street, west of Varick Street

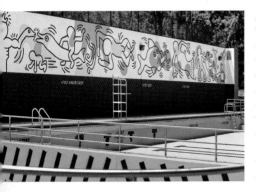

A vibrant and colorful mural enlivens the long west wall enclosing the public swimming pool at the Carmine Recreation Center. Using sinuosly outlined forms of children and sea creatures, Haring evokes a watery world of buoyant motion and delight. The figures wriggle and swim through splotches of turquoise sea and golden sun, inviting viewers to jump in beside them. The crown on a king-like figure in the middle is crafted from an outline of the New York City skyline.

041 Bust of Sylvette

PABLO PICASSO AND CARL NESJAR, 1968
COLLECTION OF NEW YORK UNIVERSITY, GIFT OF MR. AND MRS. ALLAN D. EMIL
University Village Plaza, near LaGuardia Place and Bleecker Street

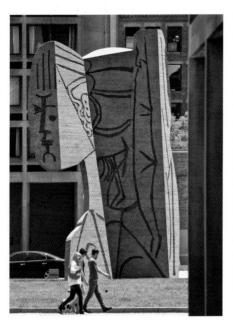

The monumental *Sylvette* dominates the open grassy courtyard between New York University's modernist Silver Towers, designed by I. M. Pei, at the south edge of Greenwich Village. The head, rendered in cast concrete planes articulated with "brush" strokes sandblasted into the concrete, provides a provocative artistic counterpoint to the rectilinear grid of the concrete towers. Based on a small metal maquette, or preliminary model, made from a 1934 drawing by Picasso, this urban-scaled version was executed by Norwegian sculptor Carl Nesjar at the request of the architect. The composition of the plaza, with concrete sculpture on a grass plane surrounded by concrete towers, accurately reflects the 1960s aesthetic.

042 Seuil Configuration

JEAN ARP, 1977

COLLECTION OF THE METROPOLITAN MUSEUM OF ART, ON LONG-TERM LOAN
TO NEW YORK UNIVERSITY

**Gould Plaza, New York University, West 4th Street
at Greene Street**

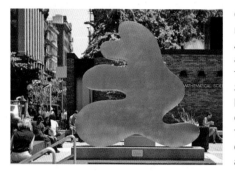

Crafted from buffed stainless steel and mounted on the north side of Gould Plaza, Arp's abstract yet evocative sculpture brings a note of whimsy to the largely hard-edged terrace in front of Tisch Hall and the Stern School of Business. With a form that has been likened to a resting rabbit or a piece of a jigsaw puzzle, the sculpture gently fires the imagination and, as a benign presence on the plaza, encourages students to catch a bit of sun nearby.

043 Fiorello La Guardia

NEIL ESTERN, 1994

COLLECTION OF THE CITY OF NEW YORK

La Guardia Gardens on east side of La Guardia Place

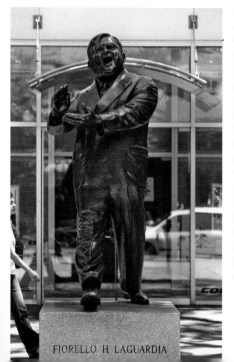

Located in front of a motley group of one-story commercial buildings on the east side of La Guardia Place, Neil Estern's diminutive statue of La Guardia nevertheless commands attention. The celebrated mayor strides forward, talking and clapping at the same time. The pint-sized figure exudes energy and vitality, illustrating why the "Little Flower" is remembered as one of the most active, outspoken, and reform-minded mayors of the twentieth century. La Guardia grew up nearby in Little Italy; the statue was placed here in an effort to improve the awkward leftover space that resulted from long-ago demolition anticipating a Lower Manhattan Expressway championed by Robert Moses, but never built due in part to the efforts of urbanist Jane Jacobs.

Washington Square

Located in the heart of Greenwich Village and the New York University campus, Washington Square serves as both the front and back yards of this historic neighborhood. Framed by a handsome and harmonious row of Greek Revival townhouses to the north and the massive buildings of New York University to the south, Washington Square valiantly mediates between the different scales of the nineteenth and twenty-first centuries. The nineteenth-century fountain in the center of the square predates the Washington Arch, which was sited to align not with the fountain but with Fifth Avenue. The Department of Parks & Recreation is moving the fountain to the centerline of the arch, relocating some statues, and increasing the amount of green space. A survivor of countless redesigns over the last century, Washington Square will remain a magnet for students, neighborhood residents, performers, and musicians.

Washington Arch

MCKIM, MEAD & WHITE, ARCHITECTS, 1892; HERMON A. MACNEIL,
ALEXANDER STIRLING CALDER, FREDERICK MACMONNIES, AND
PHILIP MARTIGNY, ARTISTS, 1914–18; CONSERVATION BY THE
CITYWIDE MONUMENTS CONSERVATION PROGRAM (CMCP) WITH
BUILDING CONSERVATION ASSOCIATES; LIGHTING BY DOMINGO
GONZALEZ, 2003
COLLECTION OF THE CITY OF NEW YORK

Washington Square North at Fifth Avenue

The Washington Arch provides a triumphal terminus to
Fifth Avenue and a grand entrance to the north side of
the park. Originally created to the designs of Stanford
White as a temporary monument commemorating the
centenary of George Washington's inauguration, the
popular arch was rebuilt in marble in 1895. The two full-
body likenesses of Washington on the north face (on the
east, Washington as General by Hermon MacNeil; on
the west, Washington as Statesman by Alexander Calder)
were installed in the early twentieth century. The arch is
covered in decorative classical motifs and inscriptions,
and inspirational words of George Washington spoken
at the Constitutional Convention are inscribed on the
south entablature:

LET US RAISE A STANDARD TO WHICH THE WISE AND THE
HONEST CAN REPAIR—THE EVENT IS IN THE HAND OF GOD.

Although it is not generally open to the public, an
interior stair provides access to the rooftop, from which
sweeping views of Greenwich Village are visible.

045 Alexander Lyman Holley Monument

JOHN QUINCY ADAMS WARD, 1889; LIMESTONE BASE BY
THOMAS HASTINGS; CONSERVATION SPONSORED BY THE ADOPT-
A-MONUMENT PROGRAM, 1999
COLLECTION OF THE CITY OF NEW YORK

Washington Square Park

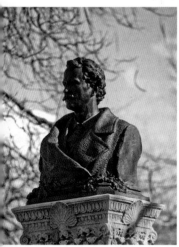

Composed of a bronze bust on a five-part, ornately
carved limestone base, the Holley Monument exemplifies
Beaux-Arts design sensibility. The carvings are inspired
by Classical ornament, including anthemions (foliated
palmette ornaments) and acanthus leaves. Set on a major
pedestrian cross axis of Washington Square, the Holley
Monument has a quiet dignity suitable to the subject,
a brilliant scientist, businessman, and innovator who
transformed the American steel industry through the
import of Bessemer technology, an efficient method for
manufacturing steel from molten iron.

046 Peter Cooper Monument

AUGUSTUS SAINT-GAUDENS, ARTIST; MCKIM, MEAD & WHITE,
ARCHITECT, 1894; RESTORATION SPONSORED BY THE ADOPT-A-
MONUMENT PROGRAM, 1987
COLLECTION OF THE CITY OF NEW YORK

Cooper Square, Third Avenue at East 7th Street

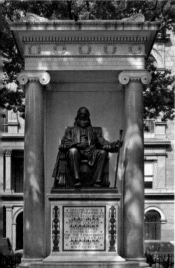

This excellent bronze statue of the founder of the Cooper
Union is located immediately south of the esteemed
institution at the north end of Cooper Square, which is
actually a triangle. The rendering of Cooper by Saint-
Gaudens is one of his best seated figures, representing
the industrialist and philanthropist as stately, wise, and
kind. Saint-Gaudens had attended classes at the Cooper
Union at the encouragement of Cooper himself, and
his modeling of Cooper is clearly based on first-hand
experience. The classical surround with granite columns
by architect Stanford White is well scaled to the figure,
and the bronze Neo-Grec lettering and ornamentation on
the marble base have a charming Beaux-Arts sensibility.
It is unfortunate that the only access to the statue is from
the back, through a gate at the northwest corner of the
park, which limits pedestrian traffic; but this handsome
statue is well worth the effort to seek it out.

Alamo

**TONY ROSENTHAL, 1966–67; RESTORATION SPONSORED BY THE
ADOPT-A-MONUMENT PROGRAM, 2005**
COLLECTION OF THE CITY OF NEW YORK
Astor Place at East 8th Street

Set back in place following a thorough restoration in 2006,
Alamo again animates Astor Place, the busy intersection
just north of the landmark Cooper Union building. Seeing
the small, concrete plaza empty while the sculpture
was being refurbished has served as a reminder of why
the sculpture works on its site so well. The scale of the
cube is large enough to hold its own in the middle of

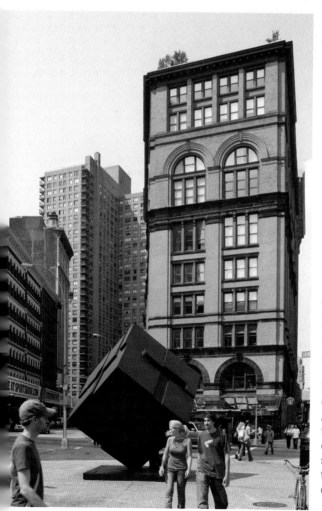

the busy intersection,
and its rich, dark brown
color complements the
surrounding masonry
buildings. The changes of
surface plane and various
curved forms on the cube
present a site-specific
counterpoint to the multitude
of arches on the Cooper
Union and other surrounding
historic buildings. Best of
all, those who know that the
cube can be rotated on its
axis are drawn to do so on
what would otherwise
be a barren traffic island.
One of the first abstract
works of art installed
permanently on city property,
Alamo adds value both for
its aesthetic distinction and
for its compatibility with
this distinguished but quirky
neighborhood.

A small model of *Alamo*
is presented to the winner
of the Doris C. Freedman
Award, given annually by
the mayor to an individual or
organization that has made
significant contributions
to the urban environment
of New York City.

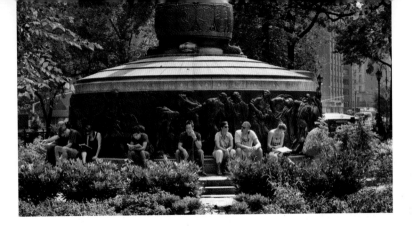

Union Square

Union Square has always been one of the most actively populated public spaces in all of New York City. The name of the square originated from its location at the "union" of Broadway and Fourth Avenue; it also was the site of the first commemoration of Labor Day in 1882, formalized as a national holiday in 1894. In recent years the largest greenmarket in the city has flourished here four days a week, creating vibrant street life. The square has been renovated by the Department of Parks & Recreation, incorporating new paving, restored Beaux-Arts period lights, additional trees, and bronze sidewalk plaques recording in a timeline highlights in the history of the square.

048 George Washington

HENRY KIRKE BROWN, ARTIST, 1853–55; PEDESTAL BY RICHARD
UPJOHN, ARCHITECT; RESTORATION SPONSORED BY THE ADOPT-
A-MONUMENT PROGRAM AND THE CITYWIDE MONUMENTS
CONSERVATION PROGRAM (CMCP), 1989
COLLECTION OF THE CITY OF NEW YORK
South end of Union Square

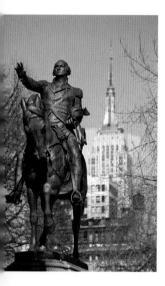

The handsome equestrian figure of George Washington,
dedicated to public acclaim in 1856, was the city's first
important piece of outdoor public art and only the second
equestrian bronze cast in this country. The statue makes
clear reference to iconic military statues such as the
Roman Marcus Aurelius, but it shows Washington with
the uniform and sword appropriate to his day. Originally
located in a traffic island at the southeast corner of the
park, the statue was moved to its current location in
1930. Now restored and beautifully repatinated, the
general holds his arm forward in a gesture of command.
In front of him, the broad sweep of the curved steps
facing south to 14th Street welcomes countless tourists
and neighborhood residents to linger at his feet. On
and after 9/11, Union Square became a center for the
outpouring of New Yorkers' grief and outrage; the George
Washington statue in particular was inundated with
photographs of loved ones, posters, and candles.

049 Marquis de Lafayette

FRÉDÉRIC-AUGUSTE BARTHOLDI, 1873; RESTORATION
SPONSORED BY THE ADOPT-A-MONUMENT PROGRAM, 1991
COLLECTION OF THE CITY OF NEW YORK
East side of Union Square

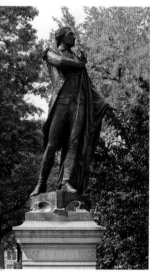

Consistent with the political and military theme of the
park, this evocative statue by the sculptor of the Statue
of Liberty (009) commemorates the stalwart support
of the Marquis de Lafayette during the American
Revolution. The marquis is modeled with the elegant
bearing and stylish clothing of an aristocrat, and he is
shown with his hand to his heart in expression of his
dedication to the cause of American liberty. Following the
revolution, Lafayette returned to France to help shepherd
the fledgling democracy in his own country, a more
challenging task as it turned out. The statue was a gift
to the City of New York from the French government
and the French citizens of New York.

050 Charles F. Murphy Memorial Flagpole

ANTHONY DE FRANCISCI, 1926

COLLECTION OF THE CITY OF NEW YORK

Center of Union Square

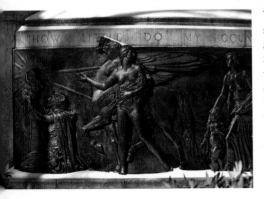

The change of grade between the outer sidewalk and the inner square brings a degree of welcome remove to Union Square's central lawn. In the middle is the monumental Liberty Flagpole, sitting on a very large granite base ringed with bronze allegorical figures in bas-relief. The text of the Declaration of Independence is displayed on the south side, and the stone frame above the figures is incised with a trenchant quote on the subject of liberty:

> HOW LITTLE DO MY COUNTRYMEN KNOW
> WHAT PRECIOUS BLESSING THEY ARE
> IN POSSESSION OF AND WHICH NO OTHER
> PEOPLE ON EARTH ENJOY
> —Thomas Jefferson

051 Mohandas Gandhi

KANTILAL B. PATEL, 1986

COLLECTION OF THE CITY OF NEW YORK

Southwest corner of Union Square, near 14th Street and Union Square West

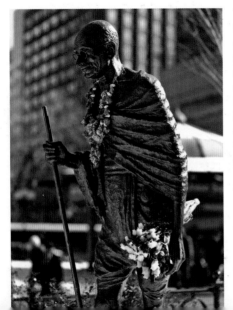

This larger-than-life-size portrait of the revered Indian nationalist is a very convincing portrayal. Gandhi's lean, muscular body clothed in a simple dhoti and sandals strides forward with quiet purpose and firm commitment. Union Square, where so much of the history of American politics and labor is commemorated, seems the perfect place to honor this internationally recognized pioneer of nonviolent protest. Gandhi's statue is often bedecked with garlands of flowers.

052 Metronome

KRISTIN JONES AND ANDREW GINZEL, ARTISTS;
DAVIS BRODY BOND, ARCHITECTS, 1999
COMMISSIONED BY THE RELATED COMPANIES WITH THE PARTICIPATION
OF THE PUBLIC ART FUND AND THE MUNICIPAL ART SOCIETY

One Union Square South, between Fourth Avenue and Broadway

This huge and mysterious work of public art dominates the view down Park Avenue toward Union Square. Designed as a reflection on the nature of man's relationship to time and to the changing character of the city, the piece comprises many elements with abstruse references. These include a dark hole (The Infinity), surrounded by concentric circles of ridged brick (The Vortex), overlaid with gilding (The Source), surmounted by a large bronze hand (fashioned after that of the statue of George Washington in Union Square, 048) and a long, thin pointer. The dark hole puffs steam on the hour and spews forth a lot of steam at noon and midnight, but time is also marked by a large electronic clock with so many numbers counting both up and down that one is hard pressed to make sense of it. The only way to grasp the full import of this multifaceted piece is to read the lengthy and discursive but fascinating description on the artists' Web site (www.jonesginzel.com). Despite the opaque references and busy design, the work broadcasts creative energy at an urban scale and has expanded public discourse on the nature of public art in New York City.

Madison Square Park

23rd to 26th Street between Fifth Avenue and Madison Avenue

Madison Square has been handsomely renovated, with a new, low fountain providing a focal point at the north end, a hip take-out pavilion with fast food of exemplary quality at the south end, and variegated plantings throughout. Temporary exhibits of contemporary art are scheduled in the park throughout the year, but Madison Square also boasts one of the most successful works of public art in the history of New York City.

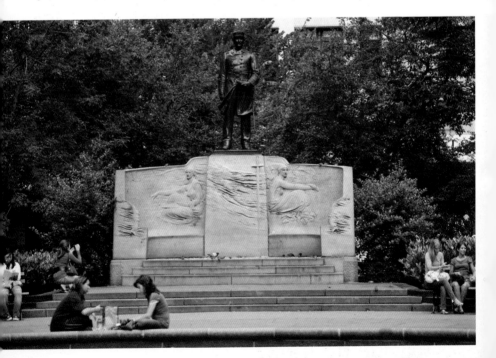

053 Farragut Monument

AUGUSTUS SAINT-GAUDENS; BASE BY STANFORD WHITE; 1880;
RESTORATION BY WILSON CONSERVATION, SPONSORED BY THE
ADOPT-A-MONUMENT PROGRAM, 2002
COLLECTION OF THE CITY OF NEW YORK

North end of Madison Square

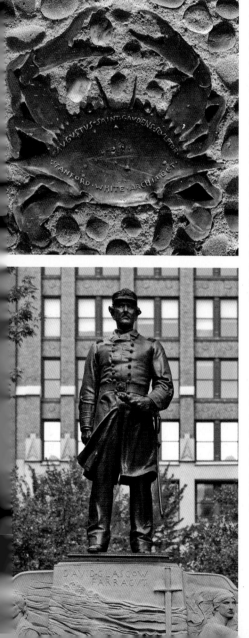

Centered in the north end of the park, the Farragut Monument is an outstanding early example of thoughtfully integrated sculpture, bas-relief, graphic design, and architectural setting. Innovative when it was unveiled in a ceremony featuring Farragut's widow, the sculptural composition drew gasps from the distinguished crowd. What set this statue apart was the realistic and commanding pose of the renowned hero of the Civil War, the ethereal rendering of the flowing figures of Courage and Loyalty on the stone exedra (a high curved niche or bench), and the extensive use of stylized, Art Nouveau–influenced graphics integral with the bas-relief figures. The sculptor's and architect's names are incised in a bronze crab set into the pebble paving at the base of the exedra. The inscription on the left side commemorates

> THE MEMORY OF A DARING AND SAGACIOUS
> COMMANDER AND GENTLE GREAT-SOULED
> MAN WHOSE LIFE FROM CHILDHOOD WAS
> GIVEN TO HIS COUNTRY. . . .

Although it was first installed on the northwest corner of the park, facing toward Fifth Avenue, the monument was moved several times. Due to rapid deterioration of the original bluestone exedra, the original was entirely replaced with granite when it was moved to its present location in the 1930s. Night lighting was added in the twentieth century.

054 Roscoe Conkling

JOHN QUINCY ADAMS WARD, 1893; CONSERVATION BY THE CITY
PARKS FOUNDATION MONUMENTS CONSERVATION PROGRAM, 2001
COLLECTION OF THE CITY OF NEW YORK
Southeast corner of Madison Square

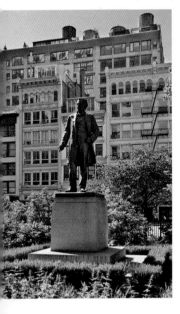

This striking statue commemorates an influential and colorful Republican politician of the era of nineteenth-century Reconstruction. Roscoe Conkling served as the Mayor of Utica, as U.S. Congressman before and after the Civil War, and then as a prominent U.S. Senator from 1867 to 1881. A key New York ally of President Ulysses S. Grant, he supported equal rights under the Fourteenth Amendment. He died in 1888 after suffering severe exposure in nearby Union Square during the infamous Blizzard of 1888. His lively persona and strong physique, represented by an unusually large head, are realistically rendered by John Quincy Adams Ward, sculptor of numerous other popular New York City sculptures, including *The Indian Hunter* in Central Park (126) and *Henry Ward Beecher* in Brooklyn's Columbus Park (211).

055 William H. Seward

RANDOLPH ROGERS, 1876; CONSERVATION
BY STUART DEAN, 1995
COLLECTION OF THE CITY OF NEW YORK
Southwest corner of Madison Square

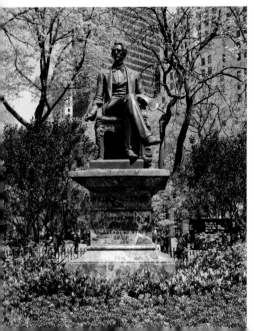

Located prominently, the statue of Seward faces out toward the entrance plaza at the intersection of 23rd Street and Fifth Avenue. Best remembered for advocating the purchase of Alaska from Russia, a transaction known at the time as Seward's Folly, Seward—once Governor of New York, later Senator, then Secretary of State—is here represented in a dignified seated pose. This was the first public statue of a New Yorker to be erected in New York City.

056 Ted's Desert Reigns

URSULA VON RYDINGSVARD

COURTESY OF THE ARTIST AND GALERIE LELONG, PRESENTED BY MAD. SQ. ART,
A TEMPORARY ART PROGRAM OF THE MADISON SQUARE PARK CONSERVANCY

Madison Square, temporary installation, 2006

A series of four monumental pieces of stacked cedar, site specific but focused on themes investigated by the artist over a long time, was installed in the park in 2006. The smallest of the pieces, these low, earthy pillars stood near the popular Shake Shack, a contemporary design with a sloped green roof and vine-covered trellises by architect James Wines.

057 Conjoined

ROXY PAINE

PRESENTED BY MAD. SQ. ART, A TEMPORARY ART PROGRAM OF THE MADISON
SQUARE PARK CONSERVANCY

Madison Square, temporary installation, 2007

These two ethereal stainless steel trees span the boundary between the natural and the man-made, evoking both labor-intensive industrial processes and the slow majesty of natural growth. The highly polished finish of the steel refracts the ambient light, attracting the eye in the midst of the dense growth of the park. This piece, one of three related pieces by Roxy Paine on display in 2007, exhibits the delightful serendipity of two separate species intermingling their branches high overhead.

JAMES BROWN LORD, ARCHITECT; SCULPTURES AND MURALS BY MULTIPLE ARTISTS: Exterior sculptures: *Wisdom* and *Force*, by Frederick Ruckstuhl, flanking steps up to central portico; *Morning, Night, Noon, Evening*, by Maximilian M. Schwartzott, above windows under portico; *Triumph of Law*, by Charles H. Niehaus, in central pediment; *Justice*, by Daniel Chester French, in middle above central pediment. Other cornice-level sculptural figures facing 25th Street are by Edward Clark Potter, Jonathan Scott Hartley, George Edwin Bissell, Herbert Adams, John Talbott Donoghue, Augustus Lukeman, and Henry Kirke Bush-Brown. Cornice-level sculptural figures facing Madison Avenue are by Thomas Shields Clarke, Philip Martigny, Karl Bitter, and William Couper, 1896–1900

COLLECTION OF THE CITY OF NEW YORK

Madison Avenue at 25th Street

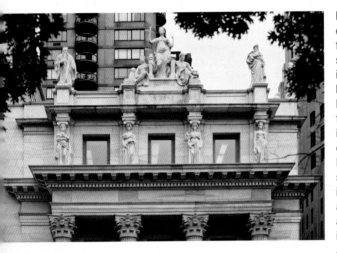

Because the principal entrance to this tour de force of architectural sculpture faces 25th Street, it is easy to overlook the building from adjacent Madison Square Park. But this jewel of a courthouse is a superlative example of how designers of the Beaux-Arts period used sculpture and, on the interior, painting, finishes, and furniture to ornament and complement classically inspired architecture. Approximately one third of the building's budget was devoted to artwork and decorative ornamentation.

The vigor and detail of many of the sculptures support the unifying theme of justice and the law depicted with a combination of historical and allegorical figures. The most prominent and clearly labeled figures are the Moses-like *Wisdom* (to the left) and *Force* (who has placed his sword in his lap to the right) flanking the entry steps. The semi-reclining figures of *Morning*, *Night*, *Noon*, and *Evening* over the window pediments, representing the eternal quality of justice, make direct reference to Michelangelo's figures over the pediments in the Medici Chapel in Florence. In the central pediment above the entrance, the female figure of *Law* presides

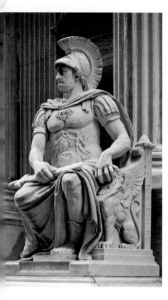

over the kneeling male figures whose swords have been directed to the ground. French's rendering of *Justice* above the pediment holds aloft twin torches above a figure reading (*Study*) to the right and a soldier (*Power*) to the left. The statues ornamenting the cornice represent historical figures distinguished in the history of law and development of civilized codes of conduct such as Alfred the Great, Solon, Saint Louis, and Justinian. A figure of Mohammed, which had been sculpted in ignorance of Muslim strictures against artistic representation, was removed in the 1950s.

The interior lobby of the courthouse has been preserved and restored to close to its original condition. Colorful murals representing the development of legal systems throughout history by Henry Siddons Mobray, Willard L. Metcalf, Robert Reid, and Charles Y. Turner ring every wall above the 8-foot level. Huge couches and chairs built by the distinguished furniture makers Herter Brothers for this space have been preserved and add immeasurably to the ambience. The historic courtroom to the east of the lobby—sumptuously decorated with allegorical murals by Edward E. Simmons, Henry O. Walker, Edwin H. Blashfield, Joseph Lauber, and Kenyon Cox—is dominated by a stunning stained glass dome by Maitland Armstrong.

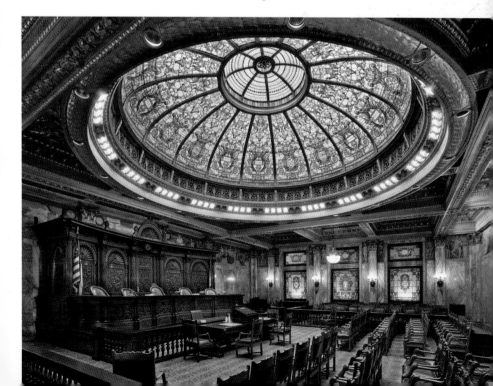

Hudson River Park

A long and skinny riverfront park, with various segments by different design teams, maximizes the narrow ribbon of land and multiple piers that constitute the 500-acre park. Well-landscaped lawns, occasional shade structures or kiosks, and a continuous bike path and walkway are buffered from the traffic on busy Route 9A. While the public art program of Hudson River Park is administered by a different state agency from that of Battery Park City, it successfully extends the concept of integrated public art along the riverfront all the way to 59th Street.

059 Long Time

PAUL RAMIREZ JONES, 2002–7
COLLECTION OF HUDSON RIVER PARK TRUST
West end of Pier 66, near 26th Street

This unusual work incorporates an industrial-looking stainless steel water wheel to measure time and make the tides and currents of the powerful Hudson River manifest to people standing on Pier 66. Although the tides are certainly predictable, the artist anticipates that the seemingly arbitrary movement of the wheel will document the unpredictable effects of wind and weather on these forces. A circular time chart in front of the wheel presents an overview of geologic time, with "NOW" noted near the middle; subsequent predicted events include the merging of the continents and the extinction of plants and animals of the earth.

060 Two Too Large Tables

ALLAN WEXLER AND ELLEN WEXLER, 2006
COLLECTION OF HUDSON RIVER PARK TRUST
Near West 29th Street

This intriguing piece throws our perception of mundane objects such as tables and chairs off kilter and provokes

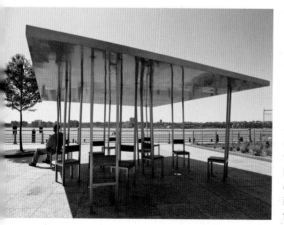

new consideration of issues of scale, support, function, and beauty. Cast in stainless steel, both tables are evidently supported by the chairs sitting underneath them. The chairs at the low table have been inserted into irregular, zigzag cuts in the perimeter, so that the seats, which face every which way, appear narrow and confining. By contrast, the chairs supporting the tall table, approximately 7 feet high, have extraordinarily long backs, creating a sense of openness that is enhanced by the shade under the table.

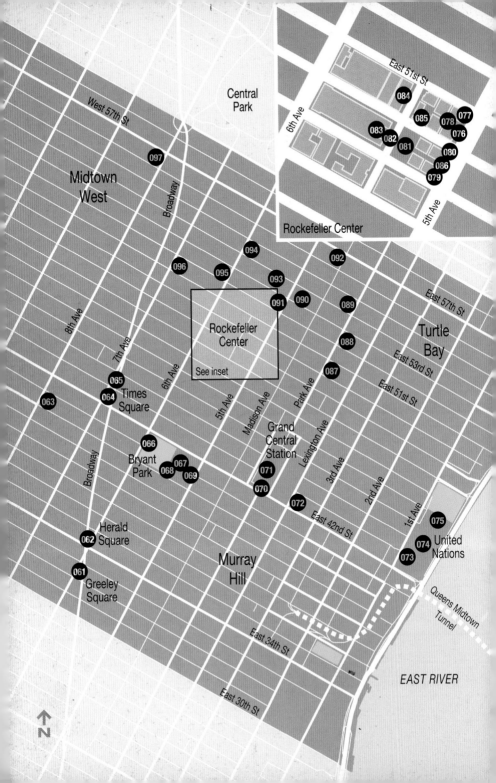

3

Midtown
Manhattan

Herald Square and Greeley Square

Thanks to the initiative of the 34th Street Partnership, the "bow tie" formed by the twin public plazas of Herald and Greeley Squares was renovated in 1999 to designs of Vollmer Associates with well-designed kiosks and public toilets by Hardy Holtzman Pfeiffer, movable tables and chairs, and lush paintings. These efforts have succeeded in drawing people into the public spaces that had been abandoned as mere traffic islands a few years ago, with the salutary effect of heightening public appreciation for the historic sculptures in their midst.

061 ## Horace Greeley

ALEXANDER DOYLE, 1892; CONSERVATION BY THE CITY PARKS FOUNDATION MONUMENTS CONSERVATION PROGRAM, 1999
COLLECTION OF THE CITY OF NEW YORK
Greeley Square, Avenue of the Americas at 32nd Street

Although not as successful artistically as the J. Q. A. Ward bronze of Horace Greeley now in City Hall Park (029), this statue probably attracts more attention because of the number of pedestrians that frequent this bustling crossroads. The Sixth Avenue elevated subway originally ran close by the sculpture. The setting today, with its seating and landscaped plaza, encourages the casual visitor to pause to appreciate the statue. Greeley, founder of the *New York Tribune* and vigorous crusader against slavery, is seated with a newspaper in his right hand.

062 The Bellringers Monument

(James Gordon Bennett Memorial)
ANTONIN JEAN PAUL CARLES; ARCHITECTURAL SETTING
BY AYMAR EMBURY II, 1940
RESTORATION SPONSORED BY THE ADOPT-A-MONUMENT PROGRAM, 2007
COLLECTION OF NEW YORK UNIVERSITY, ON PERMANENT LOAN TO THE CITY
OF NEW YORK

Herald Square, Avenue of the Americas at 35th Street

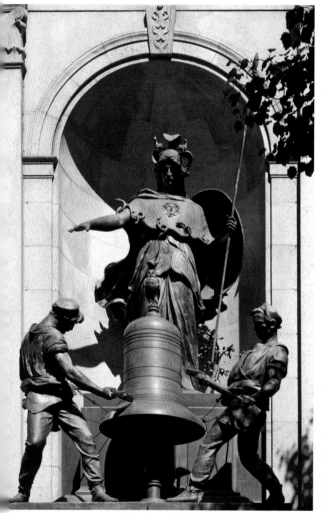

Assembled from a clock and several bronze sculptures salvaged from the top of the McKim Mead and White–designed headquarters building of the *New York Herald* (built in 1893 but now gone), this handsome monument continues to mark the time in the middle of one of Manhattan's busiest intersections. Originally seen against the skyline on top of the Italianate Herald building, the large sculpture of Minerva, the smaller bellringers (affectionately known as Stuff and Guff), and the bell are now framed by a well-scaled arched limestone surround surmounted by the clock. Two owls with electrified eyes were also salvaged from the dozens that ornamented the Herald building. The bronzes were repatinated in 2007 just after this photo was taken. As at Greeley Square, the addition of trees, attractive planters, paving, and seating provides a peaceful foreground to this memorial to the founder of the newspaper that merged with the *Tribune* in 1934.

063 **Moveable Type**

MARK HANSEN, ASSOCIATE PROFESSOR IN THE DEPARTMENT
OF STATISTICS, UCLA, AND BEN RUBIN, ARTIST, 2007
COMMISSIONED BY THE NEW YORK TIMES COMPANY AND FOREST CITY
RATNER COMPANIES

Lobby of the New York Times Building
RENZO PIANO BUILDING WORKSHOP AND FX FOWLE,
ARCHITECTS, 2007
620 Eighth Avenue between 40th and 41st Streets

The lobby of the new headquarters of the *New York Times* is
a compelling physical expression of corporate transparency.
A leading newspaper might expect to be the target of
occasional hostility. But instead of asking architects Renzo
Piano and FX Fowle to sheathe the building in bomb-proof
concrete or elevate the lobby well above the street, the
Times collaborated with the design team to maximize the
use of transparent glass at pedestrian level and to celebrate
the penetration of natural light. The public can see well
into the lobby from the principal entrance on Eighth Avenue,
through the exquisite small interior garden of birch trees
and moss, to the ruby red seats of the auditorium beyond.
The interior walls of the elevator banks are lushly finished in
Marmorino plaster of an invigorating shade of marigold that
mimics the warmth of sunlight deep in the interior.

A more abstruse and poetic sort of transparency has been achieved in the design of the spellbinding media installation *Moveable Type*. Artist Ben Rubin describes the outcome of his first meeting with architect Renzo Piano as a concept to create "a living, sleeping, waking organism that metabolizes the news." He accomplished this by using over five hundred vacuum fluorescent display screens, mounted on a grid of vertical steel cables on either side of the central hallway, that flicker to life with words and phrases. Using complex algorithms devised by Mark Hansen to cull from the immense text files of daily production of the paper, from the voluminous *Times* archives, and from online users of the *Times* Web site, the designers activate the screens to display verbal vignettes representing such themes as "the description of every groom in the weddings section today" or "phrases that refer to 'time'." One tantalizing theme limns the crossword puzzle section, listing the clues and then slowly filling in the grid of answers.

The visual patterns, occasionally supplemented by atmospheric sounds such as ticker tape or a typewriter, constantly renew with a seemingly endless variety of word clusters. Although the predefined concepts don't vary, the content is constantly updated. The combination of screens, of a style first used in the 1960s space program, with the synchronized sounds, which are both mechanical and electronic, channels the essence of technology that is both dated and timeless. Occasionally the words seem to streak around the room in a sudden burst of visual and aural energy. The effect is enthralling for both staff and visitors, demonstrating the enduring allure of the written word when interpreted with artistry and sophistication.

Times Square

Broadway and Seventh Avenue between 42nd and 45th Streets

As arguably the premier and most centrally located tourist destination in all of New York City, Times Square provides a unique and electrifying visual experience. The crossroads of Broadway, Seventh Avenue, and 42nd Street became known as Times Square when the headquarters of the New York Times Company was constructed here in 1904. The area quickly became a nexus of the theater and entertainment industries, but the Great Depression initiated a slow decline, and increasing crime and tawdriness peaked in the 1970s. When the area was planned for comprehensive redevelopment into a mammoth, soulless office park in the early 1980s, concerned citizens and public officials rallied to restore the theatrical and artistic vitality of the district while reinvigorating its distinctive commercial displays, crass yet mesmerizing.

064 **Times Square Advertising**

Brightly lit and animated public advertising has been transformed here into high art that not only obscures the façades of buildings but can also actually become the entire façade. The active, rolling "ticker tape" crawler of news along the bottom of the Reuters Building at 42nd Street and along the base of the ABC News outpost at 46th Street heighten visitors' perception of being at the center of the universe.

065 **U.S. Armed Services Recruiting Station**

ARCHITECTURE RESEARCH OFFICE, ARCHITECTS, WITH PARSONS BRINCKERHOFF, ENGINEERS, 2000
COMMISSIONED BY THE UNITED STATES ARMY CORPS OF ENGINEERS AND THE PENTAGON'S JOINT RECRUITING FACILITIES COMMITTEE
Broadway and Seventh Avenue at 43rd Street

Designed as a neon billboard to grab attention in the heart of tumultuous Times Square, this small building celebrates the American flag in gel-covered fluorescent lights on its two major façades. Before the Iraq War had dampened enthusiam for enlistment, this had reputedly become the most popular recruitment location in the nation, attracting over ten thousand candidates per year for the Army, Navy, Air Force, and Marines. The red, white, and blue fluorescent flags are integrated into a custom stainless steel and glass window wall. Although only 520 square feet in area, this building more than carries its own weight in the visual cacophony of Times Square.

Bryant Park

ORIGINAL DESIGN BY LUSBY SIMPSON, OVERSEEN BY GILMORE CLARKE AND AYMAR EMBURY II,
1930s; RENOVATION BY BRYANT PARK RESTORATION CORPORATION, HANNA/OLIN LANDSCAPE ARCHI-
TECTS; LYNDEN B. MILLER, PUBLIC GARDEN DESIGN; HARDY HOLTZMAN PFEIFFER, ARCHITECTS, 1992
Avenue of the Americas between 40th and 42nd Streets

The renovation of Bryant Park under the initial sponsorship of the Rockefeller Brothers Fund is a frequently cited success story of urban revitalization. Despite its location adjacent to the magnificent New York Public Library, Bryant Park had suffered from a takeover by drug dealers in the 1970s and 1980s; the original design of the park contributed to its being surprisingly isolated from the surrounding busy streets in the heart of midtown.

The comprehensive renovation starting in 1992 was coordinated with the expansion of the New York Public Library stacks beneath the park. Improvements to sight lines and vegetation opened the park up to the surrounding streets. Installation of mixed herbaceous borders along gravel pathways flanking a central lawn, provision of movable chairs and tables, restoration of public bathrooms, and installation of attractive kiosks renewed the vitality of the site.

066 Josephine Shaw Lowell Memorial Fountain

CHARLES A. PLATT, ARCHITECT, 1912

COLLECTION OF THE CITY OF NEW YORK

The principal axis of the park is marked at the west entrance by a monumental granite fountain in memory of social reformer Josephine Shaw Lowell, and handsome original bronze light fixtures mark the other major entrances to the park. The glades of large sycamore trees underplanted with ivy that frame and define the north, south, and east edges of the site are handsome oases that filter and soften the light and give visual and physical respite from the surrounding urban hardscape. These areas are favored by chess players, readers, and lunchtime office workers, who also throng the gravel paths between the perennial borders and the central lawn. The public bathrooms are the nicest in the city, with fresh flowers and regular maintenance provided by the Bryant Park Restoration Corporation.

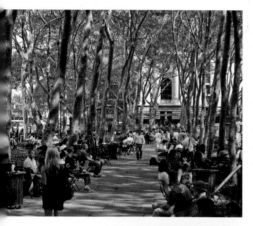

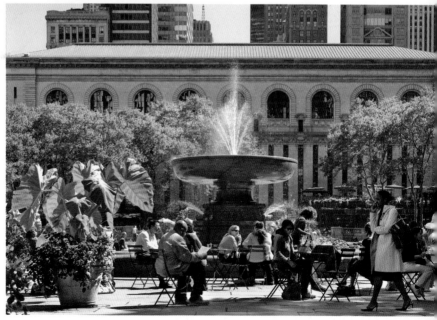

067 William Cullen Bryant Memorial

HERBERT ADAMS, SCULPTOR; THOMAS HASTINGS,
ARCHITECT, 1911

COLLECTION OF THE CITY OF NEW YORK

**East end of Bryant Park, directly behind the New York
Public Library**

The statue of William Cullen Bryant, which dominates the east end of the park on the principal axis at the back of the library, is impressive first for the massive stone canopy under which it sits. Except in the late afternoon, the statue within it is shaded and therefore difficult to appreciate in detail. The bronze statue is, however, a dignified tribute to a man of monumental accomplishments in the civic life of nineteenth-century New York, including the development of the New York Public Library and the establishment of Central Park. Bryant was also closely involved with the artists of the Hudson River School of painting. This excerpt from Bryant's 1863 poem "The Poet" is inscribed on the pedestal:

> YET LET NO EMPTY GUST
> OF PASSION FIND AN UTTERANCE
> IN THY LAY,
> A BLAST THAT WHIRLS THE DUST
> ALONG THE HOWLING STREET AND
> DIES AWAY;
> BUT FEELINGS OF CALM POWER AND
> MIGHTY SWEEP,
> LIKE CURRENTS JOURNEYING THROUGH
> THE WINDLESS DEEP.

Gertrude Stein

JO DAVIDSON, 1923

COLLECTION OF THE CITY OF NEW YORK

East end of Bryant Park, just west of principal north–south walkway

Although this early-twentieth-century portrait of writer Gertrude Stein is separated from the William Cullen Bryant statue by only a dozen years, it is stylistically of an entirely different period. Stein's Buddha-like pose and meditative gaze reflect her interest in Eastern philosophy and religion and her bohemian sensibility, deemed radical during her lifetime. Stein was an early practitioner of "stream of consciousness" writing, and she supported and promoted the work of pioneering modern artists such as Picasso, Matisse, and Braque.

Jo Davidson was known for his portraits of prominent politicians, artists, and businessmen. Artist Man Ray recorded Stein's visit to Davidson's studio in one of his many famous photographs of Stein. Davidson later reminisced in her autobiography, *Between Sittings*, "While I was doing her portrait, she would come around to my studio with a manuscript and read it aloud. The extraordinary part of it was that, as she read, I never felt any sense of mystification. 'A rose is a rose is a rose,' took on a different meaning with each inflection. When she read aloud, I got the humor of it. We both laughed, and her laughter was something to hear. There was an eternal quality about her—she somehow symbolized wisdom."

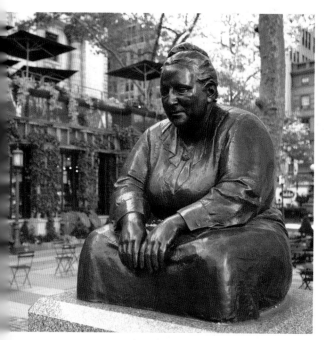

069 Lions ("Patience" and "Fortitude")

EDWARD CLARK POTTER, 1911
PROPERTY OF THE NEW YORK PUBLIC LIBRARY
CARRÈRE & HASTINGS, ARCHITECTS, 1911
West side of Fifth Avenue at 41st Street

The New York Public Library, one of the most elegant public buildings in Manhattan, boasts two of the best outdoor meeting places in midtown: the monumental steps leading up to the main entrance; and the renovated Bryant Park, which covers the underground stacks directly west of the main building. The expansive front steps are rivaled only by the Metropolitan Museum of Art as a place to catch the midday sun and to people-watch. Monumental flagpoles with handsome bases by Thomas Hastings and fountain niches with statues by Frederick MacMonnies enhance the terraces to the north and south of the steps, which offer shaded seating and, in good weather, food kiosks. The lions flanking the front steps of the Library are favorites of both native New Yorkers and visitors. During the winter holidays they are wreathed; in summer they watch benignly from their raised plinths as patrons of the Library come and go. Additional sculptures of allegorical figures History, Romance, Religion, and others by Paul Wayland Bartlett enrich the attic level of this handsome Beaux-Arts façade. The ornate and dignified interior public rooms of the library, including the Gottesman Exhibition Hall, the Main Reading Room, and the Map Room among many others, have been beautifully restored under the guidance of architects Davis Brody Bond.

Grand Central Terminal

WARREN & WETMORE AND REED & STEM, 1903–13, RESTORATION, BEYER BLINDER BELLE,
ARCHITECTS, AND BUILDING CONSERVATION ASSOCIATES 1996–9
42nd Street between Vanderbilt Avenue and Lexington Avenue

As the premier public train station and intermodal transfer point in New York, Grand Central Terminal occupies a fond place in the hearts of New Yorkers, especially since the destruction of its monumental counterpart on the west side, Pennsylvania Station, in 1966. Although it is hemmed in by tall buildings on three sides, the station was preserved from the ignominy of vanishing under a skyscraper by a 1978 Supreme Court ruling that confirmed the legal standing of New York City's Landmarks Preservation Commission to protect it. A magnificent restoration of the station in the 1990s has renewed focus on the classical structure as a vibrant meeting place, commercial center, and cultural destination.

070 Transportation with Clock

JULES-FELIX COUTAN, 1912–14
PROPERTY OF MTA METRO-NORTH RAILROAD

This huge, energetic sculpture dominates the south façade of Grand Central Terminal on axis with Park Avenue South, signifying its Beaux-Arts grandeur from a distance. Topped by a figure of Mercury, the messenger of the gods who presumably endorses the speedy operation of trains and other modern modes of transportation, the clock allows travelers and commuters to gauge how close they are to making their connections.

071 Main Concourse

PROPERTY OF MTA METRO-NORTH RAILROAD

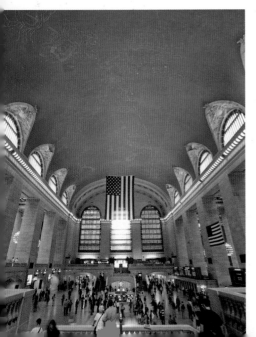

The superb interior space is defined by its colossal proportions, handsome architectural details, and the buzz of bustling commuters. From the grand stairs, to the ticket windows, to the balconies filled with diners, to the shops, to the central information booth thronged with travelers, the concourse provides an endless parade of urban characters. The vaulted ceiling, painted a luscious shade of deep turquoise, is enlivened with allegorical representations of stellar constellations painted in gold, with the principal stars noted with pin pricks of light. Even though the constellations were drawn backwards, the effect is ravishing.

072 Chrysler Building Lobby

CEILING MURAL BY EDWARD TRUMBULL, 1930;
WILLIAM VAN ALLEN, ARCHITECT, 1930
COLLECTION OF CHRYSLER CENTER

Lexington Avenue between 42nd and 43rd Streets

Although best known for its uniquely tiered, stainless steel top, the Chrysler Building's lobby is every bit its match in sheer exuberance and stylistic bravado. The ceiling

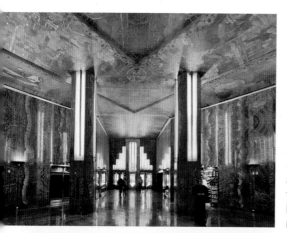

mural, painted in warm colors of orange, gold, brown, and green, features zooming biplanes and muscular construction workers in "celebration of man's application of energy to the solution of his problems." The wavy lines of the granite walls and the chevron pattern of the inlaid floor are complemented by the Art Deco stainless steel torchieres and door trim. The elevator doors and cab interiors, accessible only to those visiting tenants in the building, showcase rich patterns of numerous exotic woods.

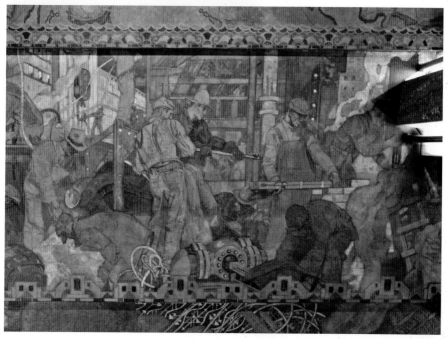

United Nations

East side of First Avenue between 42nd and 48th Streets

The United Nations complex, dominated by the tall slab of the Secretariat building and the low, swooping form of the General Assembly, was designed just after World War II by an international team of architects led by Wallace K. Harrison and strongly influenced by Le Corbusier and Oscar Niemeyer. The site is considered international territory, and works of art have been donated by almost all member countries. Efforts to renovate the aging buildings to improve life safety, weather-tightness, and energy efficiency are currently under way. Although many of the open spaces have been fenced off from the public for security reasons, several notable works of art are accessible to visitors.

073 **Single Form**

BARBARA HEPWORTH, 1964

COLLECTION OF THE UNITED NATIONS, © BOWNESS, HEPWORTH ESTATE

Center of fountain in the middle of the entry plaza to the Secretariat building

This sober and dignified monumental bronze sculpture was conceived as a memorial to Dag Hammarskjöld, the charismatic Secretary-General of the United Nations from 1953 to 1961. Hammarskjöld had begun discussions with Hepworth, a leading English practitioner of abstract sculpture, about completing a work for the UN prior to his death in a plane crash in Rhodesia, now Zambia, in 1961, so her selection to complete his memorial was compelling. This piece, with its blade-like form pierced by a perfectly round hole, is characteristic of Hepworth's art. Its brooding presence on this wide-open plaza suggests ancient monoliths and funerary markers and is an eloquent example of the commemorative power of art.

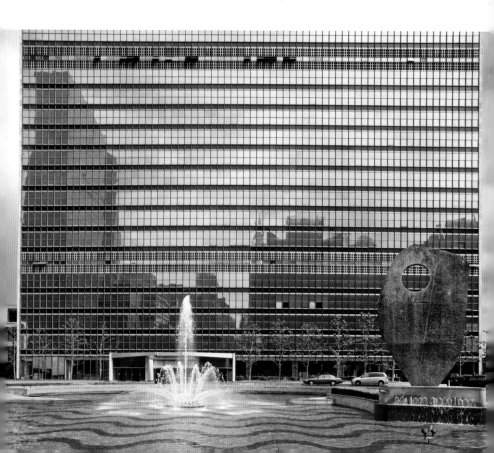

074 **Reclining Figure: Hand**

HENRY MOORE, 1979

COLLECTION OF THE UNITED NATIONS, REPRODUCED BY PERMISSION OF THE
HENRY MOORE FOUNDATION

Adjacent to the Japanese Peace Bell Garden

Henry Moore's fluid and sensual bronze seems the perfect
companion piece to the restrained rectilinear buildings of
the United Nations. It is set against the backdrop of the
colorful Japanese Peace Bell Garden, which is tucked into
a corner of a building linking the Secretariat to the General
Assembly. The beautifully landscaped garden, built in
2000 under the sponsorship of the Japanese government
and private organizations, is centered on a wooden shrine
housing the Peace Bell, which was installed here in 1954.

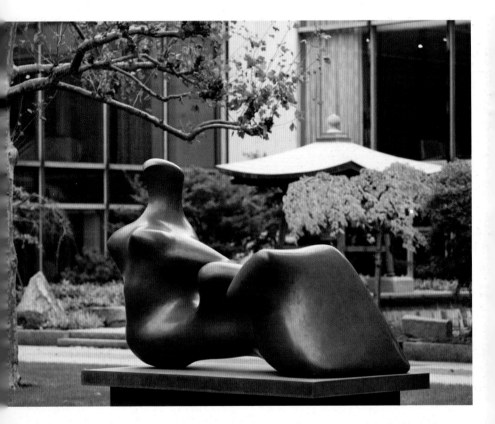

075 **Stained Glass Window**

MARC CHAGALL, 1964

COLLECTION OF THE UNITED NATIONS, DONATED BY UN STAFF AND THE ARTIST

Outside the Meditation Room near the main lobby

Dag Hammarskjöld also admired the Russian-born French artist Marc Chagall, whose stained glass memorial to Hammarskjöld and the other UN staff who perished with him is the stylistic opposite of the Hepworth bronze outside the building. With floating, dream-like figures of people, angels, and animals and saturated colors, the stained glass makes overt reference to the principles of peace and justice. Its musical notes derive from the last movement of Beethoven's Ninth Symphony, a favorite work of Hammarskjöld. The window covers an entire wall outside of the Meditation Room just off the bustling lobby.

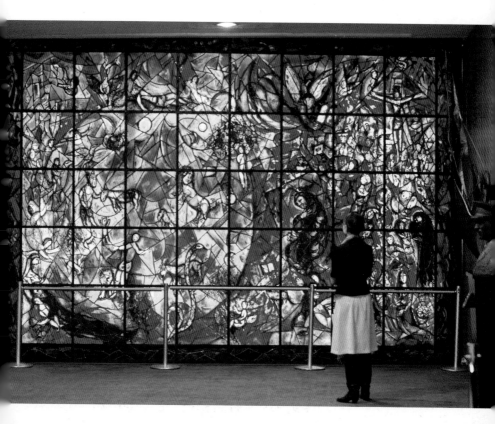

Rockefeller Center

ORIGINAL COMPLEX DESIGNED BY RAYMOND HOOD, WALLACE K. HARRISON, HARVEY WILEY
CORBETT, AND OTHER ARCHITECTS, 1931–40
Between Fifth Avenue and Avenue of the Americas, 48th Street to 51st Street

Located in the heart of midtown Manhattan,
Rockefeller Center is a showplace of three-
dimensional urban planning where public art is
an essential, integral, and highly successful part
of the design. The austere limestone Art Deco
office buildings are arranged with access from the
surrounding streets but also from their own outdoor
space centered around the sunken plaza used for
skating in winter and dining in summer. The central
east–west axis is defined by the Channel Gardens,
a landscaped plaza sloping down from Fifth Avenue
toward the west that offers the principal venue for
seasonal plantings and decorations. The view along
this central axis focuses on the towering slab of
30 Rockefeller Plaza. A lively and easily accessed
underground shopping mall visually connected
to the sunken plaza further unites the disparate
buildings, and the extensive program of colorful and

expressive public art distinguishes the handsome complex from its surroundings.

Although the unifying theme of the art, "New Frontiers and the March of Civilization," may not be apparent, the stylistic and historical consistency among the various expressions brings coherence to the whole project. Art Deco–era bas-reliefs of varying scales sit above the entrances to the buildings, and custom-designed bronze tree guards and address numbers are embedded in the sidewalks. Many of the lobbies have large-scale painted or mosaic murals, and two large pieces of three-dimensional art mark the major public plazas.

The Rockefeller family commissioned the architecture and underwrote the development costs of the entire complex, hoping that an emphasis on international cooperation would inspire and focus the artists' creativity and encourage foreign businesses to lease the commercial space. Thus, the four buildings facing Fifth Avenue are the Palazzo d'Italia, La Maison Française, the British Empire Building, and the International Building.

Atlas

LEE LAWRIE AND RENE CHAMBELLAN, 1936–37
COLLECTION OF ROCKEFELLER CENTER
Entry plaza to the International Building, 630 Fifth Avenue

The figure of Atlas supporting the world fittingly dominates
the entry to the International Building. A figure at once
commanding and dignified, Atlas carries the burden on
his well-muscled shoulders. Lawrie, an accomplished
sculptor, used armillary rings marked with zodiacal
symbols to represent the world in order to maintain
transparency in this small courtyard as requested by the
architect. The contrast between the gravity-bound Atlas,
bearing the cylindrical world, and the vertical stone spires
of St. Patrick's Cathedral reaching heavenward across
the street presents an unusual and thrilling dynamic.

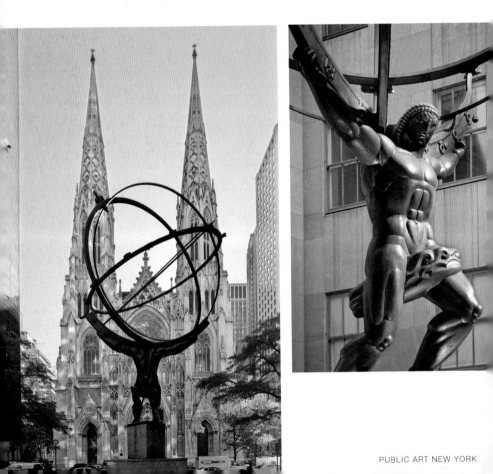

Youth Leading Industry

ATTILIO PICCIRILLI, CA. 1936

COLLECTION OF ROCKEFELLER CENTER

Over the entrance to the International Building North, 636 Fifth Avenue

As the second composition of custom glass blocks designed by Attilio Piccirilli and cast by Corning Glass Works in forty-five molds, *Youth Leading Industry* is a powerful illustration of youthful nudes in the classically derived form of charioteer and horses. The rising sun in the background speaks of a dawning age of industrial vigor and invention. The similar, pioneering first piece by Piccirilli in Corning glass block was removed from the entrance to the Palazzo d'Italia at the beginning of World War II because of its overt fascistic references.

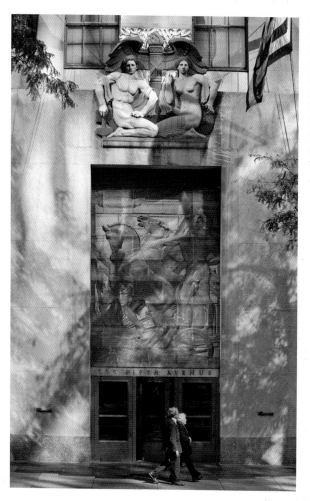

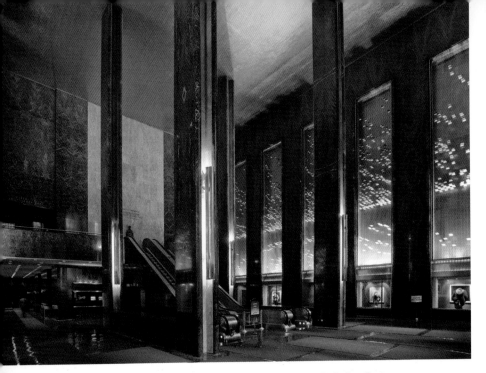

078 Sculptures of Light and Movement

MICHIO IHARA, 1978
COLLECTION OF ROCKEFELLER CENTER

Lobby of the International Building, 630 Fifthe Avenue

Because of its large scale, with escalators running both up and down, and because of the luminous abstract art on its walls, this lobby welcomes the visitor with unusual visual warmth and excitement. The high walls are enlivened with thin metal wires supporting small strips of metal foil at various heights oscillating slightly in the thermal currents activated by the movement of tempered air in the lobby. The metal strips, the walls behind them, and the ceiling are gilded, and they shimmer subtly in the glow of recessed uplights.

At the top of the escalators to the second floor is a bronze portrait bust to Charles A. Lindbergh and an inscription:

> SCIENCE, FREEDOM, BEAUTY, ADVENTURE
> WHAT MORE COULD YOU ASK OF LIFE
> AVIATION COMBINED ALL THE ELEMENTS I LOVED
>> –Charles Lindbergh, *The Spirit of St. Louis*

The Friendship of France and the United States

ALFRED JANNIOT, CA. 1934
COLLECTION OF ROCKEFELLER CENTER

La Maison Française, 610 Fifth Avenue

Designed for display over the main entrance to the Maison Française, this richly ornamented and gilded bronze relief is emblematic of the Gallic spirit and of the friendship between the United States and France. The plaque teems with florid ornamentation depicting the plants and birds of

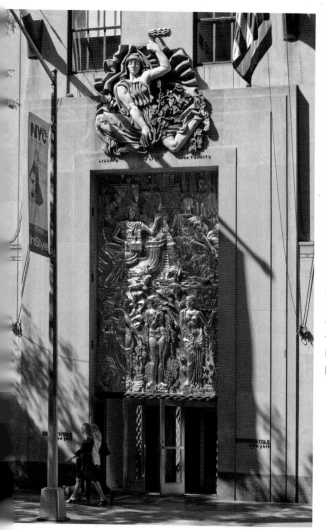

land and sea surrounding three female figures labeled vertically as representing Poetry, Beauty, and Elegance. In the top half of the design, somewhat stiff figures representing the cities of Paris and New York touch hands in a gesture of transatlantic cooperation. Paris, holding a model of Nôtre-Dame, is identified by the city's motto translated as "It floats but never sinks," while the figure of New York is backed by the skyscrapers of Lower Manhattan. The gilding of the entire surface creates a scintillating, animated tableau illustrating the abundance of nature, the grace of the human form, and the benefits of international peace and prosperity.

Industries of the British Commonwealth

CARL PAUL JENNEWEIN, 1933
COLLECTION OF ROCKEFELLER CENTER

The British Empire Building, 620 Fifth Avenue

In keeping with English sensibility, the bronze plaque over the entrance to the British Empire Building is the stylistic opposite of its extravagantly decorated counterpart at La Maison Française. The handsomely modeled human figures, each representing a crop or industry of the far-flung British Empire, are shown either at work or with the tools or products they represent close at hand, and they are formally arrayed in a loosely gridded pattern. Because only the figures and lettering are gilded, they stand in stark contrast to the muted bronze background. Typical of the British psyche, the figures are stately and strong, focused on the business at hand, and tightly controlled within the overall composition.

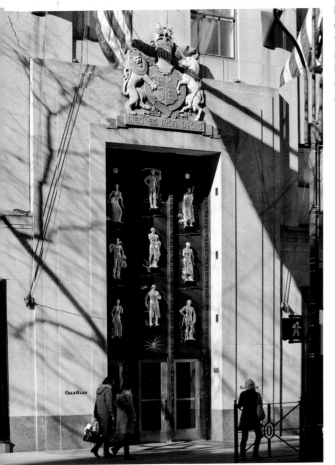

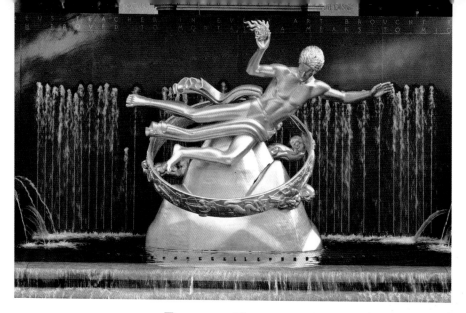

081 **Prometheus**

PAUL MANSHIP, 1934
COLLECTION OF ROCKEFELLER CENTER

At the head of the sunken plaza in front of 30 Rockefeller Plaza

When the annual Christmas tree is not in place, the gilded
statue of Prometheus on the west wall of the lower plaza
is the focus of this axial view. Descending from Olympus
to bring the civilizing gift of fire to humans, Prometheus is
ringed by the mythological signs of the zodiac. The other
primal elements are represented by the rocky mountain to
which Prometheus descends, the water of the fountain,
and the air billowing his loincloth. Although critics savaged
the piece when it first was unveiled (one critic said it
"look[s] like he [has] just sprung out of a bowl of hot
soup"), today the sculpture is one of the most popular and
well recognized in New York. Carved into the wall behind
Prometheus are these words of the playwright Aeschylus:

PROMETHEUS, TEACHER IN EVERY ART, BROUGHT THE FIRE
THAT HATH PROVED TO MORTALS A MEANS TO MIGHTY ENDS.

Prometheus was originally flanked by two additional
bronzes representing mankind in the guise of a youth and a
maiden. These two statues, augmented by heavily stylized
Deco-inspired vegetation, have been relocated to the east
edge of the lower plaza, where they provide a foreground
setting for the Prometheus. Centered on the same east
wall is a large plaque inscribed with inspirational quotes
from John D. Rockefeller, Jr.

082 # Wisdom with Light and Sound

LEE LAWRIE, 1933
COLLECTION OF ROCKEFELLER CENTER
Above the entrance to 30 Rockefeller Plaza

As the most literal embodiment of the "New Frontiers and March of Civilization" theme of Rockefeller Center, this powerfully inclined bas-relief in painted and gilded limestone and glass block provides a stunning entrance to the architectural focal point of Rockefeller Center. Wisdom is a god-like figure using a gilded compass to inscribe the concentric circles that characterize both Light and Sound in the glass block below. These innovative, translucent molded blocks were custom-manufactured by the Corning Glass Company and refract the light passing both into the lobby by day and out of the lobby at night.

Muscular stone figures representing Sound on the left and Light to the right, referencing contemporary advances in television and radio, fill the lintels above the doors flanking the central entrance. These figures and the huge central panel with Wisdom were the first at the Center to be colored under the direction of specialist Leon V. Solon. The installation was so successful and durable that Solon was engaged to design the color scheme for many other bas-reliefs at Rockefeller Center. The earthiness and harmony of his color selections play a large role in the success of the public art here.

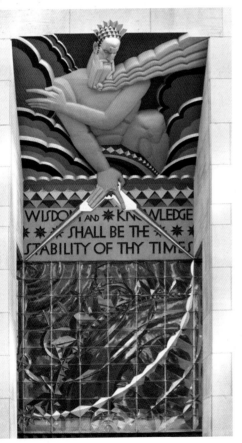

WISDOM AND KNOWLEDGE SHALL BE THE STABILITY OF THY TIMES

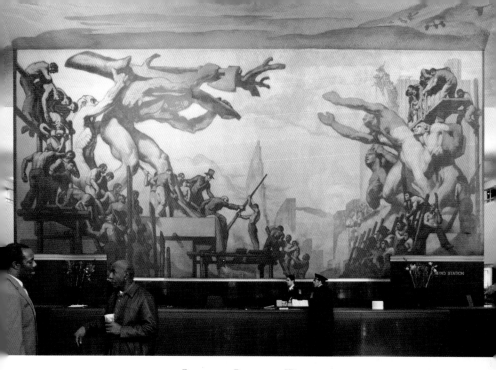

083 American Progress

JOSÉ MARIA SERT, 1937
COLLECTION OF ROCKEFELLER CENTER
Central West Wall of Lobby, 30 Rockefeller Plaza

The energetic and muscular murals in this striking lobby are strongly didactic and aim to depict the moral value of hard work and the civilizing effect of strong ideals, as evidenced in the flow of history. The monochromatic effect of the murals is a handsome complement to the monumental lines of the interior architecture.

The mural *American Progress* on the west wall replaces a controversial, politically charged mural by Diego Rivera that was removed in February 1934. In Sert's mural, Abraham Lincoln incongruously directs an obscure and laborious process in the midst of colossal allegorical figures. The masterful figures on the ceiling, also by Sert, represent the heroic struggles of man in past, present, and future time.

The murals along the south side of the lobby, executed by Sir Frank Brangwen in 1933, depict the rise of man from the stone age through the machine age and include overt textual references to Christian moral values.

084 **News**

ISAMU NOGUCHI, 1940
COLLECTION OF ROCKEFELLER CENTER

**Entrance to the Associated Press Building,
50 Rockefeller Plaza**

With the subtle sheen of highly articulated cast stainless steel, Noguchi's high relief *News* is a compelling and dynamic frontispiece for the Associated Press Building. The forceful and energetic figures, represented primarily as muscled upper torsos, depict the various tasks necessary to the production of the news, including writing notes, talking on the telephone, taking photographs, and sending teletype. The heroic scale, abstracted representation, and handsome, monochromatic coloration of this piece make it one of the most sophisticated works of art in Rockefeller Center.

The Story of Man (or, The Purpose of the International Building)

LEE LAWRIE AND RENE CHAMBELLAN, 1935

COLLECTION OF ROCKEFELLER CENTER

South front of the International Building, 19 West 50th Street

As one of the largest and most colorful bas-reliefs in the Rockefeller Center complex, Lee Lawrie's openwork limestone screen at the south entrance of the International Building strikingly embodies Art Deco style. The earthy tones of terra cotta, grey green, mustard, and brown, highlighted with gilding, are the work of Leon V. Solon, whose superb chromatic sensibility unifies many works of art throughout the Center. Even if one is ignorant of the iconography of this piece—which personifies the races of man, international trade, art, science, and industry, and which includes symbols of the Northern and Southern hemispheres—the pictorial liveliness of each vignette invigorates the gridded composition of the piece.

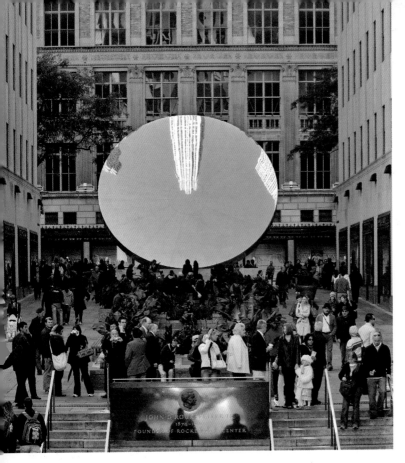

086 Sky Mirror

ANISH KAPOOR

ORGANIZED BY THE PUBLIC ART FUND, HOSTED BY TISHMAN SPEYER

South front of the International Building, 19 West 50th Street, temporary installation, Fall 2006, in the Channel Gardens

Under the auspices of property owner Tishman Speyer, the Public Art Fund has organized periodic temporary installations of public art at Rockefeller Center. Anish Kapoor's *Sky Mirror* transformed viewers' experience of this iconic urban space. Like the device of a mirror used in Flemish paintings to reflect the surroundings of the subject, this huge mirror of polished stainless steel, more than 30 feet in diameter, was canted at an angle to offer dual reflections. The concave side of the mirror faced upward to the west to showcase an inverted image of 30 Rockefeller Plaza. The convex side was angled down to offer passersby an exaggerated reflection of themselves within the lively urban streetscape.

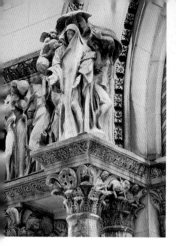

087 **Vanderbilt Portal**

ST. BARTHOLOMEW'S CHURCH, BERTRAM G. GOODHUE, 1918–19
RELOCATED FROM OLD ST. BARTHOLOMEW'S CHURCH, DESIGNED
BY STANFORD WHITE, MCKIM, MEAD & WHITE, 1902
Park Avenue between 50th and 51st Streets

Stanford White designed this portico in 1902 as a
memorial to Cornelius Vanderbilt II at the front of the now-
demolished St. Bartholomew's Church at 44th Street and
Madison Avenue; the tripartite arch design is based upon a
Romanesque church he had visited in the south of France.
When the current St. Bartholomew's was built, the vestry
asked architect Bertram Goodhue to incorporate the entire
portico in the new design, and the Romanesque/Byzantine
style of the new church was planned to harmonize with
the style of the older portico.

The portico is a rich mix of colorful stones; the warm-
toned cippolino marble columns, red porphyry wainscoting,
and green marble wall surfaces give the design an unusual
liveliness. Each of the three marble arched tympana (the
triangular or semi-circular space enclosed by a pediment)
and the corresponding sets of sculpted bronze doors was
designed by a different artist: the north tympanum and
doors sculpted by Herbert Adams; the central tympanum
and doors designed by Daniel Chester French and
executed by his protégé Andrew O'Connor; and the south
tympanum and doors sculpted by Philip Martigny.

Because of the poor condition of the operable hard-
ware, the beautifully rendered bronze doors have been
fixed in the open position behind the outer wood doors
and are not visible from the exterior. It is worth going inside
the narthex to see the doors and the spectacular, domed
mosaic ceiling executed by Hildreth Meiere and other artists.

088 Ordinary

ALEXANDER CALDER, 1969
ON LOAN FROM PACE WILDENSTEIN

Seagram's Building

LUDWIG MIES VAN DER ROHE WITH PHILIP JOHNSON, 1958

375 Park Avenue, temporary installation, 2007

As one of the iconic commercial towers of the twentieth century, the Seagram Building retains its elegant reserve despite the proliferation of knock-off office towers up and down Park Avenue. The contrast between this metal and

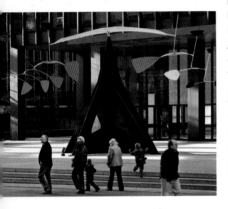

bronzed glass masterpiece of modernism and McKim Mead & White's Classical, rusticated Racquet and Tennis Club directly across Park Avenue is one of the great silent conversations of the New York streetscape. The public plaza in front of the Seagram's Building was articulated historically only by two low, rectangular fountains that flank the entrance and are filled with evergreen trees every holiday season. The current owner, a collector of modern art and architecture, has installed a changing series of pieces. With a triangulated, dark metal base and colorful mobile on top, this sprightly Calder was a lively counterpoint to the building façade.

089 The Virgin Mother

DAMIEN HIRST, 2005
COLLECTION OF LEVER HOUSE ARTWORK, LLC

Lever House

GORDON BUNSHAFT, SKIDMORE OWINGS & MERRILL, 1952

390 Park Avenue, temporary installation, 2007

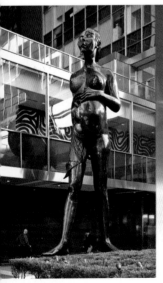

Lever House, one of the first glass curtain walls of New York commercial architecture, has been painstakingly restored to its original appearance while incorporating current standards for energy efficiency. The building's lobby, which is glass on three sides, and its open, landscaped courtyard invite the passerby to enter. The enlightened owner, the same developer who owns the Seagram Building, has instituted a program of contemporary art installations in collaboration with the nonprofit Public Art Fund. Artists have made use of the ceiling over the public sidewalk, the courtyard, and the lobby for provocative art installations.

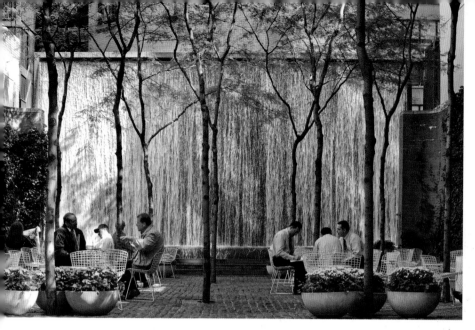

090 **Paley Park**

ZION & BREEN, LANDSCAPE ARCHITECTS, WITH ALBERT
PRESTON MOORE, CONSULTING ARCHITECT, 1967; RESTORATION
BY BEYER BLINDER BELLE, ARCHITECTS, AND LYNDEN B. MILLER
PUBLIC GARDEN DESIGN, 1999
MANAGED BY THE WILLIAM S. PALEY FOUNDATION

5 East 53rd Street

This small jewel of landscape art proves that much can be
accomplished in a constricted space with design restraint
and a simple yet sophisticated palette. Anchored by the
rushing sound of the softly lit waterfall along its back wall
and by the dappled canopy of honey locust trees, Paley
Park is a compelling oasis oriented to capture the midday
sun. The special sense of place is further reinforced by
the ivy-covered side walls, the finely textured granite block
paving, and the movable, lightweight chairs and tables.
Seasonal plantings in concrete planters provide just the
right amount of accent color.

Given the calming effect of the design, it is hard to
believe that the park is visited by, on average, up to three
thousand people a day. It is ironic that, unlike public plazas
created for zoning bonuses, the most beloved small public
park in the city was donated by a private benefactor,
William S. Paley, in memory of his father, Samuel, and it
continues to be managed by a private foundation for the
benefit of the public. A sure sign of the success of the
design is that vandalism has been minimal.

Landscape of the Cloud

ISAMU NOGUCHI, ARTIST; CARSON AND LUNDIN,
ARCHITECTS, 1957–58

Lobby of 666 Fifth Avenue between 52nd and 53rd Street

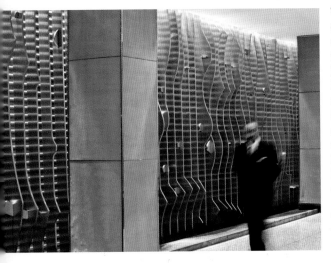

With its gridded façade of embossed metal panels and the huge 666 crowning the top, what was built in 1958 as the Tishman Building remains one of the most prominent modern buildings along Fifth Avenue. The open retail arcade at the first-floor level attracted pedestrians into the stunning lobby designed by Isamu Noguchi. In 1999, however, the lobby was subjected to a major overhaul by a different owner, and in 2001 the Fifth Avenue entrance was closed up entirely to create more retail space. Despite these changes and the installation of bland granite walls and floors, the two most significant components of the original Noguchi design—the central stainless steel wall fountain and the luminous white-painted ceilings in the halls leading to the elevator banks—have been retained and restored.

The plumbing systems for the wall of cascading water have been thoroughly rebuilt and the quirky, gently curving stainless steel fins beautifully restored and lit. The varying curves of these vertical fins stand in contrast to the horizontally ribbed back wall, and they are echoed in the varying curvatures of the white ceiling fins in the flanking elevator lobbies. The cumulative effect of the swelling ceiling fins is reminiscent of cloud cover or a reflection of roiling sea, as if one were submerged in the waters of the fountain.

092 **Saurien**

ALEXANDER CALDER, 1975

COURTESY CALDER FOUNDATION, NEW YORK

590 Madison Avenue (formerly the IBM Building), southwest corner of Madison Avenue and 57th Street

This colorful Calder stabile stands its ground in front of and under the huge, darkly elegant IBM Building. Because the ground-level corner of the building has been lopped off to create the entrance plaza, the polished granite mass of the structure looms over one of the busiest corners in midtown Manhattan. The bright red Calder piece comprises three open, arched forms under which pedestrians can cut the corner. The tops of the arches have triangular points that seem to ward off the building above and vaguely suggest the crown of the Statue of Liberty. This curving, jaunty piece thus succeeds in counterbalancing the serious austerity of the architecture and in sustaining a visually stimulating streetscape.

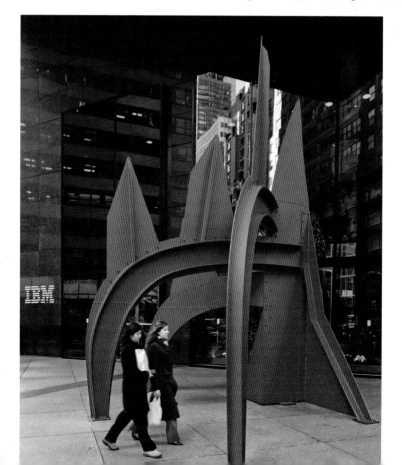

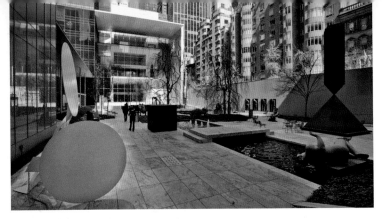

093 Abby Aldrich Rockefeller Sculpture Garden

PHILIP JOHNSON, ARCHITECT; ZION AND BREEN,
LANDSCAPE ARCHITECTS, 1953
THE MUSEUM OF MODERN ART

North side of the museum facing West 54th Street

While this masterpiece of modern design is only accessible to the public for free once a week or when the museum has occasional free access underwritten by a corporate sponsor, it is also visible through two slatted gates that face 54th Street. The quality of the outdoor sculptures and the integration of the art with the landscape design are exemplary. From the main entrance hallway to MoMA, the garden is visible to the east beyond Rodin's masterpiece *Monument to Balzac*.

The garden plaza is finished with elegant materials including large, mottled gray and white marble pavers, birch and weeping beech trees, and ivy ground cover from which tulips emerge in the spring. The central, sunken plaza is focused on a small reflecting pool, over which one of the most striking works of art, Aristide Maillol's *River* (1943), leans precariously. Also in the foreground of this view are Claes Oldenburg's *Geometric Mouse-Scale A, White* (left) and Barnett Newman's *Broken Obelisk* (right). There are works by Alexander Calder and Joel Shapiro, as well as signature pieces by Henri Matisse (*The Back I-IV*, 1908–31), Picasso (*She-Goat*, 1950), and Donald Judd (*Untitled*, 1968). Many of the works of art are rotated every few years, and occasionally a major temporary show supplants the regulars. Despite the occasional staining of the white marble by weathering steel pieces, the garden is an enchanting and essential ancillary exhibition space that has become the visual heart of the museum, surviving multiple renovations and expansions of the building.

094 **LOVE**

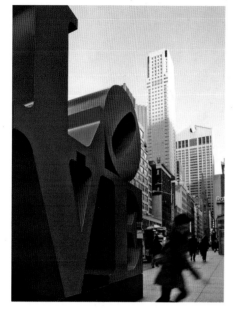

ROBERT INDIANA, 1966/1999
INSTALLED COURTESY OF SIMON SALAMA-CARO, 1999
**Southeast corner of Avenue of the Americas
and 55th Street**

Set upon a busy corner of bustling
midtown, Robert Indiana's Pop Art
classic reminds the passerby how art can
provoke, delight, and instruct, even when
it has become a cliché. This particular
piece in fire engine red and bright blue
is one of innumerable LOVE sculptures
commissioned around the world and copied
in numerous media, colors, and formats.
It is fitting that the site is just around the
corner from the Museum of Modern Art,
which commissioned the original Christmas
card for which Indiana designed the now
familiar LOVE logo in 1966.

095 **Looking Toward the Avenue**

JIM DINE, 1989
1301 Avenue of the Americas

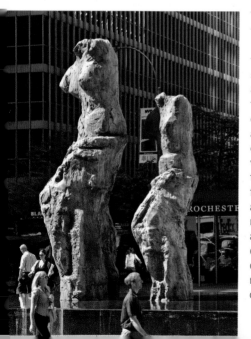

Three monumental studies of draped
female torsos, two on the south end of the
block and one on the north end, stand in
forceful and eloquent contrast to the dreary
sameness of corporate architecture along
Sixth Avenue. Making direct reference to
the restrained yet voluptuous Classical form
of the Venus de Milo, the oversized torsos
are rendered in bronze but with a plasticity
of finish reminiscent of clay. The figures
vary slightly in scale and in their orientation
to Sixth Avenue. The sensuousness of the
female forms, the fluidity of the drapery,
and the apparent malleability of the
material contrast boldly with the repetitious
abstraction of the modernist façades
directly behind. They bring a welcome
dose of humanistic creativity and historical
reference to a neighborhood focused on
commercial enterprise.

Mural with Blue Brushstroke

ROY LICHTENSTEIN, 1984–86

© ESTATE OF ROY LICHTENSTEIN; COLLECTION OF AXA EQUITABLE

AXA-Equitable Building

EDWARD LARRABEE BARNES ASSOCIATES, ARCHITECTS, 1986

787 Seventh Avenue

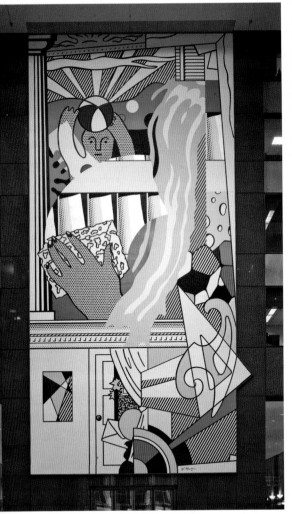

This huge canvas was commissioned by Equitable to fill the east wall of the cavernous lobby of its corporate headquarters. The bright, splashy colors and cartoon-like figures are visible from the street through the glass entry wall, enlivening the northern reaches of the theater district. Dominated by a long streak of blue acrylic that can be read as the blue stroke of paint or as cascading water, the canvas is replete with visual puns and pop references to summer fun, including a beach ball and rising sun.

Just as the pictorial themes lighten the mood of straitlaced corporate office culture, the bright colors and fluid lines relieve the rectilinearity of the Barnes lobby design. Site-specific references include traditional blinds in the upper right corner that reference the real shades in the glass-walled offices ringing the lobby, and the horizontal lines of the polished granite facing are carried right through the painting. The plastic triangle and French curve in the lower right, tools of artists and designers, illustrate the mechanical assistance upon which all the playful visual effects rely.

097 Ice Falls

JAMES CARPENTER DESIGN ASSOCIATES, 2006
COMMISSIONED BY THE HEARST CORPORATION

Hearst Building

FOSTER AND PARTNERS, ARCHITECTS, 2006
Southwest corner of Eighth Avenue and 57th Street

The Hearst Building offers several variants on forms of public art. The historic building, designed by Joseph Urban and George B. Post and completed in 1928, has been preserved solely as a façade; it has several interesting sculptural groups in Art Deco style, representing Comedy and Tragedy to the left of the entrance; Music and Art to the right of the entrance; Printing and the Sciences on the corner of 57th Street; and Sport and Industry on the corner of 56th Street.

The lobby of the massive new building features one of the most innovative public sculptures in New York. *Ice Falls*, a three-story-high sloped water feature designed by James Carpenter, not only visually animates the lobby interior (which is bisected on the diagonal by escalators) but also employs chilled water to actively cool and humidify the space. The water is piped to the top of the sculpture from rainwater harvested on the roof, and the sound of the falling water also tempers the space acoustically. Thousands of cast glass prisms accented by small glass blocks are arranged in a stepped, rigorously geometric pattern that enlivens the wall and energizes the falling water. The sculpture stimulates the eye but also actively contributes to the sustainable design of the

building. The exterior of the entire building could also be considered public art at urban scale: its "diagrid" form, an efficient structural system of diagonal supports that utilizes less steel than the typical high rise office building, is an abstractly sculptural expression that stands out on the skyline.

117

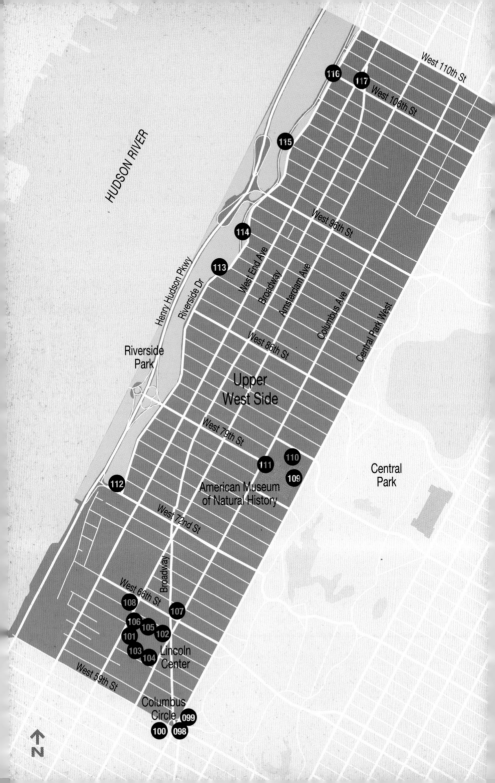

HUDSON RIVER

West 110th St

West 106th St

West 96th St

West End Ave

Broadway

Amsterdam Ave

Columbus Ave

Central Park West

Henry Hudson Pkwy

Riverside Dr

West 86th St

Riverside
Park

Upper
West Side

West 79th St

Central
Park

American Museum
of Natural History

West 72nd St

West 66th St

Broadway

Lincoln
Center

West 59th St

Columbus
Circle

116

117

115

114

113

112

111

110

109

108

107

106 105

101 102

103 104

099

100 098

N

Upper
West Side

Columbus Circle

LANDSCAPE RENOVATION BY THE OLIN PARTNERSHIP, UNDER THE DIRECTION OF THE
DEPARTMENT OF DESIGN AND CONSTRUCTION, THE DEPARTMENT OF TRANSPORTATION, AND
THE DEPARTMENT OF PARKS & RECREATION, 2005

The busy roundabout of Columbus Circle marks the intersection of the southwest corner of Central Park with both the rectilinear grid of the city and the diagonal sweep of Broadway. Columbus Circle is often used as the point of origin for official measurements of distance from New York to other cities. The convergence of so much traffic, the dual entrances to the corner of the park, and the low-rise character of surrounding buildings in the past contributed to the ill-defined character of this place. The column of the Columbus Monument in the center of the traffic roundabout was hard for pedestrians to reach, and the column made its biggest impression from a distance.

The redesign of the center of the circle and construction of the mammoth Time Warner Center, completed in 2004 on the site of the former New York Coliseum, have, notwithstanding the huge scale of the towers, reinforced the strength of the circle and

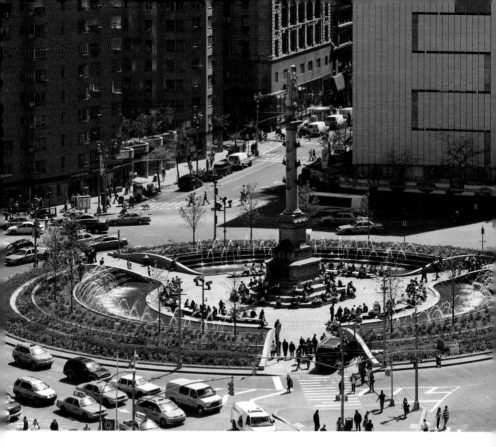

renewed focus on its monuments. The crosswalks into the center have been relocated to more logical points, and an open paved area with comfortable benches has been built in the center of the circle. Perimeter fountains, planting beds, and trees reinforce the circle and establish an effective visual buffer from traffic for pedestrians. The trees have been arranged to leave open the sight lines down each of the major avenues that converge on the site.

Columbus Monument

GAETANO RUSSO, 1892; RESTORATION BY BUILDING CONSERVA-
TION ASSOCIATES, SPONSORED BY THE ADOPT-A-MONUMENT
PROGRAM, 1991
COLLECTION OF THE CITY OF NEW YORK

Center of the Circle

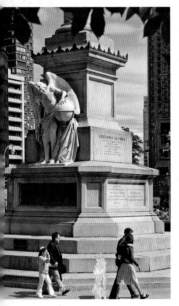

The marble statue of Columbus stands high on top of a monumental granite column gazing toward the ocean. It is now possible for the first time in recent memory both to see the monument from a great distance and to scrutinize close up the inscriptions and reliefs on its base. The bronze ornamentation on the column includes vertically stacked classical rostra (prow-like projections), anchors, and two bas-reliefs depicting the Niña, the Pinta, and the Santa Maria and Columbus's discovery of America. There is also on the south face of the column base a large winged figure carved in marble as the Genius of Discovery; he leans studiously over a globe of the world. Paid for by the donations of proud Italian-Americans, the monument was dedicated on October 12 on the four-hundredth anniversary of Columbus's discovery of the New World:

> TO
> CHRISTOPHER COLUMBUS
> THE ITALIANS, RESIDENT IN AMERICA,
> SCOFFED AT BEFORE,
> DURING THE VOYAGE MENACED,
> AFTER IT, CHAINED,
> AS GENEROUS AS OPPRESSED,
> TO THE WORLD HE GAVE A WORLD.

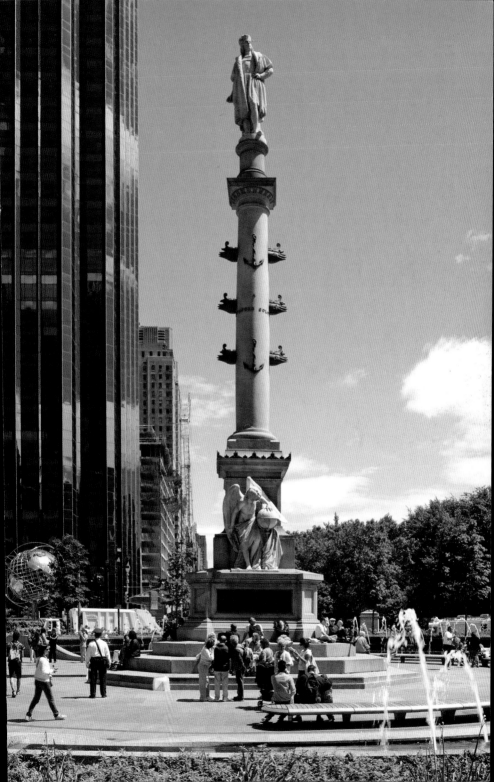

099 **Maine Monument**

ATTILIO PICCIRILLI, ARTIST; H. VAN BUREN MAGONIGLE, ARCHITECT,
1913; RESTORED BY THE CENTRAL PARK CONSERVANCY, 1997

COLLECTION OF THE CITY OF NEW YORK; GIFT OF THE NATIONAL MAINE MONUMENT
FUND COMMITTEE

**Northeast corner of Columbus Circle at the entrance
to Central Park**

A commanding Beaux-Arts composition, this memorial
honors the sailors killed in the explosion of the battleship
Maine that sparked the outbreak of the Spanish-American
War. The monumentally scaled marble pier is topped by
the gilded bronze figure of Columbia Triumphant propelled
forward by three seahorses. Closer to pedestrian level,
the carved stone figure of Victory, backed by Peace,
Courage, and Fortitude, stands astride the prow of a boat
that echoes the six bronze rostra (prow-like projections)
decorating the column of the Columbus Monument (098).

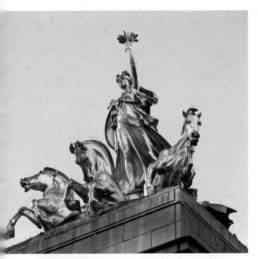

Muscular figures representative of the
Atlantic and Pacific Oceans recline on the
east and west sides of the base of the pier,
and a figure of Justice stands on the north
side. The vigorous collaboration between
sculptor Piccirilli and architect Magonigle
was reprised at about the same time in
the design of the Firemen's Memorial in
Riverside Park (115). The gilded figures
had lost their finish by the 1970s and
their regilding and the restoration of the
stonework constituted one of the first
projects signaling renewed attention to
Central Park's monuments in 1980. A
later project included the reconstruction of
handsome original light fixtures, new gravel
paving, and placement of two attractive
food kiosks behind the monument.

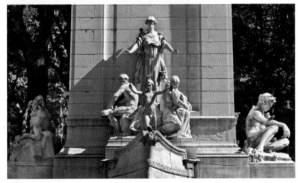

124 PUBLIC ART NEW YORK

100 **Double Cable-Net Wall**

JAMES CARPENTER DESIGN ASSOCIATES, WITH SCHLAICH,
BERGERMANN AND PARTNER, 2004
COMMISSIONED BY THE RELATED COMPANIES

Time Warner Center

SKIDMORE OWINGS AND MERRILL, ARCHITECTS, 2004

East façade of atrium and Jazz at Lincoln Center

The first six stories of the Time Warner building, which house an upscale shopping mall, strongly reinforce the curve of the circle. The main entrance to the large glass atrium, and the wall of Jazz at Lincoln Center above, share a monumentally scaled cable-net glass wall. Directly on axis with 59th Street, the extremely transparent, low-iron glass spans the 150-foot height of the façade and the full width of the street in reference to the virtual street that extends into the space. This structural tour de force is articulated with elegant details that seem to defy the overwhelming forces of wind and sheer weight that press on the wall. Higher up the façade, a smaller, single-direction, cable-net glass wall lines the inside of the exterior face of Jazz at Lincoln Center, isolating it acoustically from the busy urban scene outside. From the inside of the atrium and performance spaces above, there are captivating views of the Columbus Monument and Central Park South from heights and angles previously inaccessible to the public.

Lincoln Center

Lincoln Center is a stunning period piece of large scale public architecture from the 1960s, undergoing much-needed restoration and renewal. The central fountain and radial paving designed by Philip Johnson provide a focal point for the dignified assemblage of modernist buildings whose glass walls allow the color, light, and excitement of the art-filled lobbies to spill out into the central plaza. The secondary north and south plazas, with their allées of trees and reflecting pool, provide more modulated public spaces. Johnson designed a large bronze clock tower for the plaza in the mid-1990s, but it was installed in Dante Park between Broadway and Columbus Avenue at 63rd Street in 1999.

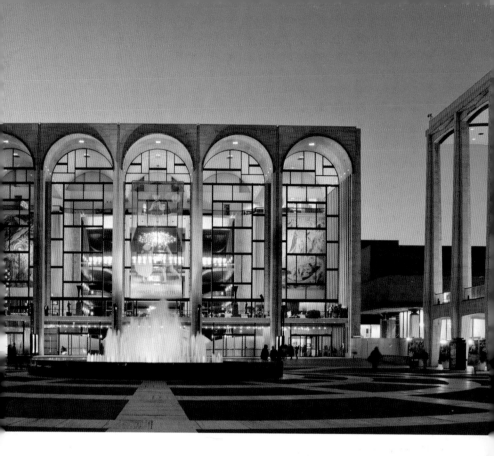

As a whole, the artwork at Lincoln Center is a diverse and invigorating collection of mid-twentieth-century art, most of it commissioned explicitly for this site and highly complementary to the architecture. The selected works of art described here were chosen for their scale and visibility to the public.

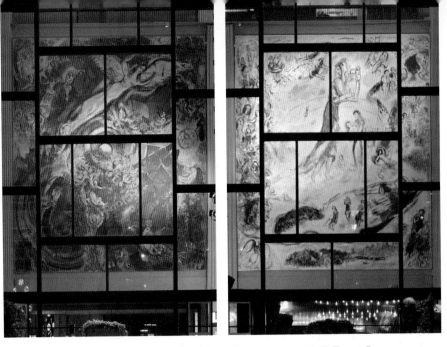

101 The Sources of Music and The Triumph of Music

MARC CHAGALL, 1966
COLLECTION OF THE METROPOLITAN OPERA ASSOCIATION, GIFT OF THE
HENRY L. AND GRACE DOHERTY CHARITABLE FOUNDATION

Lobby of the Metropolitan Opera House
WALLACE K. HARRISON, HARRISON & ABRAMOVITZ, 1966
West side of Josie Robertson Plaza

The largest and most visible works of art in the complex, Chagall's huge murals seem to float over the lobby and entrance of the Metropolitan Opera. The brilliant colors and swirling, ethereal forms present an uplifting tableau of the creative arts. Recalling mythic and historical figures such as Orpheus, Wagner, Mozart, and Bach, Chagall painted references to contemporary New York including individual buildings in the skyline and the George Washington Bridge. The murals are routinely covered with protective curtains against the eastern sun until 3:00 PM, but when the lights come on at dusk, the murals cast a warm glow that entices concertgoers making their way across the bustling plaza.

Many wonderful sculptures by Aristide Maillol and others dot the lobby and upper lobby balconies. The brilliant Swarovski crystal chandeliers in the lobby and main opera house, donated by the Austrian government, are out-standing works of the lighting designer's art.

Orpheus and Apollo

RICHARD LIPPOLD, 1962

COLLECTION OF LINCOLN CENTER FOR THE PERFORMING ARTS, INC.,
GIFT OF THE ITTLESON FAMILY FOUNDATION

Lobby of Avery Fisher Hall
MAX ABRAMOVITZ, HARRISON & ABRAMOVITZ, 1962

North side of Josie Robertson Plaza

Suspended in the tall and narrow space of the Grande Promenade lobby, Lippold's majestic abstract sculptures come to life in the late afternoon sun or at night when they shimmer under the lights. Stabilized by countless, almost imperceptible guy wires, the shiny strips of Munz metal suggest the energy, movement, and fascination of music, the art handed down from Apollo to his son Orpheus.

The work is articulated in two vortices of shiny strips that are clustered at either end of the lobby; the grouping at the east end is centered directly over the escalator that brings concertgoers up from the lobby below, creating a dizzying sensation when they look up. This work, commissioned by architect Max Abramovitz on behalf of Lincoln Center for the Performing Arts, Inc., was the first major work of art selected for Lincoln Center.

103 **Ancient Dance** and **Ancient Song**

YASUHIDE KOBASHI, 1972
COLLECTION OF CITY CENTER FOR MUSIC AND DANCE, GIFT OF LINCOLN KIRSTEIN

Lobby of the New York State Theater
PHILIP C. JOHNSON, ARCHITECT, 1964
South side of Josie Robertson Plaza

This dynamic pair of gilded wall sculptures was commissioned from Kobashi, a set designer and artist, for the twin main stairs. Inspired by the vitality of music and dance performed in the theatre as suggested by George Balanchine, the sculptures respond exuberantly to the triangular geometry of the stair landings, and the irregular finish of the gilding seems to echo the pitted surface of the travertine walls. *Numbers* by Jasper Johns (1964) and *Untitled* by Lee Bonticou (1964), mounted near the stairs, reward close scrutiny.

104 **Two Female Nudes** and **Two Circus Women**

ELIE NADELMAN, 1962
COLLECTION OF LINCOLN CENTER FOR THE PERFORMING ARTS, INC.,
GIFT OF PHILIP JOHNSON

Promenade of the New York State Theater
PHILIP C. JOHNSON, ARCHITECT, 1964
South side of Josie Robertson Plaza

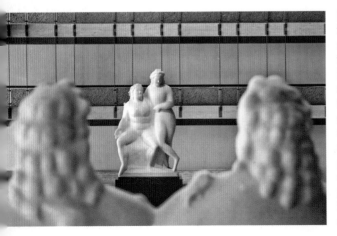

Philip Johnson commissioned these two monumental marble pairs to anchor the far ends of the promenade lobby of the theater. The scale and softly sensual curves of the women provide happy contrast to the strictly ordered and polished finishes of the multi-tiered lobby. Looming gracefully over the milling crowds of theatergoers, each pair, seemingly absorbed in each other, exudes self-assured panache.

105 **Reclining Figure**

HENRY MOORE, 1962–63

COLLECTION OF LINCOLN CENTER FOR THE PERFORMING ARTS, INC.; GIFT OF
THE ALBERT A. LIST FOUNDATION; ON INDEFINITE LOAN TO THE CITY OF NEW YORK,
REPRODUCED BY PERMISSION OF THE HENRY MOORE FOUNDATION

Josie Robertson Plaza, north plaza

Placed in the middle of the calm reflecting pool outside of
the Vivian Beaumont Theatre, this Henry Moore bronze
in two pieces is an alluring visual centerpiece in the
watery plane. It has a strong, virile presence that is both
anthropomorphic and primitive. The embossed finish and
greenish cast of the patinated bronze surfaces give the
sculpture a tactile quality even though it remains out of
reach. Alexander Calder, sculptor of nearby *Le Guichet*,
is said to have famously joked, "the pigeons like Henry
Moore than me." At the time of writing, the sculpture
was temporarily removed from the pool, which is being
reconfigured as part of the larger renovation of the plaza
to the design of architects Diller Scofidio + Renfro.

106 Le Guichet

ALEXANDER CALDER, 1963

COLLECTION OF LINCOLN CENTER FOR THE PERFORMING ARTS, INC., GIFT OF
HOWARD AND JEAN LIPMAN; ON INDEFINITE LOAN TO THE CITY OF NEW YORK

**Josie Robertson Plaza, outside of the New York Public Library
for the Performing Arts**

It is hard to believe that this classic Calder design, now one
of the most popular pieces of public art at Lincoln Center,
was once almost rejected by then Commissioner of Parks
and Recreation Newbold Morris. Perhaps it is the slightly
sinister connotation of its black, spider-like form that Morris
found objectionable. But the piece has earned the respect
and affection of audiences and visitors to the public library
immediately behind. Its spreading legs, which allow visitors
to range beneath the arched forms, serve as a graceful
foil to the regularity of Lincoln Center's architecture, and the
black painted steel harmonizes with the dark color of the
window mullions nearby.

107 Dichroic Light Field

JAMES CARPENTER DESIGN ASSOCIATES, 1994–95
COMMISSIONED BY MILLENNIUM PARTNERS

Millennium Tower

SCHUMAN, LICHTENSTEIN, CLAMAN + EFRON, ARCHITECTS, WITH
KOHN PEDERSON FOX, ASSOCIATED ARCHITECTS, 1994
West side of Columbus Avenue at 66th Street

The neighborhood surrounding Columbus Avenue
near Lincoln Center has attracted a dizzying array of
commercial buildings such as the ABC headquarters,
major retailers such as Barnes & Noble, residential
highrises, and a high volume of traffic intent on
reaching Lincoln Center or Columbus Circle. Above this
cacophonous mix, James Carpenter's *Dichroic Light
Field* hovers ethereally on the side of Millennium Tower,
establishing a lofty vertical plane of shimmering glass.

Carpenter says, "All of my work is about the
perception of light in our immediate environment—and
how to enliven and engage the viewer's experience of
place through revealing the specific phenomenology of
light that surrounds us but otherwise remains unseen."
The flat, gridded surface of textured laminations and 216
projecting glass fins reflects evanescent conditions of
ambient light, atmosphere, and sky. Depending upon the
weather, time of day, season of the year, and orientation
of the observer, the captured light can appear as
shimmering silver, electric orange, or crepuscular indigo.
This understated yet powerful work of art seduces the
passerby to consider the transcendent beauty of the ever-
changing atmosphere above the din of city life.

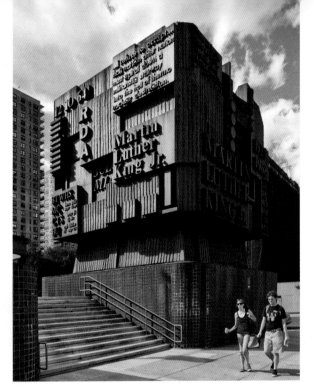

108 Martin Luther King Jr. Memorial

WILLIAM TARR, ARTIST, 1973
COLLECTION OF THE CITY OF NEW YORK

Martin Luther King Jr. High School

A. CORWIN FROST, ARCHITECT

122 Amsterdam Avenue

Commanding the northeast corner of the open plaza in front of the public high school renamed following the 1968 assassination of Dr. King, this boldly graphic monument in darkly oxidized weathering steel commemorates major events and associations in the life of the great civil rights leader. Many of the references are abbreviated cryptically as initials or dates—such as "JJ" referring to fellow activist Jesse Jackson, or "12-10-64" referring to the date Dr. King accepted the Nobel Peace Prize. But several quotes from Dr. King's speeches and writings enlarge the emotional impact of the memorial and still ring true today:

LET US BE DISSATISFIED UNTIL EVERY MAN CAN HAVE FOOD AND MATERIAL NECESSITIES FOR HIS BODY, CULTURE AND EDUCATION FOR HIS MIND, FREEDOM AND HUMAN DIGNITY FOR HIS SPIRIT.

American Museum of Natural History

ORIGINAL BUILDING, VAUX & MOULD, 1874–77; SOUTH AND PART OF WEST ELEVATION, CADY, BERG & SEE, 1888–1908; EAST WING, TROWBRIDGE & LIVINGSTON, 1912–34

Central Park West between West 77th Street, West 81st Street and Columbus Avenue

Occupying a prominent site edged with sycamores, the magnificent American Museum of Natural History embodies much of the history of American architecture from the middle of the nineteenth century to the present day. The original Victorian Gothic building has been expanded and engulfed by later wings. The muscular Romanesque Revival façade facing West 77th Street is articulated with rounded corner turrets, and the dignified Neoclassical wing facing Central Park West culminates in the grand entrance described below. The spectacular glass planetarium on the north side of the complex fronts on a neighborhood park. It is a great pedestrian experience to circumnavigate the entire perimeter of the museum site.

State of New York Memorial to Theodore Roosevelt

JAMES EARL FRASER, SCULPTOR; JAMES L. CLARK, SCULPTOR
OF BAS-RELIEFS; JOHN RUSSELL POPE, ARCHITECT, CA.1929–36
COLLECTION OF THE CITY OF NEW YORK

Main entrance, American Museum of Natural History, Central
Park West at 79th Street

A commanding presence facing Central Park West,
this memorial to Theodore Roosevelt is comprehensively
integrated with the principal entrance of the American
Museum of Natural History. The memorial consists not
only of the bronze equestrian statue of Roosevelt but
also of an expansive, two-block-long bas-relief carved
into the granite base of the museum building; the grand
entrance plaza; a dedication inscribed at the attic level

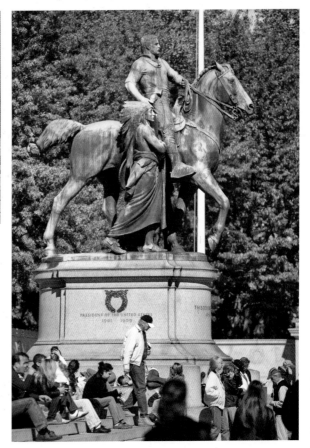

above the entrance; and three large, colorful murals and four sets of splendidly didactic Roosevelt quotations on the walls inside the museum lobby. This entire ensemble of earnest tributes in various media gives this memorial its compositional strength. However, the portrayal of a Native American and an African American as secondary to the central equestrian statue, although reflecting views of its time, is dated.

The scuptor Fraser, best known for the buffalo nickel, depicts Roosevelt as an authoritative leader astride his equestrian mount, flanked by two servile human figures representing the African and American continents. The stone bas-reliefs on either side of the statue depict African animals such as antelope, zebras, and hippos on the north side and animals from the American West such as bison, moose, and buffalo on the south side of the entrance. Twelve of Roosevelt's numerous accomplishments are spelled out along the base of the building ("statesman," "author," "explorer."...) culminating in the ultimate nineteenth-century American dream job, "ranchman." The vast plaza, with towering bronze light fixtures, monumental flagpoles, and granite benches, accommodates busloads of visiting children and successfully conceals a service drive and two entrances to the subway below. Urbanistically, one wishes there were a corresponding plaza or recess in the park wall opposite, or at least a view corridor east, to counter-balance the power of the entrance axis.

Inside the impressive lobby articulated by four sets of colossal red columns, the walls are decorated with three large and colorful murals over the entrances to each museum wing. These murals, uplit by large and ornate bronze torchieres, depict in fascinating detail Roosevelt's support for the Panama Canal (north), his activities in Russia and Japan (south), and his explorations in Africa (west). The east and west walls of the lobby are also covered in many of Roosevelt's most inspirational quotations grouped under the headings "Nature," "Youth," "Manhood," and "The State." Taken together, the diverse elements of this Depression-era memorial create a stirring and visually stimulating tribute on a grand scale that, one surmises, the former President himself would have loved.

110 The Frederick Phineas and Sandra Priest Rose Center for Earth and Space

POLSHEK PARTNERSHIP, 2000

Arthur Ross Terrace

GUSTAFSON GUTHRIE NICHOL, LTD., WITH ANDERSON & RAY, INC.
LANDSCAPE ARCHITECT, 2000

North side of the American Museum of Natural History,
81st Street between Central Park West and Columbus Avenue

The transcendent form of the Rose Center, an opaque sphere supported inside a cube of highly transparent glass, recalls the utopian architectural proposals of late-18th-century French architect Etienne-Louis Boulée. It is also a testament to the ability of well-designed contemporary architecture to transform the utilitarian side façade of an aging masonry landmark into an architectural wonder. It exemplifies how visionary new landmarks can be designed with sufficient panache to replace older buildings—in this case, a planetarium from the 1930s. The spherical form of the planetarium inside the cube is especially evocative in the evening hours, when a haunting blue light recalls the glow of the moon and distant galaxies.

The adjacent elegant raised public plaza of about one acre is reached from the Rose Center and by stairs from Theodore Roosevelt Park to the north and west of the museum. Here the landscape architect Kathryn Gustafson, better known for designing Millennium Park in Chicago and

the Diana Memorial Fountain in London, devised a spare, flush fountain surrounded by lawn and edged to the north by gingko and sephora trees. The horizontal surface of the granite fountain is inlaid with the pattern of the constellation Orion, enlivened with fiberoptic lights. Seemingly random vertical jets of water provide an endless source of delight, and the fountain has become a favorite with neighborhood children.

111 The Times Capsule

SANTIAGO CALATRAVA, 1999–2000
COMMISSIONED BY THE NEW YORK TIMES MAGAZINE; FABRICATED BY A.R.T.
RESEARCH ENTERPRISES, LANCASTER, PA

Columbus Avenue entrance to the Museum at 79th Street

In the years leading up to the celebration of the millennial year 2000, the *New York Times Magazine* sponsored an international competition for the design of a time capsule, and various *New York Times* offices around the world solicited items for inclusion in the capsule, intended to be opened in the year 3000. Architect, engineer, and artist Santiago Calatrava won the competition, submitting a concept that perfectly marries the artistic and the mathematical, the abstract and the sensual. The New York Times Company underwrote the final design and construction of the project, christened *The Times Capsule*.

The visually seductive pod of welded stainless steel, measuring 5 feet in every dimension, is located in a small plaza aligned with the major axis of West 79th Street, leading to a handsome glass entry pavilion designed by the Polshek Partnership. Even when the west entrance is closed, the elegant and intriguing *Times Capsule* remains accessible to the public in the outdoor plaza.

Riverside Drive

Stretching north from 72nd Street to the George Washington Bridge, Riverside Drive traces the sinuous border between the grid of the city and the naturalistic landscape of Riverside Park and features a succession of handsome monuments to historical figures, servicemen, and firefighters.

112 Eleanor Roosevelt Memorial

PENELOPE JENCKS, ARTIST; MICHAEL M. DWYER, ARCHITECT;
BRUCE KELLY, DAVID VARNELL, LANDSCAPE ARCHITECTS, 1996
COLLECTION OF THE CITY OF NEW YORK, GIFT OF THE ELEANOR ROOSEVELT
MONUMENT FUND

72nd Street at Riverside Drive

> WHERE, AFTER ALL, DO UNIVERSAL HUMAN RIGHTS BEGIN?
> IN SMALL PLACES, CLOSE TO HOME, SUCH ARE THE PLACES
> WHERE EVERY MAN, WOMAN AND CHILD SEEKS EQUAL
> JUSTICE, EQUAL OPPORTUNITY, EQUAL DIGNITY.
> –Eleanor Roosevelt, 1958

The Eleanor Roosevelt Memorial is a rare depiction of a twentieth century female figure in a New York City public park. At a scale larger than life, Roosevelt's figure in bronze leans against a boulder, lost in thought; the informality of her pose, with her arm modestly around her waist, underscores her accessibility. The plaque in the paving provides a brief summary of her distinguished career, focused after her husband's death on international affairs and universal human rights at the United Nations. It also includes the astonishing fact that this accomplished woman produced six children in the brief span of eleven years.

Sited in the middle of a slightly raised planting bed surrounded by a paved circle with benches, the statue can be appreciated from all sides. The memorial lends focus and dignity to this major entrance to Riverside Park, which was previously overshadowed by an entrance ramp to the West Side Highway.

113 Soldiers' and Sailors' Monument

PAUL E. DUBOY, SCULPTOR; CHARLES W. AND
ARTHUR A. STOUGHTON, ARCHITECTS, 1902
COLLECTION OF THE CITY OF NEW YORK

Riverside Drive at 89th Street

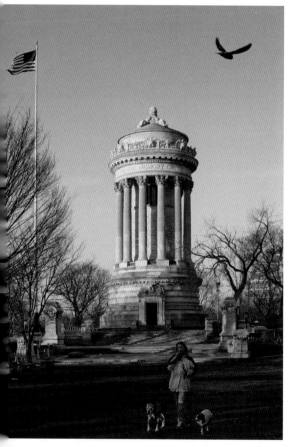

This classical memorial to those lost in the Civil War has a commanding presence both on Riverside Drive and as seen from Riverside Park below. The elements of the design—including a circular marble temple, a monumental flagpole on a bronze and marble base, and an expansive plaza paved in marble, granite, and slate—are laid out to take full advantage of a narrow site at the edge of the park. The gigantic flagpole is sited on axis with 89th Street, such that visitors arriving from that direction glimpse it from far away but are unaware of the larger monument until it unfolds dramatically at Riverside Drive. Steps leading from the flagpole and the terrace on the north side of the memorial are frequent routes down into the park for neighborhood residents.

The memorial itself, based on the ancient Choragic Monument of Lysicrates, a frequent model for Beaux-Arts designers, is surrounded by fluted columns, capped by handsome eagles, and inscribed "In Memoriam." Supplemental piers flanking the plaza south of the memorial are inscribed with the names of famous battles and commanders of the Civil War. The theme of war is extended into the paved plaza south of the memorial by the placement of several inert cannons facing toward the Hudson River.

114 Joan of Arc

ANNA VAUGHN HYATT (LATER HUNTINGTON), SCULPTOR;
JOHN V. VAN PELT, ARCHITECT, 1915; RESTORATION SPONSORED
BY THE ADOPT-A-MONUMENT PROGRAM, 1987
COLLECTION OF THE CITY OF NEW YORK; GIFT OF THE JOAN OF ARC
STATUE COMMITTEE

Riverside Drive at West 93rd Street

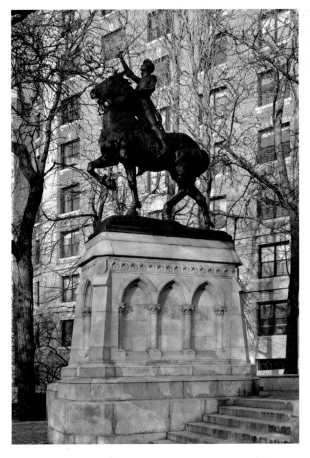

This striking equestrian statue, the first major public commission for the young Anna Hyatt, is situated at the east edge of Riverside Park where Riverside Drive is divided into express and local lanes. It is the southernmost of three sculptural compositions that face away from the residential streets to look out over the steep, west-facing slope of Riverside Park. Because there is no pathway leading from this small two-level plaza into the park below, the site is somewhat isolated and frequented primarily by dogwalkers. But the bronze statue itself is a handsome and forceful composition depicting Joan of Arc as an inspirational figure, firmly astride her mount with her sword raised and her eyes looking heavenward. Hyatt had received honorable mention for an earlier version of the subject at the Salon in Paris, prompting the New York Joan of Arc Committee to hire her for this commission. The bold granite base is strongly articulated with pointed Gothic arches that reinforce the details of Joan's medieval military dress, carefully researched by the sculptor. The arches frame panels of French limestone, said to have been recovered from the French prison in which Joan of Arc was incarcerated. This masterfully rendered equestrian statue is eloquent testimony to the lasting power of Joan of Arc's inspirational story.

115 Firemen's Memorial

ATTILIO PICCIRILLI, SCULPTOR; H. VAN BUREN MAGONIGLE, ARCHITECT, 1912; BRONZE BAS-RELIEF REPLICATED IN THE 1950s; MONUMENT RESTORED BY OTTAVINO STONE CORP, CHRISTINE ROUSSEL, AND POKORNY ASSOC. ARCHITECTS, 1992

COLLECTION OF THE CITY OF NEW YORK; GIFT OF THE FIREMEN'S MEMORIAL FUND COMMITTEE

Riverside Drive at West 100th Street

Of the three sculptural compositions facing into Riverside Park, the Firemen's Memorial illustrates the most successful integration of sculpture, landscape, and site planning, and it can be accessed both from the residential neighborhood to the east and from broad, processional steps leading up from the park to the west below.

The tomb-like memorial is designed to be seen primarily from the less populous park side, where a level plaza with benches has been carved out of the hillside. The large bronze bas-relief mounted on the granite sarcophagus depicts several horses pulling a fire engine to the scene of a conflagration. Two stone sculptural groups at the sides of the sarcophagus frame the composition. To the north, an allegorical figure of Sacrifice cradles the limp form of a dead fireman; to the south, the maternal form of Duty protects a young child. The faces of Sacrifice and Duty are said to resemble the visage of Audrey Munson, a famous model for numerous sculptures at the turn of the century. The horses necessary to propel early fire engines are referenced in the trough-like form of the central fountain and are poignantly memorialized in a bronze tablet sponsored by the ASPCA and set into the pavement close by the monument in 1927:

> THIS TABLET IS DEDICATED TO THE HORSES THAT
> SHARED IN VALOR AND DEVOTION AND WITH MIGHTY SPEED
> BORE TO THE RESCUE

The words on the east face of the sarcophagus (see below) gained even greater poignancy following the unprecedented toll of 343 firefighters at the collapse of the World Trade Center on September 11, 2001. The memorial continues to be the site of moving annual rites of commemoration by thousands of members of the fire department and the Mayor.

> TO THE MEN OF THE FIRE DEPARTMENT OF THE CITY OF
> NEW YORK WHO DIED AT THE CALL OF DUTY SOLDIERS IN A
> WAR THAT NEVER ENDS

116 **Franz Sigel**

KARL BITTER, SCULPTOR; WILLIAM WILLIS BOSWORTH,
ARCHITECT, 1907; CONSERVED BY THE CITYWIDE MONUMENTS CON-
SERVATION PROGRAM, 2004
COLLECTION OF THE CITY OF NEW YORK
Riverside Drive at West 106th Street

This statue of the prominent German-American journalist
and general who rallied support for Union forces during the
Civil War is the only equestrian statue by Karl Bitter. The
statue is seen to best effect from Riverside Drive below, as
the sculptor intended; steep steps lead the pedestrian down
to Riverside Park.

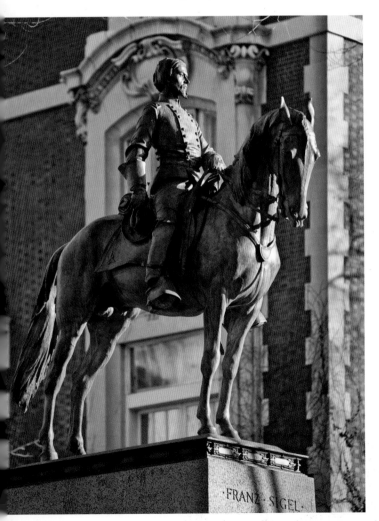

117 Straus Memorial

AUGUSTUS LUKEMAN, SCULPTOR; EVARTS TRACY, ARCHITECT,
1915; CONSERVED BY MODERN ART FOUNDRY, 1997
COLLECTION OF THE CITY OF NEW YORK; GIFT OF THE STRAUS MEMORIAL COMMITTEE
STRAUS PARK, RENOVATED AND EXPANDED, 1997
Broadway at 106th Street

Situated in the acute triangle named Straus Park where
West End Avenue and Broadway converge, the Straus
Memorial is a simple and understated tribute to Isidor and
Ida Straus, who perished in the sinking of the Titanic. The
devoted couple, whose wealth came from the establishment
of Macy's and Abraham and Straus department stores,
lived nearby at Broadway and 105th Street. They were
renowned for their generous philanthropy in the areas of
education and public health.

The memorial, buffered from the busy streets by low
fencing and trees underplanted with ivy, consists of a
low, central granite fountain presided over by a pensive,
recumbent female bronze representing Memory. Based
on the form of the model Audrey Munson, Memory leans
slightly over the fountain, almost dipping her naked toes
in the water. Handsome bronze grillwork in wave patterns
decorates the horizontal plane of the fountain drains, but
the water of the fountain was filled in with garden plantings
during the renovation of 1997.

Inscribed in gilded letters on a long, curved granite
bench at the south end of the site is a biblical quotation as
tribute to the Strauses' amiability and to the widely
reported story that Ida declined to enter a lifeboat if her
husband could not join her:

> LOVELY AND PLEASANT WERE THEY IN THEIR LIVES AND
> IN THEIR DEATH THEY WERE NOT DIVIDED. –II Samuel 1:23

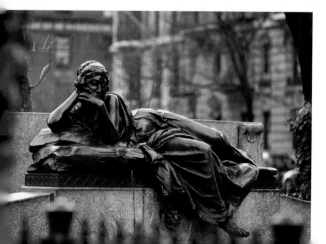

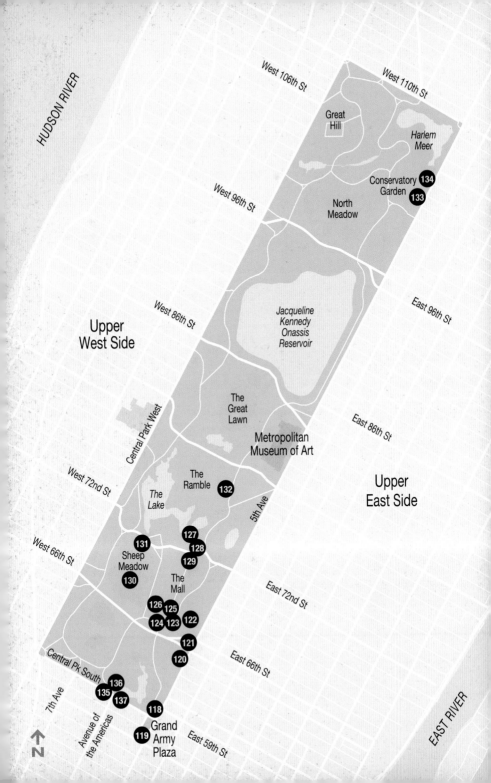

Central Park

Grand Army Plaza

PLAZA DESIGN, INCLUDING PULITZER FOUNTAIN, CARRÈRE & HASTINGS, 1913–16; RESTORATION AND FOUNTAIN RECONSTRUCTION, BUTTRICK WHITE & BURTIS, 1990

Grand Army Plaza stands at one of the most important urban crossroads of New York City. It marks the transition between the busy midtown Manhattan commercial district and the most heavily used entrance to Central Park for millions of New Yorkers and tourists. After years of changing plans in the nineteenth century, when various patrons sought to locate sculptures on the prominent site, the plaza gained its current form in 1916, when the statue of General Sherman was moved to its present location and the fountain was constructed to the competition-winning design of Carrère & Hastings.

The two semicircular islands of the plaza were originally strongly unified by a perimeter stone balustrade and two pairs of monumental columns; these features were lost in the 1930s. Additional erosion of the design concept was caused when the General Motors Building was set back over 100 feet from the otherwise consistent Fifth Avenue street face; part of this setback is now, happily,

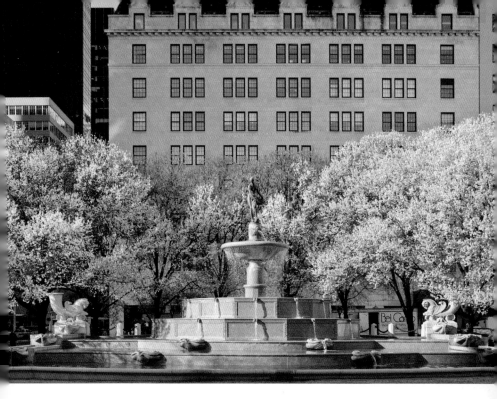

occupied by the glass cube marking the entrance to a subterranean Apple store. Despite these changes, Grand Army Plaza retains a tremendous sense of place due to the artistic strength of the Sherman equestrian statue, the visual appeal of the fountain, and the unifying sweep of large Callary pear trees that ring the north and south plazas and spring into bloom each April. The colorful plantings of annuals on both sides of 59th Street were designed for graphic punch when viewed from the tall buildings surrounding the site.

General William Tecumseh Sherman

AUGUSTUS SAINT-GAUDENS, ARTIST; PEDESTAL BY
CHARLES FOLLEN MCKIM, 1892–1903
COLLECTION OF THE CITY OF NEW YORK

North half of Grand Army Plaza, Fifth Avenue between 59th
and 60th Streets

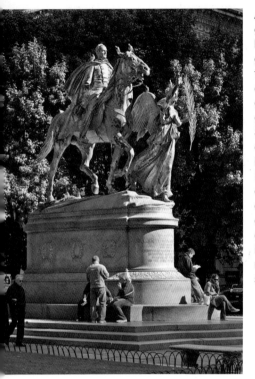

A masterpiece by one of America's greatest sculptors, the Sherman statue balances the grim determination of the general, the forceful gait of his horse, and the inspiring grace of the allegorical figure of Victory in front. Based on a bust of the general completed in 1888, the equestrian group took almost ten years to complete. Saint-Gaudens was assisted by, among others, his protégé, James Earl Fraser, later sculptor of the Theodore Roosevelt Memorial (109). The statue regained its original luster when it was regilded in the early 1990s based on newly discovered documentary evidence. Despite evident deterioration of the gilding and the incessant roosting of pigeons, the statue remains a powerful artistic and political statement. Its inscription reads:

> GRAND ARMY PLAZA SO NAMED IN HONOR
> OF AND TO PERPETUATE THE DEEDS OF
> THE GRAND ARMY OF THE REPUBLIC
> AND THE UNION FORCES THAT BROUGHT
> ABOUT THE REBIRTH OF THE NATION
> CONCEIVED IN LIBERTY.

On the north side of Grand Army Plaza, across 60th Street, is Doris Freedman Plaza, where changing temporary art installations are sponsored and curated by the Public Art Fund. The Public Art Fund has also sponsored temporary art projects throughout Central Park, such as the popular Whitney Biennial in 2002. These projects, as well as Christo and Jeanne-Claude's 2005 installation *The Gates*, continue to vitalize and interpret Central Park to an enthusiastic local and international audience.

119 Pomona

KARL BITTER, 1913–16

COLLECTION OF THE CITY OF NEW YORK

Top of the Pulitzer Fountain in the south half of Grand Army Plaza

The Pulitzer Fountain, flanked by allegorical stone carvings by Orazio Piccirilli, was originally built of French limestone, which was unable to withstand the harsh New York climate. In the 1980s restoration, the entire fountain, except for Piccirilli's figures, was replaced with more durable Deer Isle (Maine) granite in a light tone approximating the original limestone. The waters of the fountain now animate the plaza six months of the year; in the winter, evergreen trees with holiday lights decorate the tiered basins of the fountain. The statue of Pomona, or Abundance, is gracefully balanced atop the fountain. One story, probably apocryphal, claims that Cornelius Vanderbilt, whose mansion occupied the site of what is now the department store Bergdorf Goodman, was offended by the orientation of the statue's backside toward his bedroom.

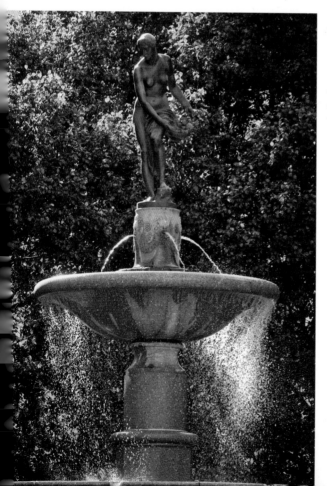

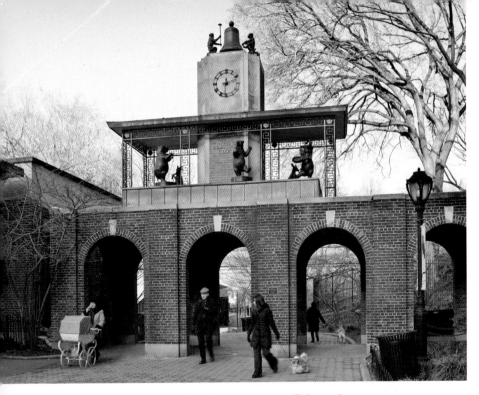

120 Delacorte Clock

**ANDREA SPADINI, 1964–65; RESTORED BY THE CENTRAL
PARK CONSERVANCY, 1995**
COLLECTION OF THE CITY OF NEW YORK

**North end of the Wildlife Conservation Center,
west of Fifth Avenue at 64th street**

The Delacorte Clock was commissioned to provide
some whimsy in this part of the park heavily frequented
by children. Building on the tradition of animated clocks
that have long enlivened European town centers, the
Delacorte Clock takes advantage of its location atop a
brick arcade astride one of the park's principal paths,
visible from both north and south. The bronze animals
wielding musical instruments, including a kangaroo with
French horn, a hippopotamus with violin, and a drumming
penguin, circle playfully every hour around the central
clock. Two monkeys with gongs strike the hours on a
bell above.

121 Tisch Children's Zoo Gates

PAUL MANSHIP, 1960–61; CONSERVED BY THE CENTRAL
PARK CONSERVANCY, 1992
COLLECTION OF THE CITY OF NEW YORK

The Children's Zoo, north of the Central Park Zoo

The carefree figure of Pan dances with two frolicking goats atop these delightful gates marking the entrance to the Children's Zoo. Manship has spanned the two entrance pathways between granite pylons with bronze arabesques of abstracted, winding foliage, accented with numerous birds and culminating with a boyish figure playing shepherds' pipes at either end. These exuberant bronzes express all the joyful abandon of childhood and are matched in quality by Manship's gates in memory of William Church Osborn at the entrance to the Ancient Playground at Fifth Avenue and 84th Street.

122 Balto

FREDERICK G. R. ROTH, 1925
COLLECTION OF THE CITY OF NEW YORK

East of Park Drive, near East 67th Street

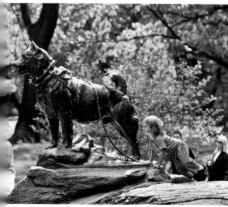

Renowned for leading a team of sled dogs in the delivery of medicine to the stranded people of Nome, Alaska, during an outbreak of deadly diphtheria, Balto is one of the most famous dogs in American history. Set in a well-traveled part of the park between the Central Park Zoo and the Mall, *Balto* has become a favorite destination for generations of children from New York City and beyond. Its popularity for climbing and petting is evident in the pattern of high polish on the otherwise darkly patinated surface of the bronze statue.

The Mall

Southeast corner of the park, extending from level of 66th Street to 72nd Street

As a landscape feature that serves as a major pedestrian pathway into Central Park and as a showcase for nineteenth-century American sculpture, the Mall serves a practical purpose. But it is the glorious spatial composition of the grove of majestic American elms that makes this a superlative work of landscape art. The two rows of trees flanking the Mall pathway are evenly spaced; the second rows out are somewhat less regular, and the spacing of the third row out from the middle is noticeably more random, thus making the transition from formal allée to informal forest plantings. The gracefully dancing branches arch overhead to create a cathedral-like space that is transformed by the variable light in different times of day and seasons of the year. That such a large grove of American Elms has survived the ravages of disease is due to its isolation in the middle of the city.

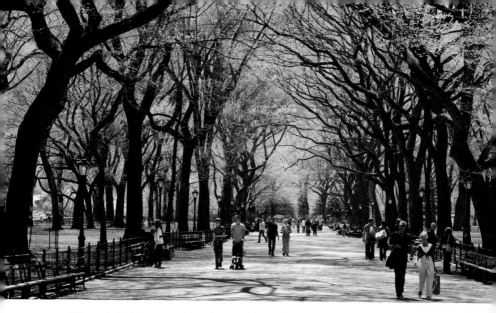

The Mall was designed to lead visitors north into the center of the park from near the principal entrance at the southeast corner. As originally planned, the visitor could reach the Mall by passing under the Park Drive through the Marble Arch, a feature demolished early in the twentieth century. Today, despite the necessity of crossing busy Park Drive at grade level, the visitor is transported back to another century as the spatial majesty of the Mall unfolds. The processional quality of the grove of trees is reinforced by the periodic placement of statues along the edge of the path, offering a framework for the nineteenth-century predilection to memorialize countless figures of literary and political accomplishment.

123 William Shakespeare

JOHN QUINCY ADAMS WARD, 1870

124 Christopher Columbus

JERONIMO SUNOL, 1892

COLLECTION OF THE CITY OF NEW YORK

South End of the Mall

Two statues of great men only indirectly connected with New York City flank the terminal plaza at the south end of the Mall. To the east, William Shakespeare stands gazing down, lost in creative thought. To the west, Christopher Columbus directs his eyes skyward; the globe beside him symbolizes how his discoveries changed the course of world history. Although the monuments to these two very different figures, one a man of action and one a man of intellect, were erected at separate times to commemorate the anniversaries of their birth, the two statues work well together, in part due to complementary tapered pedestals. Shakespeare's pedestal was designed by Jacob Wrey Mould, designer of Bethesda Terrace.

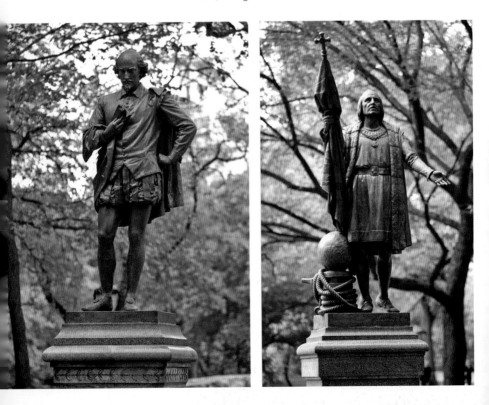

125 Robert Burns

SIR JOHN STEELL, CA. 1880, RESTORATION SPONSORED BY
THE ADOPT-A-MONUMENT PROGRAM
COLLECTION OF THE CITY OF NEW YORK

South End of the Mall

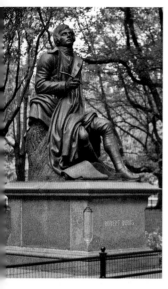

Another pair of sculptural portraits at the south end of the
Mall represent the Scottish poets Walter Scott and Robert
Burns, both created by Scottish artist Sir John Steell.
Scott, author of the novel Ivanhoe, is depicted with pen in
hand. Robert Burns, poet and composer of the words to
"Auld Lang Syne," looks dreamily upward with a scroll of
poetry at his feet.

126 The Indian Hunter

JOHN QUINCY ADAMS WARD, 1866
COLLECTION OF THE CITY OF NEW YORK

West of the south end of the Mall

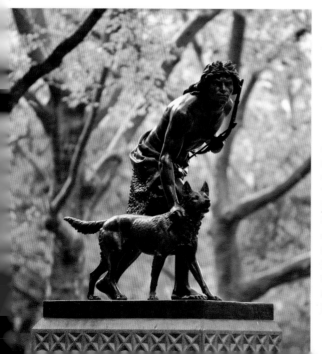

The Indian Hunter is a
masterpiece of naturalistic
American sculpture. The
Native American appears
poised and still at the
moment of spotting his
prey. This is the first statue
by an American artist
installed in Central Park.
J. Q. A. Ward was a prolific
sculptor of American
subjects; he also executed
the more stylized *Pilgrim*
just north of the 72nd
Street Transverse road. This
and all of the sculptures
shown on this page have
been maintained by the
Central Park Conservancy's
Sculpture Restoration
Program.

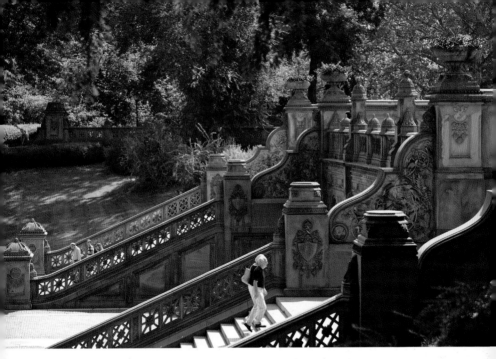

Bethesda Terrace

FREDERICK LAW OLMSTED, LANDSCAPE ARCHITECT, AND CALVERT VAUX, ARCHITECT;
JACOB WREY MOULD, ARCHITECT, 1862–64; RESTORED BY THE EHRENKRANTZ GROUP, ARCHITECTS;
PHILIP WINSLOW, LANDSCAPE ARCHITECT, 1984–86; AND THE CENTRAL PARK CONSERVANCY, 2007
North side of 72nd Street in the center of Central Park

Conceived by designers Olmsted and Vaux as the
urbane central plaza of Central Park, Bethesda
Terrace focuses on its handsome fountain. The
Terrace culminates the diagonal axis of the Mall,
which thrusts into the heart of the park. From the
upper level of the Terrrace, visitors can glimpse
the picturesque tower of the Castle on Vista Rock
in the distance above the forested Ramble.

127 The Angel of the Waters

EMMA STEBBINS, 1868

COLLECTION OF THE CITY OF NEW YORK

Top of Bethesda Fountain in the center of the lower Terrace

The Bethesda Fountain itself is a splendid centerpiece to the large open plaza. Emma Stebbins's bronze angel, the first important work commissioned from a female sculptor in the city, is a modestly successful piece well sited over the spray of fountain jets to evoke the legendary healing powers of the biblical waters of Bethesda. The strong architectural base and stone benches ringing the basin perimeter were designed by architect Jacob Wrey Mould to harmonize with the more organic forms of the carved Nova Scotia sandstone that ring the different levels of the open plaza. The gently sloped and curved pathways leading from 72nd Street to the fountain plaza embrace the landscaped hillsides like open arms, inviting visitors to linger on the sunlit lawns.

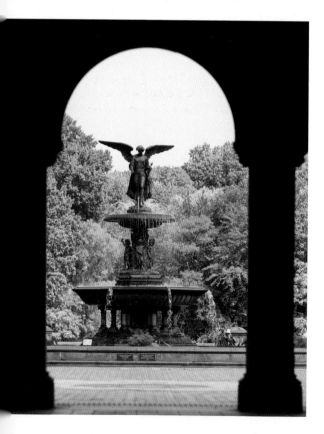

128 Stairway Stone Carvings

Because the 72nd Street Transverse is at grade level instead of sunken like other park east–west roads, the Terrace accomplishes Olmsted and Vaux's innovative separation of vehicular from pedestrian traffic with three spectacular stone staircases. The central stair south of 72nd Street allows visitors to pass under the transverse via an arcade, and the two stairs north of the transverse bring visitors from the road directly down to the terrace.

The twin stairs are flanked by superb sandstone carvings of flora and fauna. Both the ogee (double or reverse curve) shapes edging the upper run of steps and the balustrades running the full length of the stairs are ornamented with birds and flowers associated with—from east to west—spring, summer, fall, and winter, also representing the corresponding four seasons of man (childhood, youth, maturity, and old age) and the four times of day (dawn, morning, afternoon, and night). These delightfully rendered details deserve careful scrutiny: look for the witch and jack-o-lantern for fall and the ice skates and pine cones for winter.

In the arcade running under 72nd Street, Jacob Wrey Mould designed a highly unusual dropped ceiling of decorative Minton tiles mechanically fastened to cast-iron plates that are suspended from the structural beams below the roadway. The glossy finish and polychrome patterns of the tiles reflect and magnify the scant light of the subterranean passage. The openwork cast-iron beams between the tile panels were painted in bright colors and partially gilded, and the arched stone recesses along the walls were intended for decorative treatment with colorful polished stones. After a twenty-year hiatus in storage, the spectacular tile ceiling has been painstakingly restored to its original appearance in 2006–7 by the Central Park Conservancy, and the arcade is beautifully lit and open to the public once again.

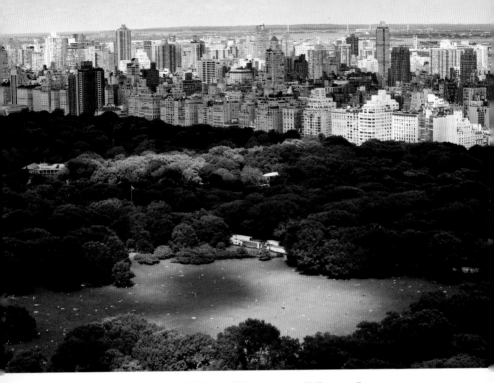

130 The Sheep Meadow

FREDERICK LAW OLMSTED AND CALVERT VAUX, 1864

As a work of landscape design, the Sheep Meadow succeeds in creating the illusion of an open, rolling meadow encircled by natural forests; sheep really did graze there in the early years of the park. Only in the twentieth century did the surrounding buildings reach such height and density that the vigorous growth of the city has overwhelmed the illusion. The startling juxtaposition of the lush green of the park with the warm and cool grays of the surrounding towers is a sublime thrill that peaks at the Sheep Meadow. The subtly rolling, English-style landscape crafted by Olmsted and Vaux attains a new level of visual excitement by the pressing in of the modern city.

131 The Falconer

GEORGE BLACKALL SIMONDS, 1871; RESTORED, 1982;
REPATINATED BY THE CENTRAL PARK CONSERVANCY, 1995
COLLECTION OF THE CITY OF NEW YORK

South side of 72nd Street west of Bethesda Terrace

When the condition, maintenance, and public safety of Central Park reached their nadir in the 1970s, *The Falconer* on the south side of the 72nd Street Transverse road was overgrown to the point of vanishing from view. The restoration of a missing arm and the falcon itself, cleaning and repatination of the statue, and clearing away of the brush surrounding it in the early 1980s signaled the revitalization of Central Park and the careful stewardship of the newly formed Central Park Conservancy. The original placement of the statue on a rock outcropping gives its silhouette prominence, drawing attention to the idealized subject.

132 Still Hunt

EDWARD KEMEYS, 1881–83; RESTORATION SPONSORED BY THE
ADOPT-A-MONUMENT PROGRAM
COLLECTION OF THE CITY OF NEW YORK

Park Drive East at 78th Street

Many a jogger or biker has done a double take upon passing the rock outcropping near the top of the hill of East Drive near 78th Street. The bronze panther crouching on top of the rock looks poised to pounce on the next person streaking by. It is a graphic reminder of the kind of animal that once roamed Manhattan, even if such wildlife was becoming extinct throughout the Northeast at the time this statue was cast. The wild panther, modeled in a somewhat stylized way, can be viewed as an ironic comment on the nature of nature in the city: "natural" Central Park is, in fact, largely man-made.

The Conservatory Garden

West side of Fifth Avenue at 105th Street

As a formal design with clipped hedges, axial walk-ways, and apsidal ends, the Conservatory Garden is an anomaly on the edge of informally landscaped Central Park. It was designed in the 1930s by Betty Sprout on the site of a former glass conservatory or greenhouse. It now comprises three sections of beautifully maintained formal gardens: an informal, English-style perennial garden in the south; a more formal French garden in the north with changing seasonal displays; and a lush central lawn leading up to tiered pergolas at the west end. Each of the three sections is focused on a fountain, two with formal sculpture.

Burnett Memorial Fountain

BESSIE POTTER VONNOH, 1936; CONSERVED BY THE CENTRAL
PARK CONSERVANCY, 1994
COLLECTION OF THE CITY OF NEW YORK

South end of the Conservatory Garden

In the English-style garden at the south end of the
composition, the shady fountain surrounded by hedges
and ornamental trees is dedicated to Frances Hodgson
Burnett, author of the beloved children's book *The Secret
Garden*. Recalling characters from her book, the boy,
reclining on a rock, plays a flute, and the girl holds aloft
a dish as a birdbath. The local birds are attracted to the
birdbath, and children are drawn equally to the birds and
the picturesque lilies in the pond of the fountain. The
statue was restored in the early 1980s at the same time
the garden itself was revitalized under the guidance of the
Central Park Conservancy and Lynden B. Miller.

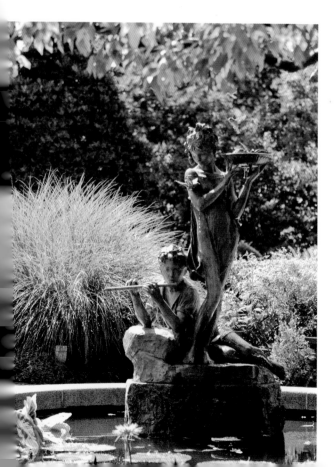

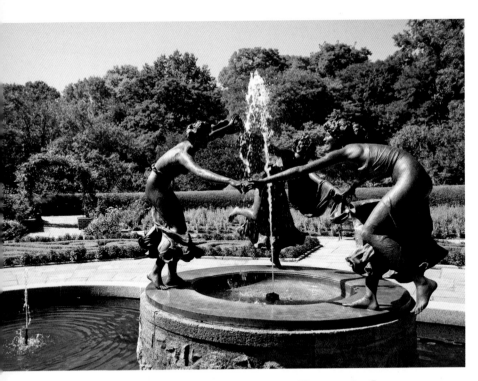

134 Untermyer Fountain

WALTER SCHOTT, CA. 1910; INSTALLED ON THIS SITE 1947;
CONSERVED BY THE CENTRAL PARK CONSERVANCY, 1993
COLLECTION OF THE CITY OF NEW YORK

North end of the Conservatory Garden

Dancing with sheer joy around the central water spout of
the fountain, the graceful bronze girls of the Untermyer
Fountain impart the carefree vitality of youth and friendship.
The fountain is surrounded by an oval of colorful seasonal
plantings of tulips in the spring, roses and annuals in the
summer, and chrysanthemums in the fall.

Bolívar Plaza

CLARK & RAPUANO, LANDSCAPE ARCHITECTS
Central Park South (59th Street) at Avenue of the Americas

Three equestrian statues at this entrance to the park from Avenue of the Americas (Sixth Avenue) represent South American liberators. The statues were placed under the direction of Robert Moses in the 1950s. Although the large scale and great height of all three statues perhaps justified their wide spacing, it is perplexing that they are so far apart and that the central statue isn't sited on the centerline of Sixth Avenue, which is marked instead by a flagpole. The resulting "plaza," bisected by a curving entry drive to the park, lacks any obvious dynamic spatial composition. Nevertheless, the looming equestrian statues, the outer two of which are on extremely high pedestals, are related by artistry and historical association.

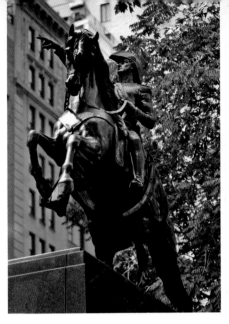
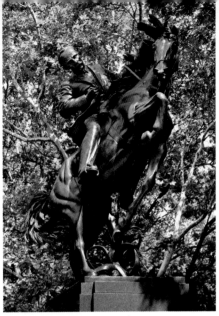

135 José de San Martín

LOUIS JOSEPH DAUMAS, CA. 1950

COLLECTION OF THE CITY OF NEW YORK

North side of Central Park South, west side of Sixth Avenue entry to park

Donated by the citizens of Argentina, the statue of José de San Martín is remarkable for the balancing of horse and rider on the hind legs of the rearing horse. San Martín's Napoleon-style hat gives him a dashing and commanding air. The three sculptures shown have all been maintained by the Central Park Conservancy.

136 José Martí

ANNA VAUGHN HYATT HUNTINGTON, 1959; RESTORATION SPONSORED BY THE ADOPT-A-MONUMENT PROGRAM

COLLECTION OF THE CITY OF NEW YORK

North side of Central Park South, north of Sixth Avenue entry to park

This statue in the middle of the ensemble is the most dynamic. It portrays Martí, a champion for the liberation of Cuba, as he fights to stay astride his horse after being shot in the heat of a battle for independence. The asymmetrical placement of his body, which leans to one side, is striking.

137 Simón Bolívar

SALLY JAMES FARNHAM, 1919; RESTORATION SPONSORED BY THE ADOPT-A-MONUMENT PROGRAM, 1988
COLLECTION OF THE CITY OF NEW YORK

North side of Central Park South, east of Sixth Avenue entry to park

This accomplished and evocative portrait of the liberator of Venezuela, Colombia, Ecuador, Peru, and Bolivia was moved here from a site near West 83rd Street when this plaza was created. One of Farnham's best known works, it ably depicts the hero Bolívar's firm leadership and distinguished character.

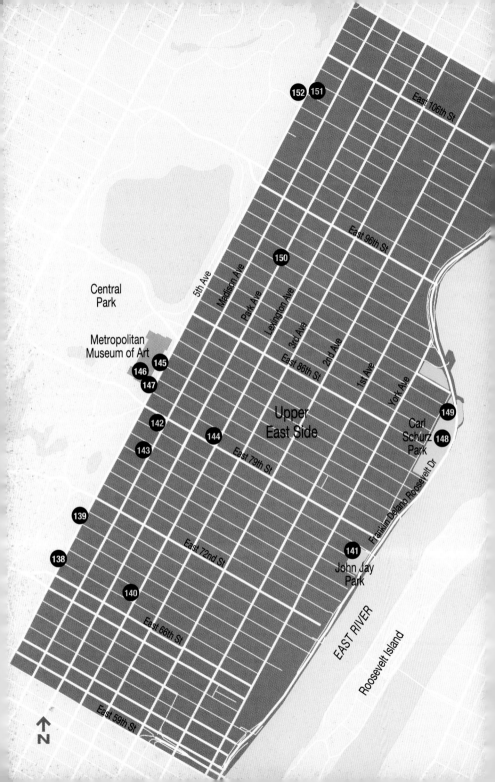

Upper
East Side

138 107th United States Infantry Memorial

KARL ILAVA, SCULPTOR; ROGERS AND HANEMAN,
ARCHITECTS, 1926–27

COLLECTION OF THE CITY OF NEW YORK, GIFT OF THE 7TH-107TH
MEMORIAL COMMITTEE

West side of Fifth Avenue at 67th Street

As the southernmost of the memorials facing Fifth Avenue
along the perimeter wall of Central Park, the 107th Infantry
Memorial is arresting in its immediacy and realism. Based
upon the sculptor's personal experience of World War I,
the sculptural group depicts infantrymen in the heat of
battle. The three soldiers in the middle of the composition
move intently forward on the attack with raised bayonettes,
while their comrades off to the side support wounded
soldiers. The memorial eloquently presents the bravery and
camaraderie, but also the suffering and loss, of war. The
monument is especially powerful given its location along
busy Fifth Avenue. Karl Ilava's name is carved in the top
right side of the granite base. The statue was beautifully
repatinated by the Central Park Conservancy in 1994.

139 Richard Morris Hunt Memorial

DANIEL CHESTER FRENCH, SCULPTOR; EXEDRA BY BRUCE PRICE,
ARCHITECT, 1896–1901; RESTORATION SPONSORED BY THE
ADOPT-A-MONUMENT PROGRAM, 1998

COLLECTION OF THE CITY OF NEW YORK; GIFT BY PUBLIC SUBSCRIPTION UNDER
THE AEGIS OF THE MUNICIPAL ART SOCIETY

Fifth Avenue at 70th Street

First President of the Municipal Art Society, accomplished
architect, mentor of designers, third President of the
American Institute of Architects, and inveterate supporter
of "the cause of art in America," Richard Morris Hunt is a
highly deserving subject for this graceful and handsome
composition. It is perhaps the most successful of the
many monuments in the perimeter wall of Central
Park along Fifth Avenue, establishing a sense of place
through the use of the curved exedra while maintaining
transparency of the view into Central Park. Although
aligned with the principal pediment of the stately Frick
Museum across Fifth Avenue, the monument was
intended to complement the Lenox Library, one of Hunt's
notable designs, that was replaced by the Frick building.
Bronze allegorical figures of Painting and Sculpture on the
left end and Architecture on the right end of the exedra
frame the dynamic bust of Hunt by Daniel Chester French.
An impressive list of the art societies in New York at
that time, all of which Hunt nurtured, is engraved on the
panels of the exedra wall. They include the Municipal Art

Society, the Metropolitan
Museum of Art, the
Architectural League, the
National Sculpture Society,
the National Academy
of Design, the Century
Association, the American
Water Color Society, and
the American Institute of
Architects. Listed names
that have morphed into
other organizations include
the Society of American
Artists, the Artist Artisans of
New York, and the Society
of Beaux Arts Architects.

140 Tau

TONY SMITH, 1965, INSTALLED ON THIS SITE IN 1980
COLLECTION OF THE CITY OF NEW YORK

Hunter College, southwest corner of Lexington Avenue and 68th Street

Located on a busy corner that serves as the entry plaza to Hunter College and that features a large recessed stair into the subway, this work by Tony Smith is a looming presence on the sidewalk. Smith served as a professor of art at Hunter College from 1962 to 1980. This large abstract sculpture was installed in Smith's honor after his death. The black painted metal surface and the boxy horizontal elements that overhang the sloped base just above average human height render the sculpture oppressive on this north-facing site. However, Smith's piece is of a period with many of the large concrete buildings that typify the Hunter College campus.

141 Kryeti-Aekyad #2 and Eaphae-Aekyad #2

DOUGLAS ABDELL, 1979
COLLECTION OF THE CITY OF NEW YORK

Cherokee Place between 76th and 77th Streets, John Jay Park

Located next to John Jay Park, these sculptures animate the pedestrian walkway that links 76th and 77th Streets. Because they are oriented parallel to the direction of pedestrian travel, the zig-zag form of the sculptures is hard to discern until one is directly upon them; but bench seating along the path allows the passerby to pause to appreciate the spirited artwork.

142 **Sidewalk**

ALEXANDER CALDER, 1970; RESTORED 2002

COMMISSIONED BY PERLS GALLERIES, GRAHAM GALLERY, AND MORTON ROSENFELD

1014–1018 Madison Avenue

In this neighborhood of boutique galleries and prestigious museums, it is delightful to find an exuberant work of art by a major artist set into the public sidewalk. Calder agreed to provide the sidewalk design at no charge for his longtime dealer Klaus Perls when he and two adjacent gallery owners collaborated to fund replacement of the deteriorated sidewalk. Calder's design in black and white marble terrazzo and zinc strips is articulated with different geometric patterns for each of the three properties: to the south, a patchwork of parallel lines; in the middle, a grid of crescent half circles; to the north, a sunburst of radiating lines. The complete design, working its way around tree pits and fire hydrants, is clearly an integrated whole, and it is signed with the initials "CA" and the date "70."

CARLYLE GALLERIES

143 **Venus and Manhattan**

WHEELER WILLIAMS, CA. 1945

980 Madison Avenue

Floating gracefully above the bustle of well-heeled
shoppers on Madison Avenue, these larger-than-life-size
semi-nude aluminum figures have been a neighborhood
landmark for over fifty years. Modeled in heroic Art Deco
style, well-endowed Venus hovers over the reclining,
manly figure of Manhattan. The stylized yet ethereal
composition of the allegorical figures is a successful
counterpoint to the suave and minimally articulated lime-
stone building at 980 Madison Avenue, formerly home
of the prestigious Parke-Bernet Galleries. Because the
sculptures were determined to project 18 inches into
the public domain over the sidewalk, the owner of the
building pays an annual fee to the city's Department
of Transportation.

144 El Gato

900 Park Avenue

Although it is located in front of a private residential tower at the northwest corner of Park Avenue and 79th Street, Botero's *El Gato*, or The Cat, commands attention. The small, curved driveway in front of the building sets the statue off from the front entrance and gives it a presence on this important corner at the heart of the Upper East Side. The stolid form of the cat, both cartoonishly corpulent and unnaturally stiff, is oddly alluring. Although known primarily as a painter, Colombian artist Botero undertook sculptural commissions for public spaces after moving to Paris in 1973. A twin of this sculpture can be seen at the Rambla del Raval in Barcelona.

145 Metropolitan Museum of Art, East Façade and Front Steps

RICHARD MORRIS HUNT, 1894–95; RICHARD HOWLAND HUNT
AND GEORGE B. POST, 1895–1902; SCULPTURES BY KARL BITTER,
1899; WINGS BY MCKIM MEAD & WHITE, 1904–26; STEPS BY
KEVIN ROCHE JOHN DINKELOO ASSOCIATES, 1970

Fifth Avenue at 82nd Street

The fact that this grand and heroically scaled façade
appears to be a unified design built all at once is a
testament to the skill of the many architects who
worked on it during a span of over eighty years. The
central section was designed by Richard Morris Hunt
in 1894–95, but it was completed at the turn of the
century by his son Richard Howland Hunt and George
B. Post. In 1899, the caryatid figures carved by Karl
Bitter, representing Painting, Sculpture, Architecture, and
Music, were installed at the attic level; several additional
locations intended for sculpture were never completed,
as is still evident today. The long, harmoniously detailed
wings were designed by McKim Mead & White starting
in 1904. Surprisingly, the magnificent steps that lead
up to the principal entrance were designed in the late
1960s by Kevin Roche John Dinkeloo Associates. Rising
to the entrance doors from three directions, they are a
triumph of the grand gesture at an urban scale, not only
welcoming thousands of daily museum visitors but also
serving as a giant, convex amphitheatre for the hundreds
of casual tourists who linger in the afternoon sun. The
steps are also a terrific backdrop for photographers
stalking the formally clad guests who arrive for museum
openings and fund-raising parties.

146 Unidentified Object

ISAMU NOGUCHI, 1979
COLLECTION OF THE METROPOLITAN MUSEUM OF ART
Fifth Avenue at 80th Street

That this enigmatic basalt monolith is set subtly amid the shrubbery just south of the Metropolitan Museum is fitting for the work of Noguchi, a sculptor fascinated by the relationship of art to nature. The monumental stone in warm, earthy tones of brown is articulated by concave recesses carved and tooled by the artist as well as by the natural surface irregularities and textures. It is this fusion of the natural and the man-made that gives Noguchi's sculptures their enigmatic allure.

147 Roof Sculpture Garden Balloon Dog (Yellow) and Sacred Heart (Red/Gold)

© **JEFF KOONS, 1994–2007**
THE STEVEN AND ALEXANDRA COHEN COLLECTION [BOTH]
Metropolitan Museum of Art, temporary installation, 2008

The Iris and B. Gerald Cantor Roof Garden is simply the best roof garden in New York for viewing seasonal shows of outdoor sculpture. Silhouetted against the backdrop of the incom-parable city skyline that rings Central Park, the small terrace hosts temporary shows of contemporary art from May through October. Other featured artists have included Andy Goldsworthy, Cai Guo-Qiang, Joel Shapiro, and Frank Stella. With a small café and scattered bench seating, the terrace offers an exquisite respite from museum burnout.

148 **Peter Pan**

CHARLES ANDREW HAFNER, 1928
COLLECTION OF THE CITY OF NEW YORK

Carl Shurz Park, East End Avenue at 87th Street

The sentimental depiction of one of the most popular
characters of children's literature serves as the
centerpiece of an attractive cul-de-sac glimpsed beyond
a Robert Moses–era bridge on axis with the east end
of 87th Street. Relocated from its original setting in a
fountain at the Paramount Theater near Times Square,
the statue has been raised within a colorful planting
bed in the center of a small plaza. Although it is sunken
below the level of the surrounding park, the plaza, ringed
by rock outcroppings, a fieldstone retaining wall, and
benches, forms a very pleasant place to linger in the
warm months. Peter Pan, clothed in his signature cap
and carrying a horn, looks down wistfully to where
the waters of the fountain used to be.

Temporary Sculpture

Gracie Mansion, East End Avenue at 89th Street

Gracie Mansion was built by Archibald Gracie, a prosperous shipping merchant, as a summer home for his family in 1799. Alexander Hamilton, Joseph Bonaparte, and Washington Irving were all visitors to Gracie's house. During construction of the Franklin Delano Roosevelt Drive, Parks Commissioner Robert Moses persuaded city officials to designate Gracie Mansion as the official residence of the Mayor of the City of New York. Since 1942, nine mayors have made Gracie Mansion their home. The house and grounds were comprehensively renovated in 2002.

On a stunning site overlooking the East River near Hell Gate that connects the river to Long Island Sound, Gracie Mansion hosts thousands of New Yorkers every year for public and private receptions. The Koch administration instituted a program of outdoor sculpture installation in the 1980s, and the Bloomberg administration developed the tradition, enhancing as well the landscape plantings. Although a tent is often deployed on the main north lawn, there is ample room for temporary sculpture installations around the perimeter of the site.

Pieces from the Museum of Modern Art were installed here during reconstruction of the museum in 2003–4. In 2007, several works of art on loan from the permanent collection of the Noguchi Museum in Long Island City were displayed on the lawn. The striking, columnar *Helix of the Endless* (1985), Noguchi's response in stone to Brancusi's iconic, metal *Endless Column* (1938), is one of the artist's last works. The subtly torqued shape of these works has inspired architects and engineers in recent years to propose similar profiles for new skyscrapers around the world.

150 **Night Presence IV**

LOUISE NEVELSON, 1973
COLLECTION OF THE CITY OF NEW YORK; GIFT OF THE ARTIST
Park Avenue at 92nd Street

As a looming abstraction in the dark color of oxidized weathering steel, Louise Nevelson's monumental sculpture can be a somber presence on the crest of a hill in the middle of Park Avenue. When animated by the warm afternoon light, however, the oscillating verticals and rounded forms suggestive of animated objects create a dynamic tableau. The artist donated this piece to New York in 1973 to commemorate her fifty years of creative life in the city.

151 **Dr. J. Marion Sims**

FERDINAND VON MILLER II,1892; BASE BY AYMAR EMBURY, CA. 1934
COLLECTION OF THE CITY OF NEW YORK
Fifth Avenue at 103rd Street

Although largely unheralded by the general public today, Dr. Sims was an innovative and charismatic leader of the medical profession in the nineteenth century. He was a pioneer in the understudied area of women's health, founding the Women's Hospital of New York and making strides in the practice of gynecology. Relocated from its original setting near the old reservoir on 42nd Street, his stately figure now stands opposite the quirkily ornamented, Byzantine-style building of the New York Academy of Medicine designed in 1926 by York and Sawyer, architects. The handsome, three-part granite base, incised with commemorative information, sets off the earnest figure of the doctor very well. The statue was conserved by the Central Park Conservancy in 1993.

152 **Alexander Hamilton and DeWitt Clinton**

ADOLPH WEINMAN, 1940

The Museum of the City of New York, Fifth Avenue at 103rd Street

This pair of sculptures stands in two marble niches that frame the ends of the principal façade of the Museum of the City of New York. Representing two major figures in the history of New York, Hamilton a founding father and first secretary of the United States Treasury, and Clinton the mayor of New York City and governor of New York State, the statues provide stately grandeur to the front of the museum, an appropriate Neoclassical touch. Instead of the usual bronze, they were cast in nickel silver, a novel material at the time, which gave the sculptures a cooler hue. But today, their oxidized finish is hard to distinguish from the more common statuary bronze. The museum owns plaster models for both statues.

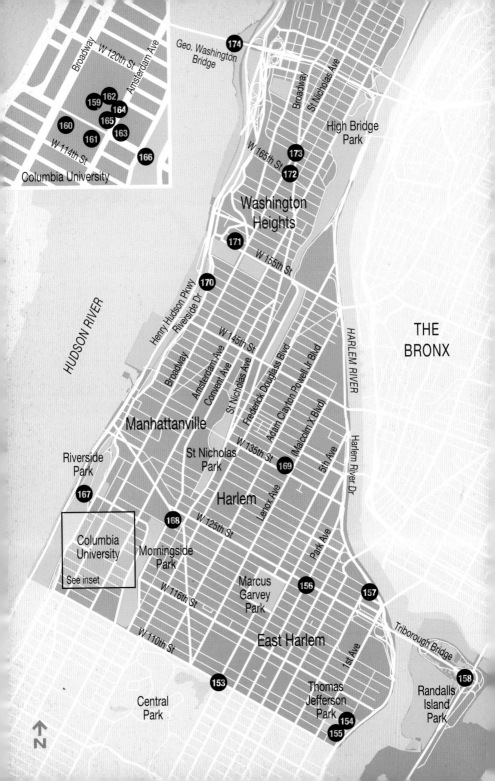

7

Upper
Manhattan

153 Duke Ellington Memorial

ROBERT GRAHAM, 1997

COLLECTION OF THE CITY OF NEW YORK, GIFT OF THE DUKE ELLINGTON
MEMORIAL FUND

**Duke Ellington Circle, formerly Frawley Circle, Fifth Avenue
and 110th Street**

As the first memorial in New York City dedicated to an
African American artist, this monumentally scaled piece
in darkly patinated bronze marks the northeast corner
of Central Park and serves as an unofficial gateway
to Harlem. Fundraising and approvals for the project
were spearheaded by the popular New York pianist and
singer Bobby Short. Although Graham, an experienced
public artist, may have intended to emphasize Ellington's
prominence by placing his figure with a grand piano
at great height, the elongated proportions of the piece
render the celebrated subject hard to see. The use of
nude female caryatids, representing the nine muses, to
support the platform on
which the remote figure of
Ellington stands also seems
an odd choice in this day
of heightened cultural
sensitivity. Nevertheless,
this singular monument
honors a great New Yorker.

Both halves of the
traffic circle on which the
work stands are rendered
with steps to form an
informal amphitheater.
But because heavy traffic
streams down Fifth Avenue,
bisecting the site, the
amphitheater does not
function in the usual sense.
On the day of the New York
City Marathon, however, a
band plays on the east half
of the amphitheater, and
spectators fill the west side
overlooking the runners'
route. At moments like
this, Duke Ellington Circle
springs to life.

154 El Arbol de Esperanza (Tree of Hope)

BROWER HATCHER, 1995

COLLECTION OF THE CITY OF NEW YORK, SPONSORED BY THE PERCENT FOR ART PROGRAM OF THE DEPARTMENT OF CULTURAL AFFAIRS

Thomas Jefferson Park, 2180 First Avenue

Tree of Hope stands near the northeast corner of the park, close to the Franklin Delano Roosevelt Drive. The sculpture consists of a large, openwork wire sphere on top of a tapered, trunk-like base covered by a skin of carefully fitted diamond-shaped stainless steel panels. The open wire sphere is filled with bronze facsimiles of everyday objects created by local schoolchildren. The tree presents a simple form with intriguing complexity of detail that fires the imagination.

155 Tomorrow's Wind

MELVIN EDWARDS, 1995

COLLECTION OF THE CITY OF NEW YORK, SPONSORED BY THE PERCENT FOR ART PROGRAM OF THE DEPARTMENT OF CULTURAL AFFAIRS

Thomas Jefferson Park, 2180 First Avenue

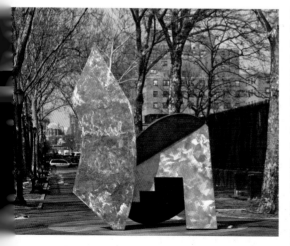

Mel Edwards's handsome stainless steel abstraction stands at the crossroads of two major paths near the southeast corner of the park. Seen from a distance and framed by rows of tall sycamores in all four directions, *Tomorrow's Wind* defines the space it fills with élan. Composed of three planes—one a circle, one angular, and one gently curved—and supported on three points, the piece compels the visitor to move all around it, seeking the best vantage point. The carefully worked surfaces reflect the light even on a dull day. Looking back toward First Avenue, one gets a unique and fabulous view directly up 112th Street on axis with the apse of St. John the Divine, far away on a rise to the west.

156 Harlem Encore

TERRY ADKINS, 1999
COMMISSIONED BY THE METROPOLITAN TRANSPORTATION AUTHORITY'S ARTS
FOR TRANSIT PROGRAM

Metro North Railroad overpass, Park Ave at 125th Street

This large-scale installation of cut aluminum panels set
against a vibrant blue background is visible from blocks
away on 125th Street, especially when enhanced by
the blue glow of nighttime lighting. With representations
of timeless images such as sphinxes and rising suns,
the panels evoke the African heritage of many of Harlem's
residents while recalling the stately classicism and
balance of architectural friezes. The panel facing east also
incorporates imagery of New York City's skyscrapers.

157 Crack Is Wack

**KEITH HARING, 1986; RESTORATION BY GOTHAM SCENIC
SPONSORED BY THE KEITH HARING FOUNDATION, 2007**
COLLECTION OF THE CITY OF NEW YORK, © ESTATE OF KEITH HARING

Crack Is Wack Playground, Second Avenue at 126th Street

Keith Haring's exuberant style and graffiti-based figuration
found expression in the gritty streets and subways of
New York. This mural, begun as spontaneous graffiti but
completed with the blessing of the parks commissioner
who condoned the message, was inspired by Haring's
horror at the ravages of the crack epidemic in the
neighborhood. The colorful mural perfectly illustrates the
fusion of street culture, creative energy, and urban decay
that energizes Haring's art, combining the frenzied, outlined
figures emblematic of his vision with a large-scale "Crack
Is Wack" warning message. ("Wack" means dangerous.)
A snake, seemingly representing the evil of addiction, slithers
across the top of the mural in pursuit of a fleeing figure.

Although it is located on the edge of Harlem next
to the Harlem River Drive and near the access ramp to
the Triborough Bridge, the mural's survival and recent
restoration is a testament to the lasting impact of Haring's
art and serves as a reminder of his numerous philanthropic
efforts on behalf of children's art education, neighborhood
revitalization, and AIDS research. Another colorful, large-
scale mural by Keith Haring (040) is illustrated in chapter 3.

The Discus Thrower

KOSTAS DIMITRIADIS, ARTIST, 1926; RESTORATION BY THE
MODERN ART FOUNDRY, SPONSORED BY BLOOMBERG NEWS, 1999
COLLECTION OF THE CITY OF NEW YORK

**Triangle at entry road from the Triborough Bridge,
Randall's Island**

This classically inspired and beautifully restored modeling
of a discus thrower has a peripatetic history. First exhibited
at the 1924 Olympics in France, it was erected in Central

Park behind the Metropolitan
Museum in 1926. After the
Municipal Stadium (renamed
Downing Stadium in 1955)
was built on Randall's Island
under the direction of Robert
Moses, the statue was
installed there in 1936, the
same year that Jesse Owens
won the Olympic trials in the
100-yard dash there. Having
suffered severe vandalism,
the statue was stored for a
while before its restoration
sponsored by Michael
Bloomberg's company
before he became mayor;
the restoration included
replacement of a missing
arm and the statue's private
parts. Because Downing
Stadium was replaced by
the new Icahn Stadium,
the statue now marks the
vehicular entry to Randall's
Island from the Manhattan
side of the Triborough
Bridge. It is a handsome and
entirely fitting symbol of the
growth of municipal sports
programs made possible
by the revitalization of the
island under the aegis of
the Randall's Island Sports
Foundation.

THE
DISCUS
THROWER

Columbia University

Between Broadway and Amsterdam Avenues at 116th Street

This magnificent, classically inspired campus, designed by renowned architects McKim, Mead & White under the guidance of university president Seth Low, was dedicated in 1897. The Italianate red brick buildings with limestone trim and copper roofs are organized around a huge, open quadrangle on two levels, with smaller landscaped courts tucked in around the perimeter. Subsequent additions and renovations in a variety of styles have generally succeeded in maintaining the visual unity of the campus.

159 Alma Mater

DANIEL CHESTER FRENCH, 1903
COLLECTION OF COLUMBIA UNIVERSITY IN THE CITY OF NEW YORK, GIFT OF
MRS. ROBERT GOELET JR., IN MEMORY OF ROBERT GOELET, CLASS OF 1860

Center of the grand steps leading from the main cross axis of the Columbia University campus up to the Low Memorial Library

Strikingly situated, *Alma Mater* serves as a focal point and potent symbol for the university community. Her arms raised in a gesture at once welcoming and protective, Alma Mater appears to be both matronly and inspiring. She is clothed in the classical robes of academia, balancing a heavy tome on her lap and harboring an owl, symbol of wisdom, in the folds of her gown. Despite her traditional appearance, she has served as a rallying point for students bent on political protest, and she appears to enjoy the company of the hordes of students who lounge on the steps on sunny days.

160 Thomas Jefferson

WILLIAM ORDWAY PARTRIDGE, 1914

COLLECTION OF COLUMBIA UNIVERSITY IN THE CITY OF NEW YORK, GIFT OF
THE ESTATE OF JOSEPH PULITZER

Front entrance, School of Journalism

This engaging portrait was donated by the estate
of newspaper magnate Joseph Pulitzer and by public
subscription. It appears to be a good likeness of
the Jefferson we know from contemporary portraits:
lost in thought, he exemplifies the simple elegance
and refinement of an eighteenth-century gentleman of
learning. His casual stance and introspective demeanor
speak eloquently of his intellectual stature and leadership.

161 Alexander Hamilton

WILLIAM ORDWAY PARTRIDGE, 1908

COLLECTION OF COLUMBIA UNIVERSITY IN THE CITY OF NEW YORK, GIFT OF
THE ASSOCIATION OF THE ALUMNI OF COLUMBIA COLLEGE

Front of Hamilton Hall

By way of contrast with the statue of Jefferson, this
portrait of Alexander Hamilton, completed years earlier
than the Jefferson, presents a more self-conscious figure
engaged in making a public speech. With his formal
oratorical pose and dressy frock coat, Hamilton appears
almost priggish. This slightly abstracted portrait depicts
the great statesman at a considerable psychological
remove from the common man.

162 **The Thinker**

AUGUSTE RODIN, MODELED IN 1880, CAST IN 1930

COLLECTION OF COLUMBIA UNIVERSITY IN THE CITY OF NEW YORK, PURCHASE, 1930

In front of the Philosophy Hall

Even though this oft-reproduced sculpture is one of the most famous images of art in the Western world, it continues to fascinate viewers with its depiction of a man focused in profound thought. Originally conceived by Rodin as a small figure of Dante for display in Paris, later iterations of the sculpture were perceived to represent the thoughtful common laborer. Whether the figure is a gifted creative artist or simply a meditative "everyman" is open to interpretation, but the placement of the statue in front of the Philosophy Hall presents students a subject for infinite debate and perpetual inspiration.

163 **Bellerophon Taming Pegasus**

JACQUES LIPCHITZ, 1966–73

COLLECTION OF COLUMBIA UNIVERSITY IN THE CITY OF NEW YORK, GIFT OF
THE ALUMNI TO THE LAW SCHOOL, 1977

**On the west façade of Jerome Greene Hall, Columbia
Law School**

An allegory of man's ability to subject nature, both his own
and that of wild beasts, to his intellectual will, Lipchitz's
huge bronze sculpture was commissioned specifically for
the Law School. The abstracted yet voluptuous forms of
struggling horse and determined human conqueror create
a lively, larger-than-life-size frontispiece that animates the
geometrical uniformity of the concrete mullions of the
modernist building behind. Although it can be seen at
street level from Amsterdam Avenue at 116th Street, the
sculpture is best appreciated from the pedestrian bridge
known as Charles H. Revson Plaza that connects the third
floor of the Law School to the main campus.

164 Three-Way Piece: Points

HENRY MOORE, 1967

COLLECTION OF COLUMBIA UNIVERSITY IN THE CITY OF NEW YORK, GIFT OF
THE MIRIAM AND IRA D. WALLACH FOUNDATION TO THE COLUMBIA LAW SCHOOL,
REPRODUCED BY PERMISSION OF THE HENRY MOORE FOUNDATION

165 Tightrope Walker

KEES VERKADE, 1979

COLLECTION OF COLUMBIA UNIVERSITY IN THE CITY OF NEW YORK, GIFT OF
FRIENDS OF GENERAL WILLIAM B. DONOVAN

Charles H. Revson Plaza

Several sculptures enliven this pedestrian overpass between the main campus and the graduate schools to the east of Amsterdam Avenue. Henry Moore's abstract bronze piece sits on three points of support. The rounded organic forms suggest joints or bulbous nodules of pleasing proportions yet without specific reference to human or natural forms. The recessed areas between the convex forms are hatched with slash marks that suggest barbarous intensity. By contrast, the attenuated form of the *Tightrope Walker* commemorates the bravery and skill of renowned Columbia alumnus General William "Wild Bill" Donovan, who led New York's 69th regiment in World War I and headed the Office of Strategic Services, precursor to the CIA, during World War II.

Carl Shurz Memorial

KARL BITTER, SCULPTOR; HENRY BACON, ARCHITECT, 1909–13

COLLECTION OF THE CITY OF NEW YORK

Morningside Drive at 116th Street

Located on the edge of Columbia's campus, perched on the brink where Morningside Drive drops sharply off to Morningside Park below, the Carl Shurz Memorial is a masterfully executed Beaux-Arts composition fusing sculpture and architecture. Schurz, a German American general, anti-slavery activist, and journalist, is depicted as "A Defender of Liberty and a Friend of Human Rights." The bronze statue and backdrop are mounted on a central granite pedestal framed by a sweeping granite exedra with benches; these are flanked at their outer ends by striking granite bas-relief panels. Executed in the style of archaic Greek sculptures, the bas-reliefs represent, on the left, a Greek warrior leading chained Africans and American Indians, and on the right, a winged female carrying the torch of Liberty ahead of a Grecian family. The dramatic location of the memorial at the edge of a precipice above the park makes for spectacular views over Harlem to the east, and one can walk down steps to the right into the park below.

167 Grant's Tomb

JOHN MASSEY RHIND, SCULPTOR; JOHN DUNCAN,
ARCHITECT, 1897
COLLECTION OF THE CITY OF NEW YORK

Riverside Drive at 122nd Street

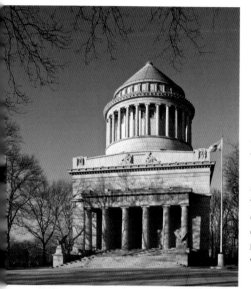

Standing opposite the tower of Riverside Church, the massive conical dome of Grant's Tomb is an impressive classical landmark overlooking the Hudson River. Viewed from a large public promenade framed by sycamore trees to the south, the severe Doric colonnade of the tomb entry porch is surmounted at the attic level by two sculptural figures framing Grant's famous words, "Let us have peace." The interior of the monument features a luminous dome lit only by natural light and a sepulchral recess in the floor that houses the stone biers of Grant and his wife. The exterior plaza surrounding the building is energized by sinuous forms of a colorful mosaic bench installed by local residents working with the City Arts Workshop.

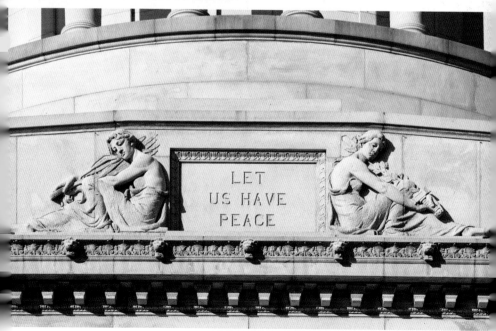

Harlem Hybrid

RICHARD HOWARD HUNT, 1976; RESTORED BY THE CITYWIDE
MONUMENTS CONSERVATION PROGRAM, 2008
COLLECTION OF THE CITY OF NEW YORK
Roosevelt Triangle, Morningside Avenue at 125th Street

Sited where 125th Street meets Morningside Avenue,
the complex form of *Harlem Hybrid* was inspired by the
triangular site, neighboring buildings, and the mounded
forms of natural rock outcroppings nearby. The sculptor
Richard Hunt has explored the intersection between
mounded forms in nature and the manufactured shapes
of industry in many of his works around the country. Here
the welded bronze plates have been assembled into
forms recalling both natural and man-made creations,
but black paint applied to cover graffiti obscured the
original clear finish. In 2008 the Department of Parks and
Recreation restored the transparent finish on the bronze
and replanted the surrounding landscape.

169 **Rivers**

HOUSTON CONWILL, ESTELLA CONWILL MAJOZO,
AND JOSEPH DEPACE, 1991

COLLECTION OF THE CITY OF NEW YORK, SPONSORED BY THE NEW YORK
PUBLIC LIBRARY AND THE PERCENT FOR ART PROGRAM OF THE DEPARTMENT
OF CULTURAL AFFAIRS

**Langston Hughes Lobby in the Schomburg Center
for Research in Black Culture, 515 Malcolm X Boulevard**

MY SOUL HAS GROWN DEEP LIKE THE RIVERS . . .

–Langston Hughes, 1922

This colorful design of inlaid brass and terrazzo was commissioned for the 1991 addition to the Schomburg Research Library, where over ten million documents and objects relating to African American history are preserved. The title and iconography of the piece are inspired by Langston Hughes's poem "The Negro Speaks of Rivers," published in 1922. Hughes, also a novelist, playwright, and librettist, is recognized as one of America's most distinguished writers. The "cosmogram" of concentric circles inlaid with excerpts from the poem references not only the life of Hughes but also that of Arturo A. Schomburg, the prolific collector of African American books and artifacts that form the basis of the current research collection. The river-like "life lines" that stream out from the center relate the birthplaces of Hughes and Schomburg to the intersection of their lives in Harlem. The remains of Hughes are buried below the cosmogram, making this work of art a moving memorial.

ELIZABETH CATLETT, 2003

COLLECTION OF THE CITY OF NEW YORK

Riverside Drive at 150th Street

I AM AN INVISIBLE MAN

I AM INVISIBLE, UNDERSTAND, SIMPLY BECAUSE

PEOPLE REFUSE TO SEE ME.

–Ralph Ellison, 1952

The idea for the Ralph Ellison Memorial, sited near the apartment building at 730 Riverside Drive where the writer lived for many years, originated with a group of his many friends and neighbors. Ellison's most popular novel, *Invisible Man*, articulated the frustrations of a young black man's treatment as a second-class citizen in postwar America. The design of the memorial gives literal form to this sense of invisibility, presenting a cutout of a forceful male figure within a larger bronze rectangle. The location of the sculpture in a landscaped island at the end of the street places the silhouetted form against the rich backdrop of the forest and river views in Riverside Park where Ellison loved to sit; Ellison is buried in Trinity Cemetery several blocks to the north. This was the first public commission in New York City of noted African American sculptor Elizabeth Catlett.

Sculptures at the Hispanic Society of America

ANNA HYATT HUNTINGTON, ARTIST; CHARLES PRATT
HUNTINGTON, ARCHITECT, 1927–43
COLLECTION OF THE HISPANIC SOCIETY OF AMERICA
Audubon Terrace, Broadway at 155–166th Streets

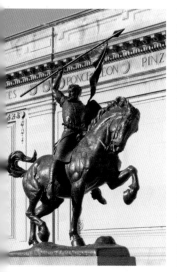

Tucked away from Broadway behind iron gates in a large sunken courtyard is a stupendous assemblage of monumental sculptures celebrating the history and culture of Spain. At the center is the triumphant bronze equestrian figure of the legendary El Cid Campeador, flanked at the base by four muscular semi-nude male figures representing the Spanish Order of Chivalry. These beautifully repatinated bronzes are silhouetted against the limestone wall of the museum to the north, blank but for the names of great Spanish explorers and statesmen inscribed at the cornice level. The east and west ends of this long north wall are animated by huge limestone bas-reliefs with inscriptions below; to the west is the rueful figure of Boabdil, the last Moorish king of Grenada, and to the east is Don Quixote astride his mount Rocinante.

The placement of the sculptures in a cordoned-off, sunken courtyard within the larger plaza between the buildings of Audubon Terrace makes for an odd relationship between the visitor and the sculpture. The smaller, decorative bronzes of a stag and a doe and her faun, which flank the stairs down to the lower courtyard, and the stone figures of vultures, boars, a jaguar, and other animals cannot mask the poor condition of the paving and retaining walls. Despite these shortcomings, the grand sculptural group retains astonishing aesthetic appeal in its original context.

172 El-Hajj Malik Shabazz, Malcolm X

GABRIEL KOREN, 1997

COLLECTION OF THE CITY OF NEW YORK, SPONSORED BY THE PERCENT FOR ART PROGRAM OF THE DEPARTMENT OF CULTURAL AFFAIRS

Audubon Ballroom, 3940 Broadway

The Audubon Ballroom building, where activist and founder of the Organization of Afro-American Unity Malcolm X was assasinated in 1965, has been partially preserved as an exuberant terra-cotta façade and lobby interior in front of a much larger biomedical research building constructed by Columbia University. In the lobby, a memorial to Malcolm X and his wife, Dr. Betty Shabazz, has been established with an educational center to celebrate their lives and legacy. The glass walls of the entry vestibule have been etched with decorative patterns based on the X form, a piece titled *Homage to Malcolm X* by Daniel Galvez (1997).

But the most striking feature is a life-size statue of Malcolm X by artist Gabriel Koren. The compelling figure speaks into a microphone on a raised platform at the back of the lobby. Video clips of his actual speeches can be heard nearby at the monitors on the lobby wall. A large and colorful mural depicting the life of Malcolm X, titled *Elegy for El-Hajj Malik Shabazz* by Colin Chase (1997), is located in the surviving portion of the ballroom on the second floor.

173 Washington Heights and Inwood War Memorial

GERTRUDE VANDERBILT WHITNEY, 1921; CONSERVED 1999
BY ROUSSEL CONSERVATION
COLLECTION OF THE CITY OF NEW YORK

Mitchel Square, between St. Nicholas Avenue and
Broadway at 167th Street

Located in a small triangular plaza directly opposite the
emergency room entrance of Columbia-Presbyterian
Hospital, Whitney's moving depiction of wounded soldiers
is set on a stepped, round granite base. The stooped
forms of the three soldiers are arranged in a roughly
pyramidal composition. One soldier on his knees looks
to the others in pain; the second is clearly wounded
and dependent on the physical support of his comrade,
whose figure standing in the middle is accentuated by the
upright form of his rifle with bayonet.

The outcroppings of Manhattan schist in Mitchel
Square directly to the south serve to ground the statue
visually to a more natural setting in the midst of this largely
paved and heavily trafficked neighborhood.

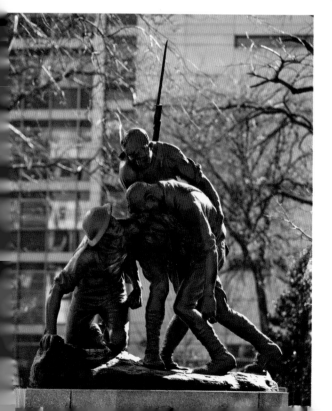

PUBLIC ART NEW YORK

174 Lighting of the George Washington Bridge

JACK BUCHSBAUM, CHIEF ELECTRICAL ENGINEER,
AND ROBERT DAVIDSON, CHIEF ARCHITECT, PORT AUTHORITY
OF NEW YORK AND NEW JERSEY; DOMINGO GONZALEZ,
LIGHTING DESIGNER, 2000

Henry Hudson Parkway at Cross Bronx Expressway,
near 179th Street

The design of the George Washington Bridge, completed in 1931, is one of the masterpieces of renowned Swiss engineer Othmar Ammann. Although originally planned to be clad in stone, the open trusswork of the gigantic steel towers is now recognized as a highly successful marriage of engineering with aesthetics. Engineers at the Port Authority of New York and New Jersey, inspired by the illumination of the Eiffel Tower, dreamed of lighting the steel towers of the bridge for years before finding a fundable occasion—the millennium celebrations in 2000. Lighting designer Domingo Gonzales developed the design and refined the approach, resulting in a scheme with hundreds of metal halide floodlights to backlight the tracery of the steel structure. The lighting is a resounding success, achieving sparkle without glare. Because of environmental concerns, the lights are only turned on for special occasions, but they produce a terrific impact on the only bridge on this stretch of the Hudson River.

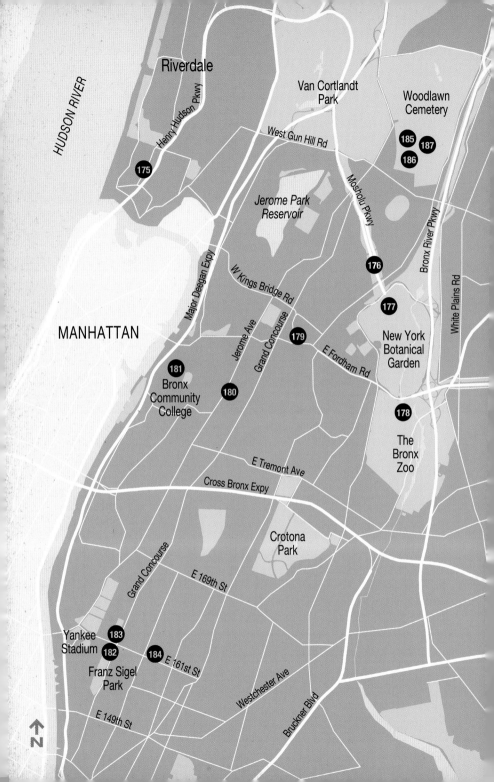

The Bronx

175 Henry Hudson Memorial

STATUE AND BAS-RELIEFS, KARL BITTER AND KARL GRUPPE,
SCULPTORS, 1938; GRANITE COLUMN, BABB, COOK AND WELCH,
ARCHITECTS, 1909; CONSERVED BY THE CITY PARKS FOUNDATION
MONUMENTS CONSERVATION PROGRAM, 2005
COLLECTION OF THE CITY OF NEW YORK

Henry Hudson Park, Independence Avenue at West 227th
Street, Riverdale

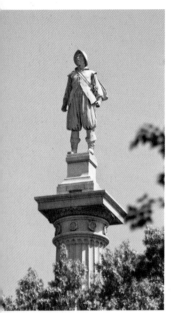

Henry Hudson, standing confidently on top of a 100-foot-high granite column in Riverdale, watches over the eponymous park near the juncture of the Harlem River with the Hudson River at Spuyten Duyvil. The column forms the north focus of a large, stepped plaza that terminates in a low stone exedra to the south. The monumental column and statue were originally conceived in the early twentieth century at the time of the renowned Hudson-Fulton commemoration of the three-hundredth anniversary of Hudson's voyage. Although the column was erected by private subscription in 1909, completion of the statue and bas-reliefs was delayed by the sudden death of Bitter. The statue was eventually finished by Bitter's acolyte Karl Gruppe and installed in 1938 under the auspices of Robert Moses's Henry Hudson Parkway Authority.

The period dress of both the statue and bas-reliefs at the base of the column is carefully rendered. In the vivid bas-reliefs on the south side of the column, Henry Hudson meets with his patrons from the Dutch East India Company; on the north side, he trades animal skins and beads with local Indians. Despite the prestige he earned as a result of

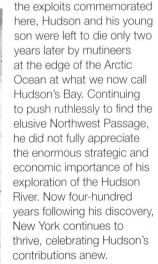

the exploits commemorated here, Hudson and his young son were left to die only two years later by mutineers at the edge of the Arctic Ocean at what we now call Hudson's Bay. Continuing to push ruthlessly to find the elusive Northwest Passage, he did not fully appreciate the enormous strategic and economic importance of his exploration of the Hudson River. Now four-hundred years following his discovery, New York continues to thrive, celebrating Hudson's contributions anew.

JEROME CONNOR, SCULPTOR; ARTHUR WALDREAON, ARCHITECT,
1925; RESTORED UNDER THE ADOPT-A-MONUMENT PROGRAM
OF THE MUNICIPAL ART SOCIETY, 1989
COLLECTION OF THE CITY OF NEW YORK

Mosholu Parkway at Hull Avenue

Located in the wide, landscaped median between the
two sides of the Mosholu Parkway, this arresting sculpture
nonetheless catches the attention of passing motorists
and pedestrians. Nicely repatinated in 1989, the sculpture
was erected in 1925 to commemorate the soldiers of the
Bronx who fought in World War I. It captures the poignancy
of an American soldier standing guard with bayoneted
rifle over his fellow soldier who has been wounded in
battle. The injured man's twisting, half-prone position
recalls the famous, classical form of The Dying Gaul, but
on the right side of the group an American eagle flaps his
wings protectively. This Beaux-Arts composition movingly
memorializes the dreadful massacre of the countless
young men who died or were maimed in World War I.

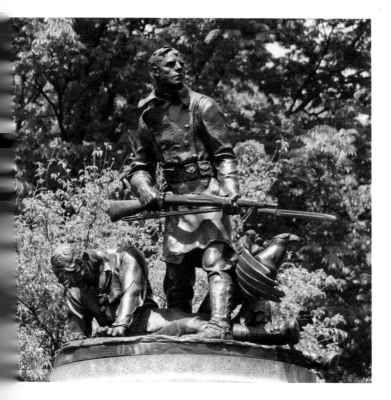

The Lillian Goldman Fountain of Life

CHARLES E. TEFFT, 1905; RESTORED BY BUILDING CONSERVATION
ASSOCIATES; MERMAID AND MERMAN MODELED BY GLENN AND
DIANE HINES, 2005
COLLECTION OF THE CITY OF NEW YORK

New York Botanical Garden, Mosholu Parkway at Kazimiroff Boulevard

This ornate and celebratory Beaux-Arts fountain is located directly in front of the main building of the New York Botanical Garden, at the head of the lovely Tulip Tree Allee. Twin sea horses with webbed feet dominate the fountain, pulling a chariot that is steered with an ornate oar by several jubilant cherubs. Small sea creatures including crabs and sea birds ornament the base. The stone mermaid and merman who crouch below the chariot were re-created from old photographs when the fountain was restored in 2005. The fountain now forms the centerpiece of a small plaza in the middle of a circular drive. A bronze book, seemingly left by chance on the rim of the fountain, commemorates the restoration.

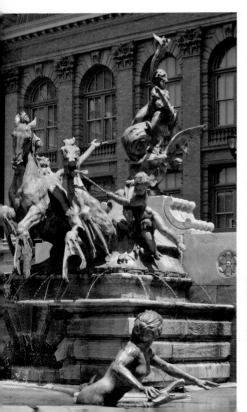

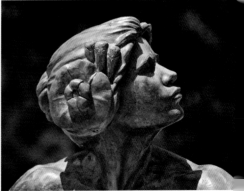

178 **Rainey Gates**

PAUL MANSHIP, ARTIST, 1938
COLLECTION OF THE CITY OF NEW YORK

**Bronx Zoological Park, Fordham Road between Southern
Boulevard and Bronx River Parkway**

These magnificent and monumental bronze gates were
dedicated in memory of Paul J. Rainey, brother of Grace
Rainey Rogers, the benefactress of the public auditorium
at the Metropolitan Museum of Art. In the mold of Teddy
Roosevelt, Mr. Rogers was a big-game hunter and a
patron of the zoo. Although the road the gates flank used
to be the main entrance, today it is used primarily as the
employees' entrance.

Manship used the Art Deco style to full effect,
employing sinuously rendered vegetation and zoo animals
to both support and decorate the gates. Large, husky
turtles support the main piers, which are crowned at the
top by stately lions, bears, and deer with striking antlers.
African animals including pumas and chimpanzees
animate the outer piers of the gates, and small gatehouses
designed by Charles A. Platt flank the driveway. The gates
can be enjoyed from both inside and outside the zoo; the
driveway leads to an ornate Italian fountain, donated by
William Rockefeller in 1902, and the refurbished, classically
inspired plaza and pavilions known as the Astor Court.

179 Portrait of a Young Reader

INIGO MANGLANO-OVALLE, 2006
COLLECTION OF THE CITY OF NEW YORK, SPONSORED BY THE PERCENT FOR ART
PROGRAM OF THE DEPARTMENT OF CULTURAL AFFAIRS

Bronx Library Center

DATTNER ARCHITECTS, 2006
310 East Kingsbridge Road

For such a significant public building in an underserved neighborhood, the interior entrance lobby to the Bronx Library Center is surprisingly understated, and the featured work of public art is not immediately apparent even to a visitor seeking it out. This thoughtful and innovative work of art animates the wall of the stair leading from the main lobby down to the lower level. Using a subdued but lively pattern of colorful disks to represent the DNA sequence of an anonymous young reader, the artwork draws the library visitor to ponder the rationale of the seemingly random pattern. The content and import of DNA is explored as "a code, a catalogue, and a library, with volumes of information to be unlocked and stories to be written." It is best appreciated from the lower level of the building. The open and light-filled reading areas on the upper floors of this energy-efficient building attract neighborhood residents of all ages to what has become a popular cultural center for the community.

180 **Honor 2000**

MIERLE LADERMAN UKELES, 2000
COLLECTION OF THE CITY OF NEW YORK, SPONSORED BY THE PERCENT
FOR ART PROGRAM OF THE DEPARTMENT OF CULTURAL AFFAIRS
© MIERLE LADERMAN UKELES, COURTESY RONALD FELDMAN FINE ARTS,
NEW YORK/WWW.FELDMANGALLERY.COM

Engine Company 75 Firehouse
DATTNER ARCHITECTS, 2000

2175 Walton Avenue at Cameron Place

In an exuberant amalgam of large-scale graphic design and architecture, this eye-catching façade design depicts an abstracted fire truck by using a pattern of colorfully finished concrete blocks. In this medium the artist aimed to create a "permeable membrane" not only between indoors and out, but also between the culture of firefighters and the communal memory of the neighborhood they serve. The façade serves as a memorial to the firefighters of the Bronx who died during the twentieth century, incorporating translucent glass blocks engraved with the names of those fallen in the line of duty. Despite this somber feature, the supergraphic succeeds in telegraphing the purpose of the building and the import of its history to the neighborhood in an engaging and evocative way.

MCKIM, MEAD, AND WHITE, ARCHITECTS; DANIEL CHESTER
FRENCH, FREDERICK MACMONNIES, JAMES EARL FRASER,
AND OTHER SCULPTORS, 1892–1912
COLLECTION OF THE CITY OF NEW YORK

Bronx Community College, Hall of Fame Terrace near
Sedgwick Avenue

MIGHTY MEN WHICH WERE OF OLD—MEN OF RENOWN

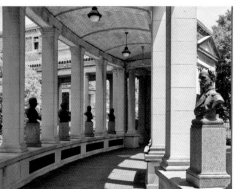

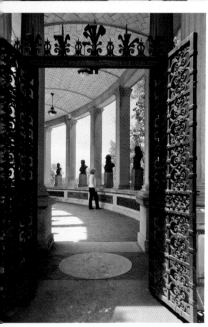

Perched on the edge of a steeply sloping hill overlooking the valley of the Harlem River, on reputedly the highest point in New York City, the Hall of Fame for Great Americans forms the dramatic west edge of this historic campus designed by Stanford White at the turn of the twentieth century for New York University. Because it curves behind the original library and two other Neoclassical classroom buildings of yellow Roman brick with limestone trim, the covered colonnade housing the Hall of Fame portrait busts unfolds incrementally to the visitor. Covered by graceful Guastavino tile vaults and lit by handsome period light fixtures, the limestone colonnade provides a dignified if somewhat melancholy setting for display of the portrait busts.

The colonnade is entered at the north end through handsome bronze gates and takes several right-angle turns before unfolding in a long, graceful curve on the axis of the library. The ninety-eight bronze busts, by numerous masterly American sculptors, are situated on granite pedestals in each open bay of the colonnade, classified by field of accomplishment such as science or theology. Some of the bronze plaques below the busts, which list notable quotes by the honorees, were designed by Tiffany Studios, but many have oxidized and are hard to read. The cumulative effect of the assembled portrait busts, including not only founding fathers but also inventors, jurists, teachers, and writers (with even a few women and minority figures represented) is visually and intellectually inspiring.

182 Bronx County Courthouse Façade Sculptures

EIGHT STATUARY GROUPS BY ADOLPH A. WEINMAN WITH GEORGE H. SNOWDEN, JOSEPH KISELEWSKI, AND EDWARD F. SANFORD; ARCHITECTURAL FRIEZE BY CHARLES KECK; MAX HAUSEL AND JOSEPH H. FREEDLANDER, ARCHITECTS, 1934
COLLECTION OF THE CITY OF NEW YORK

Bronx County Courthouse, 851 Grand Concourse at 158th–161st Streets

BE IT EVER REMEMBERED FINALLY THAT IT HAS EVER BEEN THE PRIDE AND BOAST OF AMERICA THAT THE RIGHTS FOR WHICH SHE CONTENDED WERE THE RIGHTS OF HUMAN NATURE

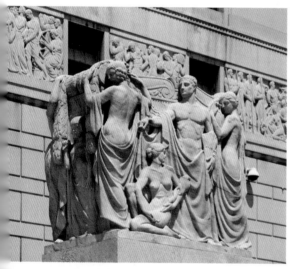

This striking Art Deco courthouse is one of the architectural standouts of the Bronx. Filling the rectangular block between the Grand Concourse, Joyce Kilmer Park, and Franz Sigel Park, the imposing courthouse is a stone's throw from the original Yankee Stadium. Its two principal façades with monumental stairs face north and south, but the east and west façades, although lacking major stairs, are almost as impressive. The artwork, completed under the auspices of the Works Progress Administration, is carefully integrated with the façades of the building.

All four sides of the court-house feature stylized Ionic

porticoes flanked by the classically inspired figures of the limestone frieze sculpted by Charles Keck. The figures depict classical and biblical subjects, scenes from historic wars fought on American soil, and allegories of American industry and prosperity, tempered by clear references to slavery. Standing forward of each façade are impressive pairs of freestanding sculptural blocks in pink granite by Adolph Weinman. These classically draped yet clearly WPA-vintage figures, outfitted with props like tablets and swords, portray with fluid, muscular forms the allegorical history of civilized rule by law. Inside the rotunda are murals original to the building depicting the history of the Bronx by James Monroe Hewlett.

183 Heinrich Heine Memorial

also known as the Lorelei Fountain
ERNST HERTER, 1900; RESTORED UNDER THE ADOPT-A-
MONUMENT PROGRAM, 1999
COLLECTION OF THE CITY OF NEW YORK

Joyce Kilmer Park, Grand Concourse at 161st Street

This highly ornate exemplar of German academic art
from the late nineteenth century, rendered in striking
white marble, stands in marked artistic contrast to the
restrained Art Deco Bronx County Courthouse across
the street (182). The studiously sculpted fountain,
featuring the dominant figure of the mythic Lorelei
surrounded by mermaids, seashells, and other denizens
of the ocean, carries a fascinating history that illuminates
the complicated social politics of turn-of-the-twentieth-
century New York.

As a monument to the German poet and social critic
Heinrich Heine, the statue became the cause célèbre
of the cultured German community in New York, which
raised funds to bring the artwork here from Germany.

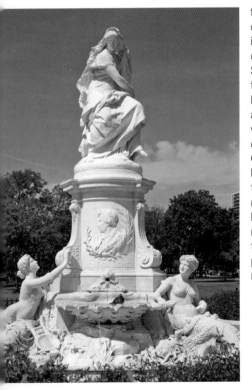

The sponsors were stymied in their quest
to place the monument at the prominent
crossroads of Fifth Avenue and 60th Street
in Manhattan, however, by the disdainful
criticism of the National Sculpture
Society, which had been asked to review
the installation by the Department of
Parks. After much political posturing
and jockeying, a back-room agreement
was reached to place the "dry, weak and
conventional" monument near the Grand
Concourse in the Bronx. After having
been vandalized and moved several more
times, the monument has been cleaned,
restored, and moved back to its original
location. It stands as a singular relic of
nineteenth-century European aesthetics,
transformed into a signifier of local ethnic
pride and a representation of the current
renewal of the Bronx.

184 One Stone

CAI GUO-QIANG, 2007
COLLECTION OF THE CITY OF NEW YORK

Bronx County Hall of Justice

RAFAEL VIÑOLY ARCHITECTS WITH DMJM+H ARCHITECTS
AND ENGINEERS, 2007

East 161st Street at Morris Avenue

Cai Guo-Qiang
March 9, 2000

This huge courthouse weighs in at 775,000 square feet, but the transparency of the energy-efficient curtain wall, the narrow footprint of the plan, and the sensitive layout of the site combine to create a public building that is easy to navigate and brings natural light deep into the interior. The intriguing art work by Chinese-born artist Cai Guo-Qiang is located on the landscaped plaza north of the open walkway that penetrates the first floor of the building. It is composed of one huge piece of granite carved into interconnected, open square links. Interspersed with shoots of live bamboo, the piece addresses the relationship of the parts to the whole, of the inert to the animate, of the immutable to the transitory, and of the nature of transparency—all subjects relevant to the administration of justice. The artist's sketch at left illustrates the intended effect when the bamboo matures.

Woodlawn Cemetery

Webster Avenue and East 233rd Street

Founded in 1863 as a landscaped rural cemetery, a concept pioneered at Mt. Auburn Cemetery in Boston, Woodlawn Cemetery was laid out with specimen trees, undulating landscape, and architecturally distinguished family monuments. The plan, originally laid out by J. C. Sidney, designer of Fairmount Park in Philadelphia, was altered by 1865 to follow the "Landscape-Lawn Plan" that eliminated fences and hedges in favor of naturalistic groupings of trees and shrubs. This picturesque landscape, in contrast to the alternative layout of multiple headstones lined up in a manicured lawn, made the cemetery a destination for urban families in search of a green oasis in the city. Numerous distinguished architects and sculptors—including John Russell Pope, Carrère & Hastings, James Gamble Rogers, Daniel Chester French, Anna Hyatt Huntington, and Gertrude Vanderbilt Whitney, to name just a few—contributed individual works to the whole. A small selection of the artwork is described on the following pages.

185 The Pulitzer Memorial

WILLIAM ORDWAY PARTRIDGE, 1913
COURTESY OF WOODLAWN CEMETERY

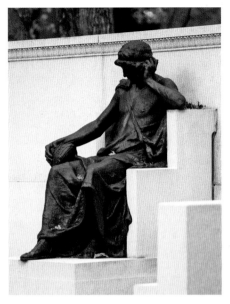

This thoughtful figure draped in classical robes with a leather strap across his bare chest represents the dignity and repose of a distinguished leader. There is no inscription citing Pulitzer's considerable accomplishments as a newspaper publisher and founder of the Columbia School of Journalism, the nation's first.

186 Door of the Gates Memorial

ROBERT AITKEN, 1914
COURTESY OF WOODLAWN CEMETERY

The moving figure of a woman shown from behind in high relief speaks of deep sorrow and longing for the departed. Her nude figure, only partially covered by draped fabric, reveals the beauty of the female form, referring both to idealized representations of immortal goddesses and to the sadness of mortals who remain grounded in this world. The figure appears to gaze through the pierced screen at the top of the door, seeking to reconnect with the departed but remaining forever outside the crypt.

187 The Outcast, or Piccirilli Memorial

ATTILIO PICCIRILLI, 1915; LOCATED HERE IN 1949
COURTESY OF WOODLAWN CEMETERY

This marble sculpture of a huddled male nude figure powerfully illustrates the convulsing anguish of all-consuming grief. Although completed earlier in the century, it was placed here to honor the son of Horatio Piccirilli, Attilio's brother, who died in World War II. The inscription reads:

> IN MEMORY OF OUR ONLY BELOVED SON, ENSIGN NATHAN Q. F. PICCIRILLI, WHO MADE THE SUPREME SACRIFICE FOR HIS COUNTRY AT THE BATTLE OF ORMAC BAY, PHILLIPPINE ISLANDS, DECEMBER 7, 1944.

It is a poignant personal statement by the family of sculptors who created so many great public works of art throughout New York City, including *Youth Leading Industry* (077), the Maine Monument (099) and the Firemen's Memorial (115).

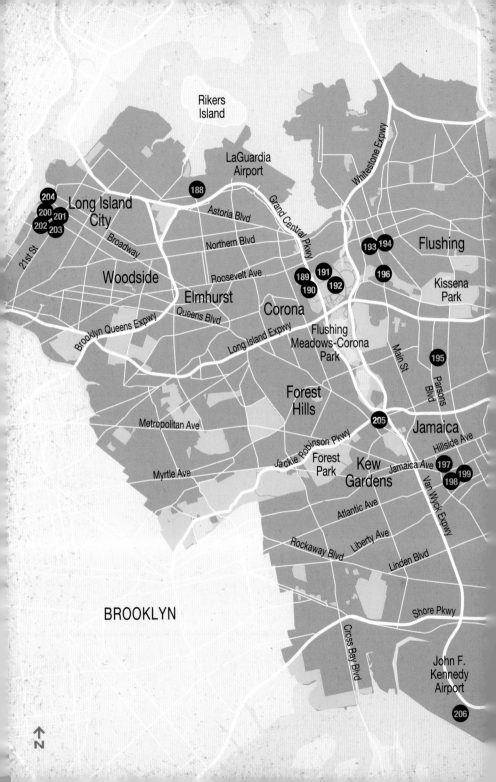

Queens

188 Flight

JAMES BROOKS, ARTIST, 1938–40
COLLECTION OF THE CITY OF NEW YORK

Marine Air Terminal
DELANO & ALDRICH, ARCHITECTS, 1937–40; RESTORATION BY
BEYER BLINDER BELLE, ARCHITECTS, 1995–6
West end of LaGuardia Airport, Flushing

Built just before World War II at the urging of Mayor Fiorello LaGuardia, the Marine Air Terminal originally served passengers for the legendary seaplanes known as Yankee Clippers. Over time, as air travel changed from seaways to runways, the terminal became divorced from the waterfront and was poorly renovated, masking its Art Deco style. The murals were inexplicably painted over in the 1950s but were restored in the late 1970s. Declared a New York City landmark, the terminal and its interior finally regained their former glory in the 1990s.

The colorful murals ringing the upper level of the interior of the original main hall are a striking reminder of the excitement and sophistication of the early days of air travel. Completed under the Works Progress Administration, the murals combine historical representation with artistic exuberance. Subjects include early biplanes, pilots undertaking navigational computations, and various representations of humanity benefiting from the advances of flight. The model of an old plane that now hangs from the middle of the dome is the perfect touch in this highly evocative public space.

New York Hall of Science

47-01 111th Street, Flushing Meadows-Corona Park

The unusual concrete and glass core of this building was constructed to the designs of Harrison and Abramovitz for the 1964 World's Fair. A new entrance and galleries by Beyer Blinder Belle were opened in 1996, and several fantastic outdoor science playgrounds by BKSK architects have been built since. The newest wing to the north, designed by the Polshek Partnership, opened in 2004. The upper Hall of Light in this wing is clad in a luminous membrane of translucent panels that brings filtered daylight into the interior exhibits. The terrific public art throughout the museum has been inspired by scientific inquiry and interprets natural phenomena in innovative ways to an audience of all ages. A few of these pieces are described on the following pages.

189 Sun Sculpture

MATY GRUNBERG, 1999
COLLECTION OF THE CITY OF NEW YORK

This gigantic astrolabe, 10 feet in diameter, sits in front of
the entrance to the Hall of Science. Part artwork and part
scientific instrument, it is a direct demonstration of how our
daily and seasonal cycles are calibrated from the rotation
of the earth around the sun. Whereas this sculpture
celebrates the sun's hegemony over human time, the
collection of historic rockets displayed nearby documents
man's attempts to break free of earthly gravity to explore
the solar system.

190 Inclined Light Wall

JAMES CARPENTER, 2004

COLLECTION OF THE CITY OF NEW YORK, SPONSORED BY THE PERCENT FOR ART
PROGRAM OF THE DEPARTMENT OF CULTURAL AFFAIRS

Installed on the inside of the north end of Polshek's 2004 addition to the Hall of Science, James Carpenter's slanted glass sculpture takes full advantage of the light streaming through the glass skylight above to project changing patterns and color on the wall. Because the sun and clouds are constantly moving across the sky, the intensity of the yellow color and the definition of the dot screens on both the inclined glass plane and the wall beyond continue to overlay in complex and evolving relationships. Located at the end of the wing, the piece acts as a magnet for visitors throughout the building and can be seen as well from the exterior. Says Carpenter, "It is a play on large-scale moiré patterns that shift with the viewers' movement through the space."

Soul in Flight: A Memorial to Arthur Ashe

ERIC FISCHL, SCULPTOR; MARK SULLIVAN, LANDSCAPE
ARCHITECT, 2000
COLLECTION OF THE CITY OF NEW YORK

National Tennis Center, Flushing Meadows—Corona Park

FROM WHAT WE GET, WE MAKE A LIVING; WHAT WE GIVE,
HOWEVER, MAKES A LIFE. —Arthur Ashe

The sculptor Eric Fischl, selected to design this memorial by a committee that included Ashe's widow, opted to represent Ashe's athletic prowess and humanitarian spirit with a nude figure. The novelty of depicting a tennis champion in the midst of the serving motion totally in the buff has perplexed some of the star's fans. But the muscled figure can be read as reaching heavenward in a universal gesture of striving and hope. The torqued counterpoint of the figure, recalling forms of classical sculpture, depicts the moment of recoil before the energy release of his mammoth tennis serve, evoking the graceful confidence of Arthur Ashe the champion.

192 Unisphere

GILMORE D. CLARKE, 1964

Granite Pavement

MATT MULLICAN, ARTIST; MICELI KULIK WILLIAMS, LANDSCAPE
ARCHITECTS,1995

COLLECTION OF THE CITY OF NEW YORK, SPONSORED BY THE PERCENT FOR ART
PROGRAM OF THE DEPARTMENT OF CULTURAL AFFAIRS

**Flushing Meadows-Corona Park, East of the Grand
Central Parkway**

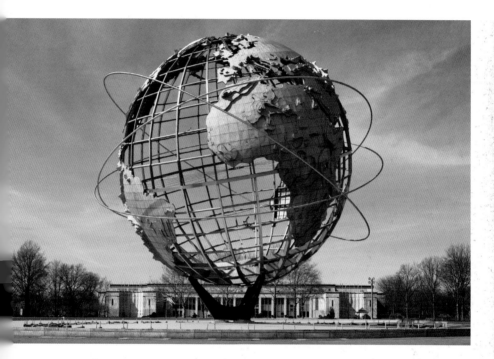

Although the huge *Unisphere*, built for the 1964 World's
Fair in shiny stainless steel, is regarded by some as an
incongruous relic of World's Fair bombast, it has earned
the fond regard of many as an example of mid-twentieth-
century design and has been designated a New York City
landmark. The gigantic globe, 120 feet in diameter, hovers
over a large fountain with spray jets that add palpably to
its appeal in the hot summer months. The extensive area
of pavement around the fountain has been reinvigorated
with highly detailed pictorial depictions of historical events
in the vicinity of the park, etched with matte finish into the
polished black granite. The scale of the whole ensemble,
therefore, is an odd mix of the gargantuan and the minute,
isolated in the huge expanse of the sprawling park.

193 Search: Literature

SHEILA LEVRANT DE BRETTEVILLE, ARTIST, 1998

COLLECTION OF THE CITY OF NEW YORK, SPONSORED BY THE PERCENT FOR ART
PROGRAM OF THE DEPARTMENT OF CULTURAL AFFAIRS

Flushing Regional Branch Library

POLSHEK PARTNERSHIP, ARCHITECTS,1998

41-17 Main Street

Queens is home to the most heterogeneous immigrant community in New York, and the Flushing library is the most heavily used branch in New York City. Subtly incised on the risers of the granite steps leading up to the main entrance of the library, the titles of classic stories in many languages evoke subjects of travel, relocation, and yearning for the manifold immigrants of Queens.

194 World of Flowers

YONG SOON MIN, ARTIST, 1998

COLLECTION OF THE CITY OF NEW YORK, SPONSORED BY THE PERCENT FOR ART
PROGRAM OF THE DEPARTMENT OF CULTURAL AFFAIRS

Flushing Regional Branch Library

POLSHEK PARTNERSHIP, ARCHITECTS, 1998

41-17 Main Street

Striking from both inside and outside the library, this series of twenty-four panels of sandblasted glass has a charming pictorial immediacy that juxtaposes maps of Queens and the world with cascading images of flowers from many countries. Recalling the graphic decorative patterns of wallpaper, the windows give the children's reading room a delightful sense of serendipity.

195 Roof Sculpture for the 107th Police Precinct Station House

ALICE AYCOCK, ARTIST, 1988

COLLECTION OF THE CITY OF NEW YORK, SPONSORED BY THE PERCENT FOR ART PROGRAM OF THE DEPARTMENT OF CULTURAL AFFAIRS

107th Precinct Stationhouse
PERKINS EASTMAN, ARCHITECTS, 1992

71-01 Parsons Boulevard

This striking composition sits on the roof at the most prominent corner of the three-story stationhouse. Composed of a large circular fiberglass dome reminiscent of a satellite dish or abstracted astrolabe, surrounded by miscellaneous geometric steel shapes, the piece at first elicited concern about bureaucratic eavesdropping among some neighborhood residents. However, it should be read as a more benign expression of the need for open communications between public officials and the citizens they aim to protect. The outsize scale of the sculptural forms should be enough to convince anyone that transparency, not secrecy, is the intended message.

196 **Tree Gate**

NOERAH ALVI, VOLLMER ASSOCIATES, AND ALEX KVETON,
MILGO INDUSTRIAL, INC., 2002
COLLECTION OF THE CITY OF NEW YORK

Queens Botanical Garden, 43-50 Main Street, Flushing

This stylized yet delightfully botanical gate telegraphs to
the street the remarkable transformation of the Queens
Botanical Garden since 2000. The garden, situated on
the 39 acre site of a horticultural exhibit for the 1939
World's Fair, has boldly transformed itself into a beacon
of sustainable design and an active park for the vibrant
local immigrant community. A handsome administrative
building designed by BKSK Architects, the first city
building to achieve LEED Platinum rating (the highest
level of sustainability) by using on-site water collection
and cleansing systems, opened in 2007. This gate,
fabricated from weathering steel, presents the silhouette
of the American hornbeam tree. Framed by two real and
formidable Blue Atlas cedars that survive from the World's
Fair display, the tree gate signifies to passersby that a
green oasis awaits inside.

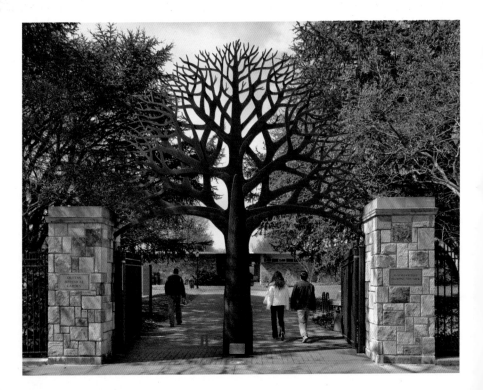

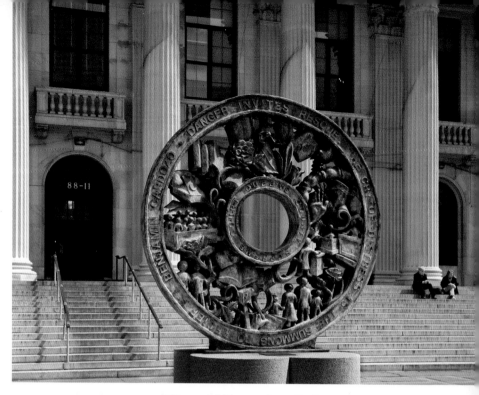

197 The Wheel of Justice

ED MCGOWIN AND CLAUDIA DEMONTE, 1998

COLLECTION OF THE CITY OF NEW YORK, SPONSORED BY THE PERCENT FOR ART
PROGRAM OF THE DEPARTMENT OF CULTURAL AFFAIRS

**Queens Supreme Court, 88-11 Sutphin Boulevard at 89th
Avenue, Jamaica**

Cast in the form of an ancient totem animated by primitive
figures and vegetative forms, the oxidized bronze *Wheel
of Justice* appears at first glance to have been unearthed
from a Mayan archeological site. On closer inspection,
it is clearly of our time, being decorated with aphorisms
such as "Danger Invites Rescue" and "The Cry of Distress
Is the Summons to Relief." The figures include policemen
and families, everyday objects such as a telephone, and
symbolic flowers from the Queens County flag. The wheel
is mounted in the center of the pleasant courtyard in front
of the colonnaded Supreme Court building; the sculptural
ensemble also includes granite benches inscribed with
the names of towns in Queens.

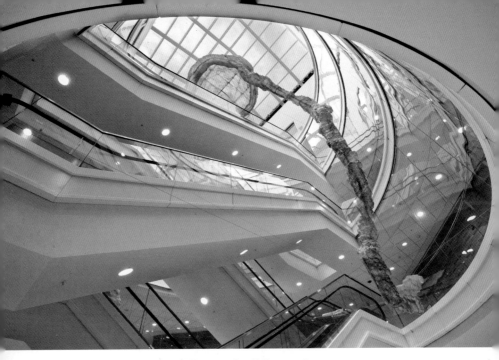

198 **Katul, Katul**

URSULA VON RYDINGSVARD, 2003
COLLECTION OF THE CITY OF NEW YORK, SPONSORED BY THE PERCENT
FOR ART PROGRAM OF THE DEPARTMENT OF CULTURAL AFFAIRS, OFFICE OF COURT
ADMINISTRATION AND THE DORMITORY AUTHORITY OF THE STATE OF NEW YORK

Queens Family Court
PEI COBB FREED & PARTNERS, ARCHITECTS, AND GRUZEN
SAMTON, ASSOCIATED ARCHITECTS, 2003
151-20 Jamaica Avenue

This intriguing piece was conceived by well-known artist
Ursula von Rydingsvard in consultation with architects
Pei Cobb Freed. Von Rydingsvard is best known for her
earthy, bowl-like pieces carved from dark masses of solid
cedar. That this piece had to be suspended from the lofty
ceiling of the public space presented an unprecedented
challenge. Her solution was to use cedar as the formwork
for the co-polyethylene resin material of the piece, and
to suspend the plastic from the ceiling on aluminum
armatures. One can glimpse the residual contour of
the cedar formwork in the shape and finish of the resin
skin. Although some have struggled to understand the
conceptual format of the piece, it demonstrates the verve
of an accomplished artist confronting new parameters.

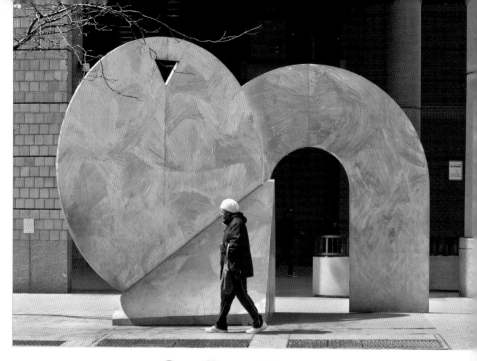

199 Confirmation

MELVIN EDWARDS, 1989
COLLECTION OF THE UNITED STATES GOVERNMENT

Joseph P. Addabbo Federal Building, 155-10 Jamaica Avenue at Parsons Boulevard

Because this was the first federal building completed in New York City after the removal of Richard Serra's controversial *Tilted Arc* from Jacob Javits Plaza in downtown Manhattan, the public art selection committee made a serious effort to involve the surrounding community of South Jamaica. They commissioned several African American artists to design site-specific works of art for the exterior and lobby of the building. The most visible of these, *Confirmation*, is an elegant addition to the urban landscape of the civic center. As in much of Edwards's work, the burnished stainless steel planes present a composition that is both restrained and dynamic. The large, circular plane echoes the round columns supporting the corner of the building, and the arched plane forms a curved gateway aligned with the building's entrance. The muted red brick color of the building's masonry façades sets off well the low-luster sheen of the stainless steel. Together, the elements of the composition manifest balance and exuberance.

The Isamu Noguchi Foundation and Garden Museum

9-01 33rd Road, Long Island City

Established in a former factory building in 1985, the Noguchi Museum was the first established by a living American artist to feature his own work. Noguchi himself closely directed the renovations to the building, creating a striking outdoor-indoor entrance space, an open, landscaped courtyard, and interior galleries flooded with light.

Substantially renovated in 2004, the Museum is open on a pay-as-you-wish basis on the first Friday of every month.

200 Entrance Court

A diagonal opening high in the far corner of the entrance court allows natural light to suffuse a portion of the space, creating a stark but dramatic setting for a selection of Noguchi's sculptures, including, in the left foreground *Break Through Capistrano*, 1982, and in the right foreground *Gift of Stone*, 1983.

201 Miharu
ISAMU NOGUCHI, 1968 (L)

Behind Inner Seeking Shiva Dancing
ISAMU NOGUCHI, 1976–82 (R)

The open courtyard is a serene Japanese-inspired garden with concrete pathways curving among stone or metal sculptures set on plinths in defined areas of earth, gravel, or evergreen groundcover. The landscape is further defined by specimen evergreen and deciduous trees, climbing vines on the walls, and the large, industrial windows that light the galleries inside. This elegant but restrained landscape and the earthy tones of the garden finishes provide the perfect setting for the display of Noguchi's signature work in granite, basalt, wood, and metal.

202 To Darkness
ISAMU NOGUCHI, 1965-66

Originally shown at the Whitney Museum in 1968, this dark granite piece has been mounted on a new base that mirrors its form for this courtyard installation.

203 Core (Cored Sculpture)
ISAMU NOGUCHI, 1978

The round hole in the middle of this upright piece of basalt is accentuated by a larger, shallow ring that exposes a darker face of the stone below the surface patina. The shallow ring wraps the corner of the piece in an intriguing way.

Socrates Sculpture Park

32-01 Vernon Boulevard at Broadway, Long Island City

Created in 1986 on the site of a remediated brownfield by a coalition of artists and community activists led by artist Mark di Suvero, Socrates Sculpture Park is an oasis of riverside open space that showcases the large-scale work of emerging artists. Set in a transitional industrial neighborhood on the East River, the park utilizes the visual tension between gritty surroundings and the open views to Manhattan to exhibit innovative and experimental art. Its programs to nurture young local artists are hailed as a model of community activism. Shown in the foreground is *In Advance of a Woodpile* by Brian Wondergem, 2000.

204 **King**

KEN LANDAUER, 2007
COURTESY OF THE ARTIST AND SOCRATES SCULPTURE PARK

Temporary installation

This delightfully ironic piece sets a king-size bed, carefully made up with white Pratesi linens, inside a white box on top of a small rise. The box is roofed over and has double-glazed picture windows that allow visitors to stare inside at the bed, spotlit with downlights. The grand placement of this fragment of domestic luxury inside a sealed box at the edge of the river is a tantalizing reminder of the fragility of isolated attempts at civilization and the absurdity of aggrandizing statements in the face of this urban landscape.

Civic Virtue

**FREDERICK MACMONNIES, 1920; UNVEILED IN CITY HALL PARK
1922; MOVED TO PRESENT SITE IN 1941**
COLLECTION OF THE CITY OF NEW YORK

Queens Boulevard and Union Turnpike at 80th Road

This much-maligned piece of public sculpture has a fascinating history that illustrates the disconnect between academic art and fast-paced historical and cultural developments in the early twentieth century. Although it was funded by a bequest from Angelina Crane, who died in 1891, the marble fountain was not unveiled until 1922, when the distinguished artist's use of allegorical figures to illustrate graphically the triumph of virtue (male) over vice (female) was perceived as coarse and outdated. The larger-than-life sized male figure, bearing a sword, stands with his foot firmly planted on the back of one of the supine female figures intertwined with repulsive reptilian or octopus-like forms.

The vehemence of the continuing protests in the early twentieth century was such that the Parks Department removed the fountain from City Hall Park (where, ironically, MacMonnies' acclaimed *Nathan Hale* (028) stands today) to the relative obscurity of its current location near the Queens Borough Hall. However, even knowing the history of the piece, a visitor today has to look hard to find the female figures because they face backwards; from any distance, it is the huge nude form of the male figure that dominates the piece. The large, multitiered fountain at the base, clearly oversized for its current location on the edge of a wooded slope, is in very poor condition, and the sculpture itself would benefit greatly from a good cleaning.

Flight/.125

ALEXANDER CALDER, 1957

COLLECTION OF THE PORT AUTHORITY OF NEW YORK AND NEW JERSEY,
ON PERMANENT LOAN TO JFK INTERNATIONAL AIR TERMINAL LLC.

**Departures Hall, Terminal 4, John F. Kennedy
International Airport**

The Port Authority of New York and New Jersey focused
professional expertise and considerable resources on
the installation of a range of historic and contemporary
art to enliven the traveler's experience of this modern
terminal. The Calder mobile, relocated from the existing
International Arrivals Building, hangs just below an
elongated skylight at the center of the departures
concourse, and the colorful composition moves slowly in
the rising air currents high above the active space below.

Another artwork in a publicly accessible area of the
terminal is a small but lively ceramic mural based on an

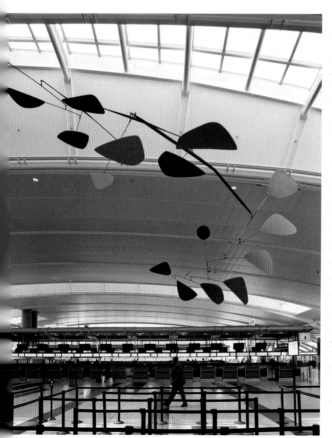

Arshile Gorky design at
Newark Liberty International
Airport; it is located at one
end of the Arrivals Hall on
the ground level. The most
innovative contemporary
works are located in
the long corridors of the
secure arrivals areas of the
terminal. These include
Travelogues, by Diller &
Scofidio, a series of backlit
screens with random
information activated by the
movement of passengers;
Curtain Wall, a pun on the
term for the exterior glass
wall of a building by Harry
Roseman, which is a series
of cast fiberglass curtains
that are like snapshots of
the movement of fabric
in the wind; and *Walking
New York*, a group of
twenty eight large painted
murals by Deborah Masters
high on the walls of the
Immigration Hall.

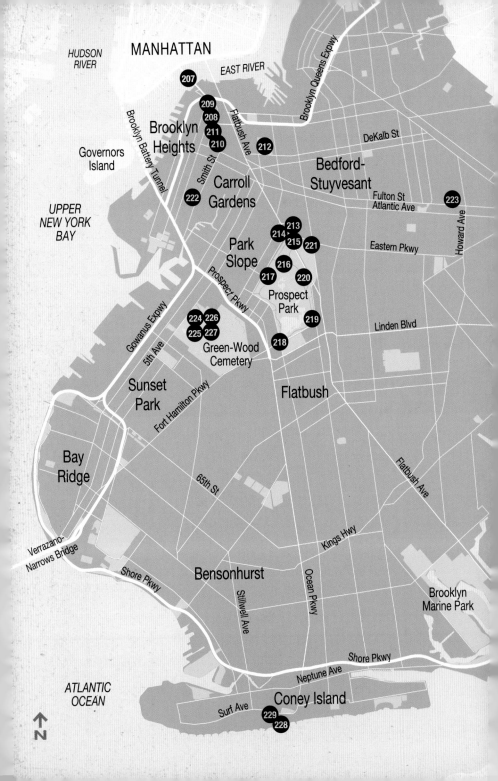

Brooklyn

207 **Brooklyn Bridge**

JOHN AUGUSTUS ROEBLING, WASHINGTON ROEBLING,
AND WILHELM HILDENBRAND, 1869–83

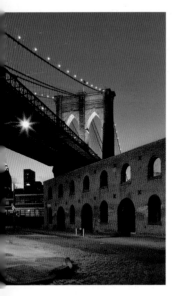

The Brooklyn Bridge is a masterpiece of design and construction that illustrates how structural engineering can be raised to the level of sublime visual art. Daring and innovative at the time of its construction, the structure exploited the strength of steel cables spun on site to span 1,600 feet, a greater distance by far than ever before. The breathtaking structure was conceived as a practical combination of gigantic stone masonry piers resting on bedrock, open steel trusses to support the roadbed, and trim steel cables to span the huge distance over the river. The difficulty of reaching bedrock, particularly below the Manhattan tower, resulted in many deaths including that of John Augustus Roebling, and the debilitating illness of his son Washington Roebling, whose wife stepped in to assist in the completion of the landmark project.

The stolid masonry piers are pierced and lightened by majestically scaled pointed arches that recall the spirit of Gothic cathedrals. They are juxtaposed with the graceful catenary of suspended steel cables braced by innumerable diagonal cable stays. The very subtly arched roadway and pedestrian walkway are rhythmically punctuated by the railings and historic light fixtures. It is thrilling to walk over the bridge at any time of day or night to experience the transcendent architecture and to luxuriate in the stunning views of the New York City skyline.

Cadman Plaza and Columbus Park

Between Tillary and Prospect Streets, and Cadman Plaza East and West

Named for a popular Congregational minister who was an early practitioner of radio evangelism, Cadman Plaza is the principal green connection between Brooklyn's civic center and the waterfront and the border between Brooklyn Heights and downtown Brooklyn. Because it is bordered primarily by large government buildings, including the city's Office of Emergency Management, its full potential as a neighborhood park has yet to be realized, and the green spaces appear underutilized.

Columbus Park, the paved south end of Cadman Plaza, defines the space in front of Brooklyn's Borough Hall, the New York State Supreme Court, and other public buildings. A statue of Christopher Columbus by Emma Stebbins stands on a tall column directly in front of the Supreme Court, and a bas-relief of Washington A. Roebling, builder of the Brooklyn Bridge, stands under the trees to the right of the Supreme Court.

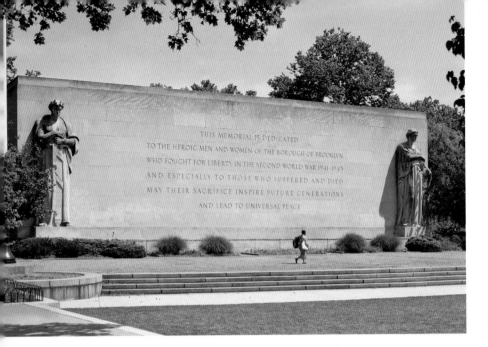

208 **Brooklyn War Memorial**

CHARLES KECK, SCULPTOR; STUART CONSTABLE, GILMORE
D. CLARKE, W. EARLE ANDREWS WITH
EGGERS AND HIGGINS, ARCHITECTS, 1951
COLLECTION OF THE CITY OF NEW YORK

Center of Cadman Plaza Park near Orange Street

An austere and imposing memorial achieves its intended somber effect as a reminder of the vast and ruthless toll of war. The south face of the memorial is blank except for a formal inscription and a colossal sculpted figure at either end. On the west end, a man stands solemnly with a sword; on the east, a mother shields her son from the scourge of combat. The monumentality of the entire composition, which is over 24 feet high and flanked by flagpoles, is best appreciated from a distance. To this end, the lawn just south of the memorial has been successfully refurbished with artificial turf, new paving, benches, plantings, and light fixtures. Inside the memorial is a hall used by veterans groups and arts organizations.

209 The Gaynor Memorial

ADOLPH A. WEINMAN, 1926
COLLECTION OF THE CITY OF NEW YORK

North End of Cadman Plaza Park near Middagh Street

OURS IS A GOVERNMENT OF LAWS NOT OF MEN.

Sculpted by the eminent German artist better known for completing Civic Fame on top of the Municipal Building (030), the Gaynor Memorial consists of a bronze bust of the

reform mayor of New York from 1910 to 1913, backed by large, bronze bas-reliefs let into a granite stele with a gracefully curved top. A lawyer and distinguished jurist, Gaynor as mayor took on Tammany Hall and fought to reduce corruption in the civil service system. The bas-reliefs depict classically draped allegorical figures of Law and Knowledge. Situated in a peaceful setting under sycamore trees, the Gaynor Memorial creates a dignified terminus to the north end of Cadman Plaza.

210 Robert F. Kennedy

ANNETA DUVEEN, 1965–72; RELOCATED TO CURRENT SITE IN 1994

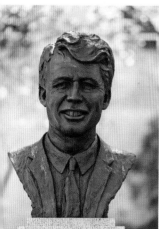

FEW WILL HAVE THE GREATNESS TO BEND HISTORY ITSELF, BUT EACH OF US CAN WORK TO CHANGE A SMALL PORTION OF EVENTS, AND IN THE TOTAL OF ALL THOSE ACTS WILL BE WRITTEN THE HISTORY OF THIS GENERATION.

This bronze bust, dedicated in 1972, sits on a splayed, four-sided base on which words of Robert Kennedy have been inscribed. The statesman, attorney general, senator, and brother of President John F. Kennedy was recognized for his support of racial justice and equality.

211 Henry Ward Beecher

JOHN QUINCY ADAMS WARD, SCULPTOR; BASE BY RICHARD
MORRIS HUNT, 1891; RELOCATED TO PRESENT SITE IN 1960;
CONSERVED UNDER THE ADOPT-A-MONUMENT PROGRAM, 1987
COLLECTION OF THE CITY OF NEW YORK

North end of Columbus Park, near Johnson Street

This statue of one of the greatest preachers of the
nineteenth century and the brother of author Harriet
Beecher Stowe is one of the acknowledged masterpieces
of John Quincy Adams Ward, who also created statues
of Horace Greeley (029), Roscoe Conkling (054), and
Alexander Holley (045) in other New York City parks.
What captures the viewer's attention first here are
the unusual figures,
reminiscent of nineteenth-
century French academic
sculpture, that flank the
tall granite base. To the
left, an African American
woman importunes the
somewhat aloof Beecher
with an olive branch. To
the right, two children
linger with a garland
to place at Beecher's
feet. The commanding
form of Beecher himself
looks thoughtfully into
the distance. Despite his
psychological remove from
the figures below, he was
recognized for his fiery
support of abolition and
of the causes of children.
Although the statue is
placed somewhat out of
the pedestrian mainstream
at the north edge of
Columbus Park, from it you
can glimpse the Manhattan
Bridge in the distance over
Beecher's shoulder.

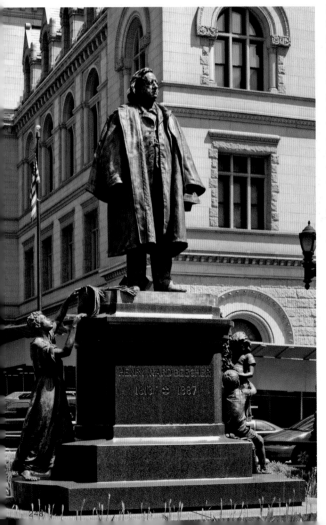

Prison Ship Martyrs Monument

ADOLPH A. WEINMAN, SCULPTOR; MCKIM, MEAD & WHITE, ARCHITECTS, 1908; FREDERICK LAW OLMSTED AND CALVERT VAUX, LANDSCAPE ARCHITECTS, 1867; RESTORATION BY THE DEPARTMENT OF PARKS & RECREATION, 2008
COLLECTION OF THE CITY OF NEW YORK

Fort Greene Park, between Myrtle and DeKalb Avenues; between Edwards Street and Washington Park Street

The tragic story of the more than 11,000 American prisoners of war who died while held by the British on fetid ships during the Revolutionary War sparked growing outrage during the nineteenth century as their bones continued to wash up on the shores of Brooklyn. The *Prison Ship Martyrs Monument* in Fort Greene Park is the culmination of many years of planning and redesign on this site on top of a steep hill that served as a fort during the Revolutionary War and the War of 1812. Shortly after the Civil War, Olmsted and Vaux, the designers of Central Park and Prospect Park, created a master plan for this historic site, then known as Washington Park, with provision for a memorial crypt where the remains of the prison ship martyrs could be relocated from near the Brooklyn Navy Yard.

McKim, Mead & White's competition-winning design placed a monumental column at the top of twin multitiered flights of steps, employing architectural perspective and processional drama to emphasize the majesty of the Doric column and the height of the hill. This strong architectural statement incorporates sculptural elements in bronze, including a large, classical lantern on top of the column and four eagles on granite piers to reinforce the commemorative theme of the site. The eagles were removed by the Department of Parks & Recreation after repeated vandalism (two of the eagles are on view in the Arsenal on Fifth Avenue at 64th Street in Manhattan), but two of the originals and two reproductions have been reinstalled here. Dramatic new lighting improves upon the original design to light the lantern.

Grand Army Plaza

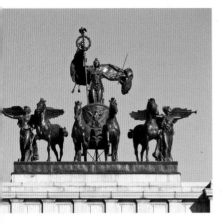

Initially laid out in 1867 under the guidance of Calvert Vaux but named Grand Army Plaza only after installation of the Memorial Arch in the early twentieth century, this huge traffic roundabout has been one of the greatest underdeveloped urban design opportunities in all of Brooklyn, if not the city. Despite the best efforts of McKim, Mead & White to classicize the space and relate it to the entrance to Prospect Park, the magnificent arch in the center of the plaza has been isolated from the neighborhood by the rush of circling vehicular traffic. Pedestrians take their lives in their hands in trying to cross to the middle of the plaza to see the architectural and sculptural details on the arch or to make their way by the most direct route from the subway station to Prospect Park. The Prospect Park Alliance is working with a consortium of community groups to make substantial improvements in circulation and accessibility.

213 Soldiers' and Sailors' Memorial Arch

JOHN H. DUNCAN AND MCKIM, MEAD & WHITE,
ARCHITECTS, 1892; PHILIP MARTIGNY, SCULPTOR

Quadriga: The Triumphal Progress of Columbia

FREDERICK MACMONNIES, SCULPTOR, 1896

Grant and Lincoln inside the arch

THOMAS EAKINS, SCULPTOR OF THE HORSES, AND WILLIAM
O'DONOVAN, SCULPTOR OF THE FIGURES, 1894/1901
COLLECTION OF THE CITY OF NEW YORK

Grand Army Plaza

This magnificent sculptural tour-de-force is a culmination of Beaux-Arts design in New York City. It consists of a classically inspired monumental granite arch, 50 feet high underneath, surmounted by lively bronze sculptural groups on the top and on the side ledges facing Prospect Park. Although the entire composition, honoring the sacrifices of the Union forces during the Civil War, took years to complete, it is now a fully integrated aesthetic composition that magnifies the grandeur of the entrance plaza to Prospect Park.

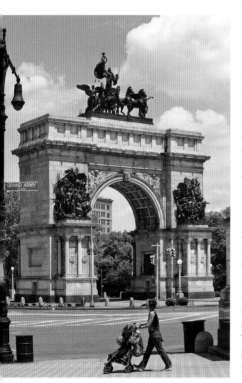

The grouping of four horses pulling a chariot (known as a classical "quadriga") on the top of the arch supports Columbia, an allegorical embodiment of the United States of America who holds aloft the symbol of peaceful civilization in one hand and a sword in the other. The widely spaced horses are flanked by winged victory figures blowing trumpets. The bronze relief panels on the interior of the arch depict Lincoln and Grant on horseback, but both the figures and the horses appear oddly passive compared to the lively and aggressive figures on the outside of the arch. This might be explained by the unusual arrangement of having different sculptors complete the people and the horses. But the overall effect of the arch and the exterior sculptures is stirring. The bronzes were handsomely restored in 1999 by the City Parks Foundation Monuments Conservation Program.

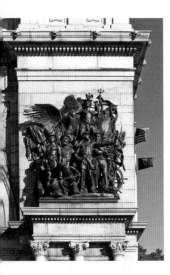

The Army: Genius of Patriotism Urging American Soldiers On to Victory (on the west pedestal)
The Navy: American Sailors at Sea Urged On by the Genius of Patriotism (on the east pedestal)

FREDERICK MACMONNIES, SCULPTOR, 1901

On the face of the arch, twin sculptural groupings depict the soldiers of the army (left) and the sailors of the navy (right). In both groupings MacMonnies has successfully balanced aesthetic composition with animated and realistic portrayal of the fighting forces. It has been noted that the commanding officer of the army group looks like MacMonnies himself and that many of the other soldiers and sailors were modeled on his friends. It is significant that one of the foremost figures in the navy group is an African American kneeling with a revolver in his hand; heroic depictions of African Americans in this era were rare.

214 Bailey Fountain

EUGENE SAVAGE, SCULPTOR; EDGERTON SWARTWOUT AND
H. CRAIG SEVERANCE, ARCHITECTS, 1932; RESTORATION 2002
COLLECTION OF THE CITY OF NEW YORK

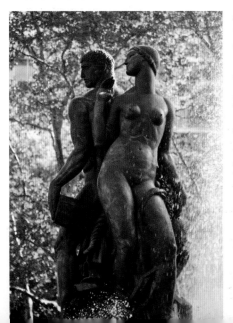

As the fourth fountain on this spot, named for Frank Bailey, once chairman of the Brooklyn Botanic Garden, the Bailey Fountain is a historically interesting addition to an otherwise barren public plaza that suffers from too much paving and not enough greenery. The nicely repatinated bronze figures, including well-muscled humans, sea creatures, and Neptune with his triton, are clustered around a central pedestal; although the restored rubble stone base looks heavy-handed, the fountain's individual figures are appealing representations of Art Deco style.

215 **Entrance Doors**

THOMAS HUDSON JAMES, SCULPTOR, 1941; RESTORED, 2007
COLLECTION OF THE CITY OF NEW YORK

Central Library of the Brooklyn Public Library, Flatbush Avenue and Eastern Parkway

HERE ARE ENSHRINED THE LONGING OF GREAT HEARTS
AND NOBLE THINGS THAT TOWER ABOVE THE TIDE,
THE MAGIC WORD THAT WINGED WONDER STARTS, THE
GARNERED WISDOM THAT NEVER DIES.
—Roscoe C. Brown, President,
Brooklyn Public Library Board, 1939–41

Renovated to provide an expansive public space for reading and relaxation, the main entrance to the Central Library has become a hub of activity on the edge of Grand Army Plaza. The handsome bronze grillework above the doors is decorated with gilded figures and flanked by simple yet massive limestone columns with gilded pictorial

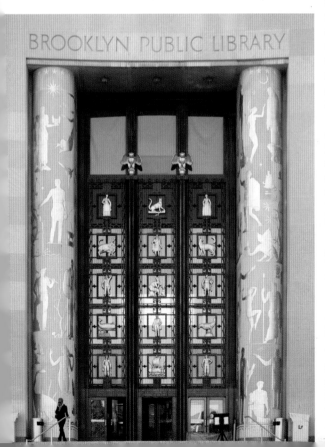

decoration. Reminiscent of the art deco architectural ornamentation that distinguishes Rockefeller Center, this composition celebrates figures, both animal and human, from classic American literature.

The three-dimensional, gilded figures stand forthrightly, each one filling one of the fifteen squares of the dark bronze grille. Moving down from the top left, they include, for example, Hester Prynne of Nathaniel Hawthorne's *The Scarlet Letter*; Babe the Blue Ox from the Paul Bunyan stories; Washington Irving's Rip van Winkle; Herman Melville's Moby Dick; and Mark Twain's Tom Sawyer. The flat gilded figures on the flanking round stone columns, by contrast, are two-dimensional yet lively, recalling Egyptian forms of ornamentation.

Prospect Park

As the acknowledged masterpiece of Frederick
Law Olmsted and Calvert Vaux, who undertook
its design and construction immediately after the
Civil War following their success with Manhattan's
Central Park, Prospect Park is the visual and
recreational heart of Brooklyn. Incorporating portions
of a terminal moraine that cut across western
Long Island, the park was masterfully sculpted by
augmentation of the existing terrain including bogs
and gravelly hills. Now listed as a New York City
scenic landmark and on the National Register of
Historic Places, the park is celebrated for the variety
and beauty of its landscape features including
open meadows, picturesque lakes, and forested
ravines. The Prospect Park Alliance, a public–private
partnership, has acted as a superb custodian in
restoring and maintaining this treasured and heavily
used park.

216 The Long Meadow

FREDERICK LAW OLMSTED AND CALVERT VAUX, CA. 1868

From Grand Army Plaza to Prospect Park Southwest

Reputedly the longest continuous open meadow surrounded by forest in an American urban park, the Long Meadow transports the visitor out of the city into an idealized vision of pastoral English landscape in the tradition of eighteenth-century designers Humphrey Repton and Capability Brown. It is a triumph of landscape art in the way its slightly curved and undulating forms draw the eye into the middle and far distance, disguising the immediate context and seducing the viewer into perceiving infinite space. The Long Meadow remains not only an icon of nineteenth-century landscape design but also a favored retreat for neighborhood families.

217 Lafayette Monument

DANIEL CHESTER FRENCH AND AUGUSTUS LUKEMAN,
SCULPTORS; HENRY BACON, ARCHITECT, 1917; RESTORED
UNDER THE ADOPT-A-MONUMENT PROGRAM, 1988
COLLECTION OF THE CITY OF NEW YORK

Prospect Park West at 9th Street

This striking and handsome monument has been well
integrated into the urban edge of Prospect Park. The
granite monument, set on axis with 9th Street, is set off by
a low granite exedra surrounding a small plaza paved with
yellow herringbone bricks and flanked by twin benches,
planting beds, and light fixtures. The large inset bronze
plaque depicts General Lafayette in high relief standing
confidently in front of his comely horse, which is restrained
by an African groom. Lafayette wields a long sword that
is emblematic of his many ceremonial swords preserved
in American museums. In its carefully crafted setting,
the Lafayette Monument is dignified and approachable,
celebrating a legendary historical figure at one of the
major pedestrian entrances to the most significant park
in Brooklyn.

218 The Horse Tamers

FREDERICK MACMONNIES, SCULPTOR; GRANITE BASES BY
MCKIM, MEAD & WHITE, 1899; CONSERVED BY THE CITY PARKS
FOUNDATION MONUMENTS CONSERVATION PROGRAM, 1998
COLLECTION OF THE CITY OF NEW YORK

Park Circle at the southwest entrance to Prospect Park

The Horse Tamers is an arresting pair of equestrian
statues mounted dramatically high up on stone pedestals.
Originally conceived as an allegory of the triumph of mind
over matter, each statue depicts a male figure wrestling
frantically to keep his balance while attempting to control
an energetic horse. Although the particular relevance of
this abstract theme to Prospect Park is not obvious, it is
a reflection of the tastes of its time, and the twin statues
do provide a bracing stereoscopic frame for this entrance
to the park. Because they are mounted on such high
bases, the undersides of the horses are seen more easily
by pedestrians than are the allegorical figures above.
The statues are flanked by granite benches and classical
pavilions that render this corner of the park welcoming for
neighborhood residents.

219 The Honor Roll, World War I Memorial

ARTHUR PICKERING, AUGUSTUS LUKEMAN, 1921
COLLECTION OF THE CITY OF NEW YORK

Southeast corner of Prospect Lake

The principal bronze statue at the center of the tall granite exedra has been handsomely repatinated and is wonderfully representative of the aesthetic of the early twentieth century. An angel of death, her face covered by a thin veil, shepherds a young soldier who carries a broken rifle and gazes up at her; in the hand that reaches around him, she holds wilting poppies. Although two of the six bronze panels with names of the deceased have been removed because of their poor condition, this dignified memorial is to be restored and integrated into the renewed landscape around the redesigned skating rink.

220 Topiary: A Twenty Year Project

MAGS HARRIES, 1993
COLLECTION OF THE CITY OF NEW YORK, SPONSORED BY THE PERCENT FOR ART PROGRAM OF THE DEPARTMENT OF CULTURAL AFFAIRS

Prospect Park Zoo, 450 Flatbush Avenue

Phantasmagoric figures of marine and animal life, constructed of heavy aluminum wire, loom playfully over and around one of the principal walkways of the Prospect Park Zoo. The openwork forms seem to grow out of planting beds adjacent to the walkway, and they are intended to be increasingly covered in climbing vines as a time-lapse variant of traditional topiary. Shrouded in clematis and climbing hydrangea, and grounded in boxwood hedges, the sculptures stand in wonderful counterpoint to the relatively staid brick buildings of the zoo. Children are fascinated by the arching form of a giant octopus or jumping fish, and the juxtaposition of metallic form with greenery is visually rich and stimulating.

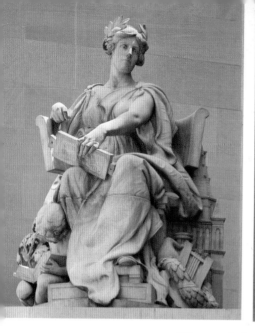
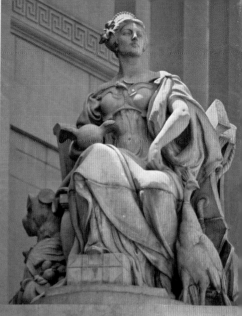

221 # Brooklyn and Manhattan

DANIEL CHESTER FRENCH, 1916; MOVED TO THIS LOCATION 1964;
CLEANED AND CONSERVED 2003

Front of the Brooklyn Museum, Eastern Parkway

Salvaged in 1964 from their original location on the
Brooklyn side of the Manhattan Bridge, these two
monumental stone allegorical figures seem perfectly
at home flanking the main entrance to the Brooklyn
Museum. They have been placed on large stone
bases forward of the building and serve as sculptural
bookends to the new steel and glass entrance awning.
The figure of Brooklyn is interpreted with symbols of
culture and learning such as a child reading a book,
laurel branches, and a church. Manhattan, on the other
hand, is accessorized with symbols of commerce
and fashion, such as a money chest, ships' rudders,
exotic fruits, and a peacock.

The sweeping new entrance, designed in the
1990s by the Polshek Partnership to compensate for
the removal of the original stone steps in the 1930s,
provides a grandly scaled and welcoming public space.
It succeeds in engaging passersby with stepped
seating areas, grass lawns, and a serendipitous fountain.
Visitors might even linger long enough to appreciate
the multitude of relief stone carvings in the pediment
completed by various sculptors under the direction of
Daniel Chester French.

Carroll Park War Memorial

EUGENE H. MORAHAN, SCULPTOR, 1920–21; CONSERVED BY FINE
ARTS CONSERVATION, 1994
COLLECTION OF THE CITY OF NEW YORK

**Carroll Park, between Smith, Court, Carroll, and
President Streets**

A distinguished memorial to the neighborhood men who
lost their lives during World War I is a graceful centerpiece
to this well-used park. The bronze bas-reliefs depict, on
one side, a soldier with helmet and rifle gazing down at
the grave of a fallen comrade, and, on the other, a sailor
standing watch. The plaques and the lists of the dead on
the side are recessed in a well-proportioned and slightly
tapered granite stele topped by deeply carved and highly
decorative anthemions in the center and at the corners.
The unusually harmonious integration of bronze and
stone elements and the quality of the artistic execution
make this an outstanding example of the numerous
neighborhood memorials dating from World War I.

Freedom's Gate

CHARLES SEARLES, 1997
COLLECTION OF THE CITY OF NEW YORK, SPONSORED BY THE PERCENT FOR ART
PROGRAM OF THE DEPARTMENT OF CULTURAL AFFAIRS

Fulton Street and Ralph Avenue

Situated in a raised, landscaped triangle on a busy street
intersection, *Freedom's Gate* is a striking, contemporary
piece that is almost overwhelmed by the zelkova trees
surrounding it, planted with the best of intentions. The
large piece, finished in two tones of bronze, has five
comb-like projections on the top of a reversed central
arch and three finger-like projections on the side,
resulting in a bracingly exotic form that contrasts with
the rectilinearity of the neighborhood architecture. The
opening in the middle would be big enough to walk
through if the structure were not located in a planting bed.

Green-Wood Cemetery

Fifth Avenue at 25th Street

Green-Wood Cemetery is one of the premier examples in the country of the mid-nineteenth-century practice of laying out cemeteries as beautifully landscaped parks, punctuated by high-quality funerary monuments. Since its founding in 1838, the cemetery has welcomed the dead and the living, who stroll the grounds to savor the mature trees, picturesque landscaping, and distant views over New York harbor.

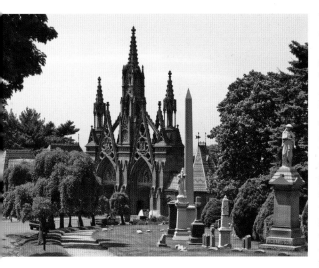

The ornate entrance gate, designed by Richard Upjohn in 1861–65, and set back grandly on a hill from nearby Fifth Avenue, is a masterpiece of Victorian Gothic carving of which John Ruskin would be proud, ornamented with two steeply peaked, openwork gables, three pointed and crocketed spires, and a pair of tympana in yellow Nova Scotia sandstone illustrating the resurrection. The three central spires of the gate are flanked by lower pavilions topped by multicolored slate roofs, copper trim, and iron cresting. Wild parakeets have nested in the spires and swarm around the gates early and late in the day. Some of the most visually remarkable funerary monuments are easily accessible from the main entrance gate.

224 Stewart Mausoleum

AUGUSTUS SAINT-GAUDENS, ARTIST; MCKIM, MEAD & WHITE,
ARCHITECTS, 1883

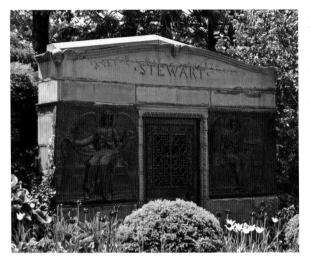

Set into the landscape at the corner of Battle Avenue and Arbor Avenue, the light-colored sandstone tomb features a gently curved stone pediment and a central bronze door ornamented with open latticework; it is flanked by two handsome bronze bas-reliefs of winged male and female angels, completed in 1883 by Augustus Saint-Gaudens. The tomb houses the parents of Isabella Stewart Gardner, founder of Boston's beloved museum.

225 Van Ness-Parsons Tomb

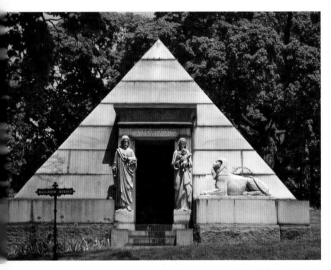

This striking stone pyramid is up the hill to the east on Battle Avenue. Egyptian imagery was popular in nineteenth-century funerary art, but this tomb for prominent Egyptologist Albert Parsons is particularly appropriate. The tomb features both ancient Egyptian and Christian iconography, including sphinxes and figures of Jesus and Mary. Surprisingly, it probably dates from the 1920s.

226 Civil War Soldiers' Monument

One of the earliest Civil War memorials, this column was erected by the City of New York in 1869 on a commanding site near the top of Battle Hill. Four quite life-like soldiers around the base hold weapons representing different tasks of battle: an ax, a rifle, a rod for ramming ammunition, and a sword. These statues, originally in zinc, were replaced in more durable bronze in 2002, and the bronze tablets have been repatinated.

227 Minerva with the Altar of Liberty

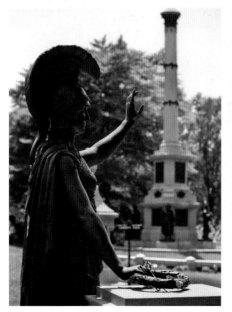

Standing just across Liberty Path on the top of Battle Hill, Minerva commemorates the Battle of Brooklyn, which was waged on this site during the War of Independence in 1776. Minerva, the goddess both of battle and of wisdom, looks directly out to New York Harbor with her arm raised toward the Statue of Liberty. She is a stately and becoming commemoration of this highest point in Brooklyn, which has played such a pivotal role in American history. Local residents have been vigilant in ensuring that commercial development does not block the historic sight lines between the two monumental ladies.

228 **Parachute Jump**

CONSTRUCTED 1939; LIGHTING BY LENI SCHWENDINGER, 2006
THE CITY OF NEW YORK

Coney Island Beach Boardwalk near West 16th Street

The dramatic, multicolored lighting of the *Parachute Jump* has revitalized this sole survivor from Coney Island's famed Steeplechase Park. The openwork steel tower was moved from the site of the 1939 World's Fair to Steeplechase Park and was opened for public rides in 1941. Although the parachute-assisted drop from the 262-foot-high tower pleased thrill seekers until 1968, it has been closed and buffeted by the seaside environment ever since. Listed on the National Register of Historic Places in 1980, the tower has now been partially rebuilt and completely repainted under the guidance of the city's Economic Development Corporation. Although it has not been restored to operation because it does not meet contemporary safety standards, the iridescent lighting keyed to the seasons of the year and to special holidays has renewed the neighborhood's appreciation of its delightful and colorful past. The inventive scheme by Leni Schwendinger relies upon custom-mounted LED's and floodlights to bathe both the canopy and the tower in a rotating sequence of six sparkling colors. The project brings renewed focus and artful celebration to a previously neglected remnant of recreational infrastructure.

The following text appears on the monument base:

1947, ON CINCINNATI'S CROSLEY FIELD,
ROBINSON ENDURED RACIST TAUNTS,
JEERS, AND DEATH THREATS
THAT WOULD HAVE BROKEN THE SPIRIT
OF A LESSER MAN.

REESE, CAPTAIN OF THE HOME TEAM...

229 **Jackie Robinson and Pee Wee Reese Monument**

WILL BEHRENDS, 2005

COLLECTION OF THE CITY OF NEW YORK

Keyspan Park, Surf Avenue and West 17th Street

The life-like figures of baseball greats Jackie Robinson and Pee Wee Reese have been united in this popular sculpture, which commemorates the storied moment in 1947 when Reese put his arm around Robinson to signal unity and support in the face of ugly heckling by a crowd in Cincinnati. The statue was dedicated in 2005 in the presence of the widows and children of the subjects to demonstrate that, in the words of Rachel Robinson, "no one who stands up stands alone." Its location near the entrance to Keyspan Park provides a memorable link to Brooklyn's passionate baseball history and treasured memory of the Dodgers.

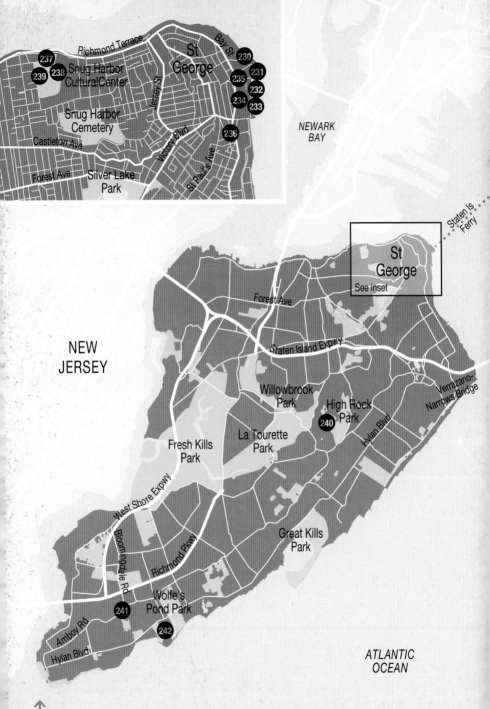

11

Staten Island

230 Postcards, Staten Island September 11 Memorial

MASAYUKI SONO, ARCHITECT, 2004

COLLECTION OF THE CITY OF NEW YORK

North Shore Esplanade, west of Richmond County Ballpark

Due to its prominent waterfront location and the designer's poetic visualization of his artistic concept, this memorial has become one of the most significant in the city to the victims of the attacks on the World Trade Center, a disproportionate number of whom lived on Staten Island. The paired planes of off-white concrete represent the sending of thoughts and prayers to loved ones over a great distance, as with postcards; but their forms are also strongly reminiscent of wings, a universally resonant symbol of peace, hope, and resurrection. The planes are oriented toward Lower Manhattan across the inner harbor, framing a breathtaking view of one of the most famous cityscapes in the world, which is also the site of the destruction memorialized here.

On the inside surfaces of the planes are mounted granite silhouettes of each of the victims, listing his or her name, employer, and date of birth; office workers and rescue workers are treated equally. It is heartbreaking to realize that no death dates need to be listed because all of the hundreds memorialized here perished on a single tragic day. The grid-like arrangement of heads allows the placement of flowers or small mementos on the inner face of the memorial. The outside face of each large plane is embossed at the top with fold marks like the back of an envelope, and the bottom of each outer surface is articulated with open slits to allow the passage of light and air through the concrete.

The memorial, the first of this magnitude created in New York City, succeeds at both the grand scale of the harbor and the intimate scale of the visitor. At pedestrian level it memorializes each one of the more than 270 local victims in a personal way, yet its larger, abstract form celebrates the common hope of humanity for redemption and reconciliation.

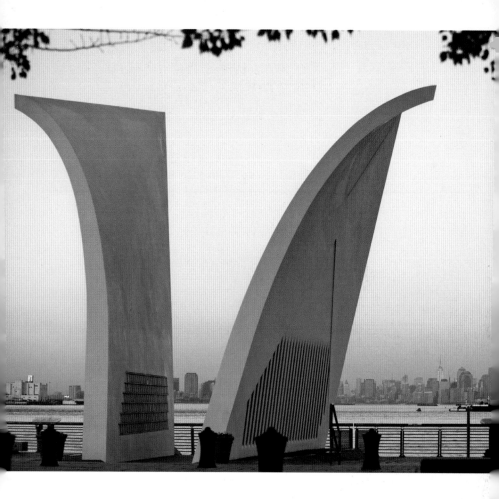

231 **Where the Marsh Meets the Sea**

MICHAEL FALCO, ARTIST, 2007

COLLECTION OF THE CITY OF NEW YORK, SPONSORED BY THE PERCENT FOR ART PROGRAM OF THE DEPARTMENT OF CULTURAL AFFAIRS

St. George Intermodal and Cultural Center

HELMUTH OBATA KASSABAUM, ARCHITECTS, 2007

South entrance from passenger drop-off area

This 30-foot-wide glass mural, almost cinematic in scale, is mounted atop the stair leading into the St. George ferry terminal from the Staten Island side. It is the product of years of effort and hundreds of images compiled by photographer Mike Falco. A collage of both time and place, it presents plants, birds, and human commerce on the marshy shoreline of Staten Island. The serene foreground of cattails, phragmites, ducks, and seagulls is focused on a rowboat trolling along the shore. Ships of various periods, including a tugboat, naval ship, and diverse sailboats, populate the far shore. But a ghostly scrim of bridges, industrial activity, and the working waterfront overlays the seemingly bucolic scene and points to the changing nature of the shoreline community.

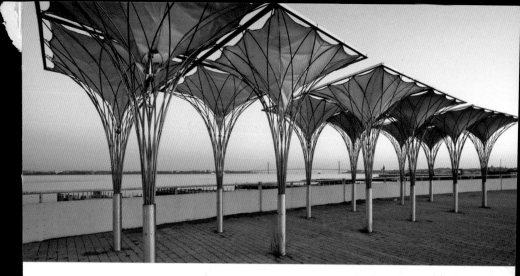

232 **Tensile Structures**

TODD DALLAND, FTL VENTURES LLC, DESIGNER; JOHANSSON
& WALCAVAGE, LANDSCAPE ARCHITECTS, 1996
PROPERTY OF THE CITY OF NEW YORK

North Shore Esplanade Extension east of Ferry Terminal

These elegant and spare tent structures supported on
gathered stems of stainless steel rods were commissioned
to provide a pedestrian shelter along the otherwise empty
north shore esplanade extension east of the St. George
Ferry Terminal. Functioning as inverted umbrellas that
provide shade from the sun and protection from the rain,
the tent structures have been likened to a group of tulips.

Inspired by the graceful catenary of the Verrazano
Narrows Bridge seen from this spot, designer Todd Dalland
envisioned the twelve structures as a "cybergrove of metal
and fabric trees—luminous membranes of fabric taut within
exoshells of steel rod." The stainless steel rods, tightly
clustered at the base, blossom into petal-like forms that
support open, rectangular frames at the top. The curving
silhouette of the openwork steel, mirrored by the light skin
of the stretched fabric, is highlighted by dramatic lighting
at night.

233 **Lighthouse and Bridge on Staten Island**

SIAH ARMAJANI, ARTIST; JOHANSSON & WALCAVAGE,
LANDSCAPE ARCHITECTS, 1996
COLLECTION OF THE CITY OF NEW YORK

North Shore Esplanade Extension east of Ferry Terminal

An intriguing evocation of Staten Island's industrial heritage serves as a link from the upper level of the esplanade to the historic waterfront buildings surviving from a former nineteenth-century lighthouse depot of the Coast Guard. Built immediately after the Civil War into the early twentieth-century, this collection of handsome brick and stone buildings, designated as landmarks by New York City and listed on the National Register of Historic Places, is planned to become a National Lighthouse Museum. The artfully composed modern bridge and tower, topped by a stained glass lens structure, marks the site of a vanished lighthouse as well as the surviving historic district and celebrates the functional preeminence of lighthouse structures along the waterfront. A line from a poem by Wallace Stevens is mounted at the edge of the bridge:

THE CLOUD ROSE UPWARD LIKE A HEAVY STONE
THAT LOST ITS HEAVINESS THROUGH THE SAME ILL,
WHICH CHANGED LIGHT GREEN TO OLIVE THEN TO BLUE.

234 Memorial to Major Clarence T. Barrett

SHERRY EDMONSON FRY, 1915; RESTORED BY FINE OBJECTS
CONSERVATION UNDER THE ADOPT-A-MONUMENT PROGRAM, 1989
COLLECTION OF THE CITY OF NEW YORK

Barrett Triangle, Stuyvesant Place at Borough Place,
east of Borough Hall

This handsome classical monument is the centerpiece
of a pleasant, small triangle close to the civic center.
At the intermediate level between the main entrance to
Borough Hall and the lower thoroughfare and bus stops
of Richmond Terrace, the triangle offers a shady place to
sit. The bronze figure, draped and outfitted with antique
helmet, spear, and shield, points with his strong right arm

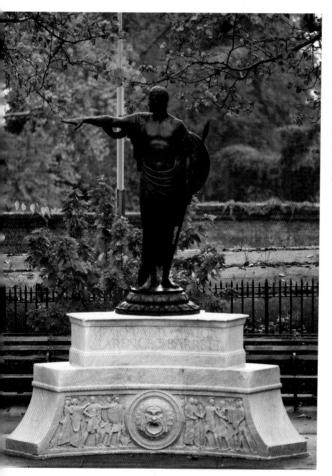

into the distance. The pink
marble plinth on which
he stands is decorated
at the base with a central
grotesque masque flanked
by lively bas-reliefs of
Grecian warriors. That
Barrett, who lived from
1840 to 1906, survived the
Civil War, unlike so many
of those memorialized,
makes this no less powerful
a monument.

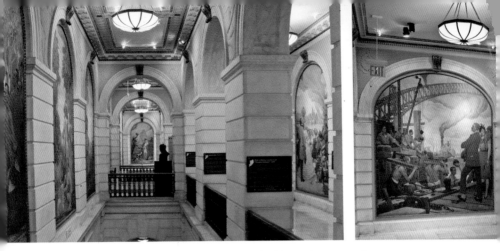

235 Murals (History of Staten Island)

FREDERICK CHARLES STAHR, MURALIST, 1935–40; BAS-RELIEFS,
SALVATORE MORANI, SCULPTOR, 1936–50; CLEANING BY
ALAN FARANCZ UNDER THE SPONSORSHIP OF BOROUGH
PRESIDENT JAMES P. MOLINARO AND THE ADOPT-A-MONUMENT
PROGRAM, 2001
COLLECTION OF THE CITY OF NEW YORK

Staten Island Borough Hall
CARRÈRE & HASTINGS, ARCHITECTS, 1906

2-10 Richmond Terrace

Inside the imposing French Renaissance–style Borough
Hall are colorfully detailed murals of the history of Staten
Island. Architect Carrère was a resident of Staten Island
and is buried at the Moravian cemetery there. The murals
and flanking plaster medallions have been beautifully
restored and relit.

Although painted under the auspices of the Works
Progress Administration, the murals derive from the
traditional artistic aesthetic of the earlier twentieth century.
Subjects include the European exploration and settlement
of Staten Island, treaties with the Native Americans, and
pivotal local events. The most modern mural, "Bayonne
Bridge Under Construction, 1928–31," appears in the
northeast corner of the lobby. The engineer Othmar
Ammann stands boldly in the foreground, watching the
burly and energetic workmen execute his plans. He
appears almost as a dandy, eyed by a fashionably dressed
lady to his right sporting a fox stole. It is a charmingly
glamorous portrayal of the art and science of structural
engineering, which resulted in the construction of reportedly
the second-longest steel arch bridge in the world.

236 The Hiker

**ALLEN G. NEWMAN, 1916; CONSERVED 1998 BY THE CITY
PARKS FOUNDATION**

COLLECTION OF THE CITY OF NEW YORK

Tompkinsville Park at Bay Street

Originally installed in front of Borough Hall to
commemorate Staten Island's veterans of the Spanish-
American War, *The Hiker* was moved to Tompkinsville
Park in 1925. Subsequent plaques have widened the
commemorative dedication of the statue to include all
American wars through the early twentieth century.

With his jaunty, wide-brimmed hat, his rifle cradled in
his right arm, and his casual stance, this soldier presents
a romanticized portrait of the freedom fighter supporting
local patriots against their European oppressors. Artist
Allen Newman copyrighted this fetching sculptural
depiction, and it became a standard used for many
Spanish-American War memorials throughout the
country. Looking almost like Indiana Jones, this Hiker
is a more seductive image than another widely used,
contemporaneous Hiker in which the soldier holds his
rifle with both hands horizontally. Despite his dapper air,
this Hiker gazes downward, perhaps remembering the
grimmer aspects of his battlefield encounters.

Snug Harbor Cultural Center

Richmond Terrace between Tysen Street and Kissel Avenue

Constructed in the 1830s to house "aged, decrepit and worn-out seamen," Sailors' Snug Harbor survives as a superb collection of early Greek Revival buildings, many designed by renowned architect Minard Lafever. The principal row of temple-fronted structures, centered on Lafever's original Administration Building, faces out across a lawn shaded by mature trees to Richmond Terrace. The entire extraordinary ensemble, including the historic gatehouse and fence, is both a New York City landmark and a National Historic Landmark. After being threatened with demolition in the 1960s, the complex was acquired by New York City in the 1970s when Snug Harbor relocated to North Carolina. Today the property houses a multifaceted cultural complex, including the Staten Island Botanical Garden, the Children's Museum, and the Institute of Arts and Sciences, among others. Temporary art shows are mounted periodically on the grounds of the Cultural Center.

Robert Richard Randall

REPLICA (CA. 1982) OF ORIGINAL BRONZE BY AUGUSTUS
SAINT-GAUDENS, 1884; PINK GRANITE PEDESTAL BY MCKIM,
MEAD & WHITE, 1884; CONSERVED BY THE CITY PARKS
FOUNDATION MONUMENTS CONSERVATION PROGRAM, 2002
COLLECTION OF THE CITY OF NEW YORK

West side of north lawn, facing Richmond Terrace

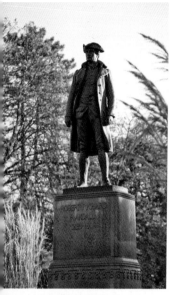

As the founder and benefactor of Sailors' Snug Harbor,
Robert Richard Randall demonstrated compassion and
foresight upon his death in 1801. His statue by Saint-
Gaudens was so valued by the institution's trustees
that they took it with them when they relocated their
facilities to North Carolina, unable to maintain these
original elegant but deteriorating buildings. The facsimile
effectively preserves the artistry of Saint-Gaudens and the
memory of Randall on site. He stands forthrightly looking
out to the harbor on top of a handsome pink granite
pedestal detailed by Stanford White. The intricate rope
frieze of figure 8s around the pedestal recalls the rigging
and rope crafts perpetuated by generations of seamen.

Neptune Fountain

ARTIST UNKNOWN, 1893; RESTORED UNDER THE ADOPT A-MONU-
MENT PROGRAM 1995; LANDSCAPE ARCHITECTS, QUENNELL
ROTHSCHILD; MODERN ART FOUNDRY, CONSERVATOR, 1994
COLLECTION OF THE CITY OF NEW YORK

East side of north lawn, facing Richmond Terrace

This traditional representation of Neptune with his trident,
a suitable iconographic reference for a sailors' home, was
originally cast in zinc and painted bronze color in order
to cut costs. Because of vandalism and deterioration,
the sculpture was recast in 1994 in bronze as originally
intended, and the surrounding cast-iron fountain, painted
white, was restored. Now ringed with benches and a
pathway, the fountain offers a pleasant place to enjoy the
view of the historic buildings, and the original sculpture can
be seen in the interior gallery.

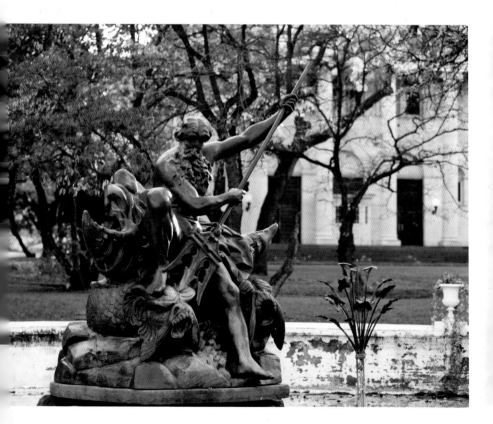

The New York Chinese Scholars Garden

ZOU GONGWU AND LANDSCAPE ARCHITECTURE CORPORATION OF CHINA, DEMETRI SARANTITIS ARCHITECTS, 1999
COLLECTION OF THE CITY OF NEW YORK

Staten Island Botanical Garden, 1000 Richmond Terrace

This exquisitely detailed jewel of a garden is tucked down a slope of the Botanical Garden and is entered, incongruously, through a small Victorian brick house. Approaching the walled garden by either of two paths through landscaped grounds, a visitor has little inkling of the treasures within. But upon entering this oasis, one feels transported to another world. Building upon the ancient traditions of Chinese gardens, and using simple materials of wood, stone, water, and plants, the designers have developed a choreographed sequence of carefully composed views. These vignettes are based upon the Chinese concepts of borrowed views (of adjacent landscape and sky), framed views (through doorways or gateways), and hidden views (opening up as one progresses through space). Each view is articulated with rich contrasts of color, texture, and shape, not only of plants but also in rocks, tiles, and architectural finishes. The water features add complexity and variability, reflecting the sky and trees above and harboring colorful fish and aquatic plants below the surface.

Most of the architectural features, including clay tiles, ornamental stone, rounded paving pebbles, and wood columns, were prefabricated as required and brought from the vicinity of Suzhou, China, a city visited by Marco Polo. The Chinese builders on site in Staten Island skillfully wove the picturesque structures, rough-hewn stones, and pebbled pathways together with the variegated plants and water features, capturing views both inside and outside the walls. The result is a contemplative yet visually stimulating retreat.

240 Gretta Moulton Gates

BRADFORD M. GREENE, ARCHITECT, 1995
COLLECTION OF THE CITY OF NEW YORK

High Rock Park, Nevada Avenue Entrance

Gretta Moulton was an early environmental activist on Staten Island, and these charming gates were designed in recognition of her role in saving High Rock as public parkland. Designer Brad Greene, a former member of the Art Commission of the City of New York, blended images of local flora and fauna in silhouette to achieve this engaging design. Abstracted cattails, flowers, and foliage decorate the four main vertical panels of each side of the gate, while turtles, rabbits, and squirrels frolic along the gently curved top rails. The cutout metal forms of the gates contrast pleasingly with the horizontally laid fieldstone of the flanking piers, and the entire ensemble blends harmoniously into the dappled light of the surrounding forest.

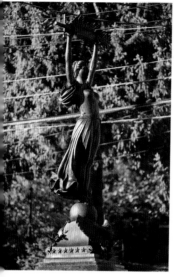

241 Pleasant Plains Memorial

GEORGE T. BREWSTER, SCULPTOR, 1923; REPLACEMENT FIGURE
BY DIANE AND GLENN HINES, 1996.
COLLECTION OF THE CITY OF NEW YORK

Amboy Road at Bloomingdale Road

This stirring memorial to the soldiers and sailors of the
Fifth Ward who perished in World War I is a replica of
the original bronze, which was removed after repeated
damage from passing cars. Although the site on a traffic
median was improved at the time of reinstallation, one still
feels vulnerable when visiting the statue, and overhead
telephone and electrical wires mar the background view.
However, the statue itself has dignity and presence. The
female figure stands on her toes, holding a large palm
frond of peace horizontally above her head. Her skirt and
the sleeves of her dress billow out behind her, and an
eagle spreads his wings at her feet. The helmet behind
the figure suggests that war has ceded to peace. The
flagpole with yardarm, which is placed behind the statue,
is dark bronze in color, minimizing its distracting effect,
and large bell-shaped bollards define the perimeter of the
memorial site.

242 Sewer Covers

ELIZABETH TURK, 2000

COLLECTION OF THE CITY OF NEW YORK, SPONSORED BY THE PERCENT FOR ART
PROGRAM OF THE DEPARTMENT OF CULTURAL AFFAIRS

Seguine Avenue near Hylan Boulevard

It is hard to image a less prominent location for public art
than the street bed in a largely residential neighborhood,

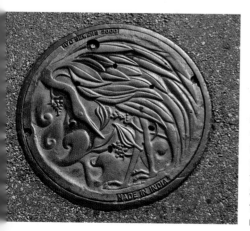

and if one didn't know where to look
for these sewer manhole covers, one
would pass them by without a thought.
But pedestrians with an eagle eye will be
drawn to these lyrical pieces, which are
scattered along Seguine Avenue near
Staten Island University Hospital South.
Keeping a watchful eye for approaching
ambulances, one can scout out numerous
variations that feature local birds and
foliage in flowing, Art Nouveau–like
patterns. The artwork draws attention
to the ecology of natural areas such as
Staten Island's protected Green Belt and
the huge Fresh Kills Park currently under
remediation and development.

Acknowledgments

I would like to recognize first and foremost the

generous support from Furthermore: a Project of the J. M. Kaplan Fund, which made this book possible, and to thank Joan Davidson for her advice and encouragement throughout the writing and design of the book. I also thank the staff of the Municipal Art Society for their collaboration and assistance from the beginning of the project, especially Kent Barwick, Frank Sanchis, Phyllis Samitz Cohen, Jean Tatje, Jo Steffens, Kathy O'Callaghan, and Dale Ramsey. This project could not have moved forward without them.

I thank the Office of the Mayor, especially Deputy Mayor Patricia Harris, as well as Nanette Smith, Katie Shopkorn, and Diana Carroll for their support of the project and for arranging access to Gracie Mansion. Executive Director Jackie Snyder and the staff of the Public Design Commission of the City of New York (formerly the Art Commission) were also extremely helpful over the course of several years in tracking down records and answering questions.

It was a privilege to speak to several artists about their work, and I especially thank the following artists and designers for discussing their work at length with me in personal interviews: James Carpenter, Todd Dalland, Neil Estern, Domingo Gonzalez, Richard Haas, Jenny Holzer, Forrest Myers, Lorenzo Pace, Ben Rubin, Leni Schwendinger, Brian Tolle, and Gail Wittwer.

The New York City Department of Parks & Recreation, led by Commissioner Adrian Benepe, was helpful in innumerable ways. Jonathan Kuhn, Director of Art and Antiquities, generously shared his knowledge of the history and conservation of park monuments, and he has assembled an impressive catalog of information on works of art in the public parks of New York City on the city's Web site. He also oversees conservation efforts and serves as liaison to the Public Design Commission of the City of New York. Access throughout Staten Island was made immeasurably easier by Borough Commissioner Thomas Paulo and Joe Ferlazzo, and Director of Historic Preservation John Krawchuk was very helpful.

I am grateful to Susan Chin and Lisa Kim of the Department of Cultural Affairs for their assistance in contacting artists in the Percent for Art program. Susan Friedman of the Public Art Fund gave valuable advice. Janet Hicks and Amanda Guccione of the Artists Rights Society arranged for permissions from many of the artists represented in the book.

David Brookstaver and Kali Halloway of the Office of Court Administration could not have been more helpful, putting me in touch with Joe Bleshman and Tom Rode at the Appellate Division, Mike Castellano at 60 Centre Street, and George Cafasso at the Queens Family Court. Fred Wilmers of Rafael Viñoly Architects and John Demase of DASNY arranged for access to the Bronx County Hall of Justice.

David Thurm of the *New York Times* gave immediate and enthusiastic support to the project, and Abbe Serphos facilitated our visit to the Times building. Casey Copenhaver of Tishman Speyer Properties ably assisted with obtaining permissions, and Amanda Carpenter, Blaine McShall, and Dan Fernandez helped with access to specific properties. Shelley Lee of the Roy Lichtenstein Foundation and Pari Stave of AXA Equitable helped me gain permission to photograph at the AXA Equitable Building. James Czajka kindly gave access to his office.

Permissions were expedited by Kate McGrath of RFR Holding LLC; Daniel Silva of the Hispanic Society; Robin Salmon of Brookgreen Gardens; Rikke Dau of UvR Studios; Tom Licanti of the New York Public Library; Hilda Rodriguez at the Metropolitan Museum; James Vickers at MOMA; Wayne Ehamann of the Metropolitan Transportation Authority; and Gary Fowlie and Chloe Naneix of the United Nations Press Office, and Sarah Elliston Weiner, curator of Art Properties for Columbia University.

I thank Elizabeth Cooke Levy and Reynold Levy for their support of the project at Lincoln Center; Alexandra Day of the Metropolitan Opera; Mark Heiser of the New York State Theater; and Alicia Everett and Kerry Madden of Lincoln Center for their assistance in obtaining permissions; Judith Johnson, Tom Lollar and John Pennino for their help in research.

Sidney Druckman of the Battery Park City Authority and Connie Fishman of the Hudson River Park Trust, both important sponsors of public art, gave enthusiastic assistance to the project. Jenny Dixon, Heidi Coleman, and Amy Hau of the Noguchi Museum were supremely welcoming and helpful. Wendy Feuer and Rita Nederman arranged for access to photograph in Terminal 4 at John F. Kennedy airport.

Susan Olsen of the Friends of Woodlawn Cemetery was helpful in identifying the most notable sculptures at Woodlawn, only a few of which could be included in the book. I also thank Leslie Ma of Cai Studios for her assistance. Fran Huber of the Snug Harbor Cultural Center gave wonderful recommendations for works of art on Staten Island, and Nicholas Dmytryszyn of the Staten Island Borough President's office offered details on the history and restoration of the murals at Borough Hall.

Production of the book was greatly enhanced by the skillful graphic design of Vivian Ghazarian and the handsome maps laid out by Walton Chan. Lola Conde and Rosa Weinberg of Thomas Phifer and Partners gave invaluable support. My editor Nancy Green and her colleague Vani Kannan of W. W. Norton were a pleasure to work with; Nancy is a fount of sound advice, scrupulous editing, and spirited encouragement.

Michele Bogart, distinguished art historian and former Vice President of the Art Commission, offered many constructive suggestions and read portions of the text.

Lastly, my family, Tom, William, and Thomas Phifer, allowed me to spend countless evenings and weekends preparing this book, and I thank them from the bottom of my heart for their cheerful forbearance and loving support.

Photographer's Note

I thank Scott Frances for introducing me to Jean Phifer for this project. Jean, thank you for all the wonderful guided walks we took through the city. Thanks to Richard Barnes, David Sundberg, Jock Pottle, and Chris Gray for helping ease my transition to working as a photographer in New York City. Peter Aaron, thank you for teaching me how to be a better photographer and, more important, how to enjoy life as a photographer.

I would like to thank my parents for all their loving support. To Claudia, my wife, thank you for caring for our children and supporting me every time I ran out of the house, shirking my duties at home, in order to photograph another site for this book. Your encouragement was indispensable.

Selected Bibliography

This short list does not include the innumerable books on the individual artists and sites mentioned in the book. Readers are encouraged to consult the Web sites nycgovparks.org and nyc.gov/artcommission for more information on these and many other works of art.

Burrows, Edwin G., and Mike Wallace. *Gotham: A History of New York City to 1898* (New York: Oxford University Press, 1998).

Bogart, Michele H. *The Politics of Urban Beauty: New York City and its Art Commission* (Chicago: University of Chicago Press, 2006).

———. *Public Sculpture and the Civic Ideal in New York City 1890–1930* (Washington, D.C.: Smithsonian Institution Press, 1997).

Heiferman, Marvin, ed. *City Art: New York's Percent for Art Program* (New York: Merrell Publishers Limited, 2005).

Dolkart, Andrew S. *Guide to New York City Landmarks* (New York: John Wiley & Sons, 1998).

Durante, Dianne L. *Outdoor Monuments of Manhattan: A Historical Guide* (New York: New York University Press, 2007).

Freedman, Susan K., Tom Eccles, Dan Cameron, Katy Siegel, Jeffrey Kastner, Anne Wehr. *PLOP: Recent Projects of the Public Art Fund* (New York: Merrell, 2004).

Gayle, Margot, and Michele Cohen. *The Art Commission and the Municipal Art Society Guide to Manhattan's Outdoor Sculpture.* (New York: Prentice Hall, 1988).

Masello, David. *New York's 50 Best Art in Public Places* (New York: City & Company, 1999).

Miller, Sarah Cedar. *Central Park, An American Masterpiece* (New York: Harry N. Abrams, 2003).

Okrent, Daniel. *Great Fortune: The Epic of Rockefeller Center* (New York: Viking, 2003).

Painting and Sculpture at Lincoln Center. Brochure published by Lincoln Center, no date. Out of print.

Reynolds, Donald Martin, *Monuments and Masterpieces: Histories and View of Public Sculpture in New York City* (New York: Macmillan Publishing Company, 1988).

Roussel, Christine. *The Art of Rockefeller Center* (New York: W.W. Norton & Company, 2006).

Shorto, Russell. *The Island at the Center of the World: The Epic Story of Dutch Manhatan and the Forgotten Colony that Shaped America* (New York: Vintage Books, 2005).

Snyder, Cal. *Out of Fire and Valor: The War Memorials of New York City from the Revolution to 9-11* (Piermont, NH: Bunker Hill Publishing, Inc., 2005).

Tate, Alan. *Great City Parks* (London: Spon Press, 2001).

The Complete Illustrated Guidebook to Prospect Park and the Brooklyn Botanic Garden (New York, 2001).

White, Norval, and Elliot Willensky. *AIA Guide to New York City* (New York: Three Rivers Press, 2000).

Index